THE BEST OF

The Digital Photography Book Series

The step-by-step secrets for how to make your photos look like the pros'!

PARTS 1-5

Scott Kelby

Author of the top-selling digital photography book ever—*The Digital Photography Book*, part 1

The Best of The Digital Photography Book Series

The Best of The Digital Photography Book Series **Team**

MANAGING EDITOR
Kim Doty

TECHNICAL EDITOR
Cindy Snyder

ART DIRECTOR
Jessica Maldonado

PHOTOGRAPHY
Scott Kelby

STUDIO AND
PRODUCTION SHOTS
Brad Moore

PUBLISHED BY

Peachpit Press

©2016 Scott Kelby

Composed in Myriad Pro (Adobe Systems Incorporated) and LCD (Esselte) by Kelby Media Group Inc.

Trademarks
All terms mentioned in this book that are known to be trademarks or service marks have been appropriately capitalized. Peachpit Press cannot attest to the accuracy of this information. Use of a term in the book should not be regarded as affecting the validity of any trademark or service mark.

Photoshop, Elements, and Lightroom are registered trademarks of Adobe Systems, Inc.
Nikon is a registered trademark of Nikon Corporation.
Canon is a registered trademark of Canon Inc.

Warning and Disclaimer
This book is designed to provide information about digital photography. Every effort has been made to make this book as complete and as accurate as possible, but no warranty of fitness is implied.

The information is provided on an as-is basis. The author and Peachpit Press shall have neither the liability nor responsibility to any person or entity with respect to any loss or damages arising from the information contained in this book or from the use of the discs, videos, or programs that may accompany it.

ISBN 13: 978-0-134-38512-9

ISBN 10: 0-134-38512-8

15 14 13 12 11 10 9 8 7 6 5 4 3 2

Printed and bound in the United States of America

www.peachpit.com
www.kelbyone.com

*This book is dedicated to my friend and colleague
Kleber Stephenson, for always being willing to come to our rescue;
for being "all in" in everything you do; and for
putting up with me, and my decisions, even when
you knew they weren't always right.
You rock, dude!*

Acknowledgments

Although only one name appears on the spine of this book, it takes a team of dedicated and talented people to pull a project like this together. I'm not only delighted to be working with them, but I also get the honor and privilege of thanking them here.

To my amazing wife Kalebra: I don't know how you do it, but each year you somehow get more beautiful, more compassionate, more generous, more fun, and you get me to fall even more madly in love with you than the year before (and so far, you've done this 26 years in a row)! They don't make words to express how I feel about you, and how thankful and blessed I am to have you as my wife, but since all I have here are words—thank you for making me the luckiest man in the world.

To my wonderful, crazy, fun-filled, son Jordan: When I wrote the first version of this book, I wrote that you were the coolest little boy any dad could ever ask for. Now that you're off at college, you're not a little boy by any means, but you are definitely still the coolest! Although I know you don't read these acknowledgments, it means so much to me that I can write it, just to tell you how proud I am of you, how thrilled I am to be your dad, and what a great big brother you've become to your little sister. Your mom and I were truly blessed the day you were born (and we sure miss you back here at home).

To my beautiful daughter Kira: You are a little clone of your mom, and that's the best compliment I could ever give you. You have your mom's sweet nature, her beautiful smile, and like her, you always have a song in your heart. You're already starting to realize that your mom is someone incredibly special, and take it from Dad, you're in for a really fun, exciting, hug-filled, and adventure-filled life. I'm so proud to be your dad.

To my big brother Jeff: A lot of younger brothers look up to their older brother because, well…they're older. But I look up to you because you've been much more than a brother to me. It's like you've been my "other dad" in the way you always looked out for me, gave me wise and thoughtful council, and always put me first—just like Dad put us first. Your boundless generosity, kindness, positive attitude, and humility have been an inspiration to me my entire life, and I'm just so honored to be your brother and lifelong friend.

To my in-house team at KelbyOne: You make coming into work an awful lot of fun for me, and each time I walk in the door, I can feel that infectious buzz of creativity you put out that makes me enjoy what we do so much. I'm still amazed to this day at how we all come together to hit our often impossible deadlines, and as always, you do it with class, poise, and a can-do attitude that is truly inspiring. You guys rock!

To my Photo Assistant Brad Moore: Thanks so much for all your help, advice, patience, and production shots throughout the project. You rock! (And, your beard is really something to behold in person.)

To my Editor Kim Doty: I couldn't be any luckier than to have you editing my books and shepherding them along. This one has taken a lot more time and sweat than any of us expected, but you always kept your trademark attitude and a smile on your face. Both of those kept a smile on mine, and I'm very grateful. Also, a big thanks to **Cindy Snyder** who tirelessly tech edits, checks, and rechecks everything I write to make sure it works (I keep telling her, "Hey, this stuff actually works," but she still somehow feels compelled to make certain). I'm delighted that you do what you do the way you do it. Thanks again, Cindy!

To Jessica Maldonado: I can't thank you enough for all your hard work on the cover, layout, and on the look of this and all my books. I love the way you design, and all the clever little things you add to everything you do. You're incredibly talented, a joy to work with, and I feel very, very fortunate to have you on my team.

To my new Editor at Peachpit Press, Nikki McDonald: This is our first book together, and I'm very excited to be working with you to create some books that really matter. I know you feel like you have some big shoes to fill, but don't worry, we're going to do some great projects together, and then I will try to get you to get Peachpit to buy me some fancy gifts. Unfortunately, that's how it works, but at least you know now. ;-)

To my best buddy Dave Moser: Thanks for everything you did to make this, our 60-somethingth book together, come together. I know, I know "Write, Forrest, write!" ;-)

To my dear friend and business partner Jean A. Kendra: Thanks for putting up with me all these years, and for your support for all my crazy ideas. It really means a lot.

To my Executive Assistant Lynn Miller: Thanks so much for managing my schedule and constantly juggling it so I can actually have time to write. I know I don't make it easy (I'm kind of a moving target), but I really appreciate all your hard work, wrangling, and patience throughout it all. I'm very glad to have you on our team.

To Sara Jane Todd ("SJ"), and the incredibly dedicated team at Peachpit Press: It's a real honor to get to work with people who really just want to make great books.

To all the talented and gifted photographers who've taught me so much over the years: Moose Peterson, Joe McNally, Bill Fortney, George Lepp, Anne Cahill, Vincent Versace, David Ziser, Jim DiVitale, Tim Wallace, Peter Hurley, Cliff Mautner, Dave Black, Helene Glassman, and Monte Zucker.

To my mentors John Graden, Jack Lee, Dave Gales, Judy Farmer, and Douglas Poole: Your wisdom and whip-cracking have helped me immeasurably throughout my life, and I will always be in your debt, and grateful for your friendship and guidance.

Most importantly, I want to thank God, and His Son Jesus Christ, for leading me to the woman of my dreams, for blessing us with such amazing children, for allowing me to make a living doing something I truly love, for always being there when I need Him, for blessing me with a wonderful, fulfilling, and happy life, and such a warm, loving family to share it with.

Other Books by Scott Kelby

The Adobe Photoshop Lightroom Book for Digital Photographers

Professional Portrait Retouching Techniques for Photographers Using Photoshop

The Digital Photography Book, parts 1, 2, 3, 4 & 5

Light It, Shoot It, Retouch It: Learn Step by Step How to Go from Empty Studio to Finished Image

The Adobe Photoshop Book for Digital Photographers

The Photoshop Elements Book for Digital Photographers

It's a Jesus Thing: The Book for Wanna Be-lievers

Photoshop for Lightroom Users

Professional Sports Photography Workflow

About the Author

Scott Kelby

Scott is Editor, Publisher, and co-founder of *Photoshop User* magazine and is co-host of the influential weekly photography talk show *The Grid*. He is also President of the online educational community for photographers, KelbyOne.

Scott is a photographer, designer, and an award-winning author of more than 60 books, including *The Digital Photography Book*, parts 1, 2, 3, 4 & 5, *The Adobe Photoshop Book for Digital Photographers*, *Professional Portrait Retouching Techniques for Photographers Using Photoshop*, *The Adobe Photoshop Lightroom Book for Digital Photographers*, and *Light It, Shoot It, Retouch It: Learn Step by Step How to Go from Empty Studio to Finished Image*. The first book in this series, *The Digital Photography Book*, part 1, has become the top-selling book on digital photography in history.

For the past five years, Scott has been honored with the distinction of being the #1 best-selling author of photography techniques books. His books have been translated into dozens of different languages, including Chinese, Russian, Spanish, Korean, Polish, Taiwanese, French, German, Italian, Japanese, Dutch, Swedish, Turkish, and Portuguese, among others.

Scott is Training Director for the Adobe Photoshop Seminar Tour, and Conference Technical Chair for the Photoshop World Conference & Expo. He is also the founder of Scott Kelby's Annual Worldwide Photowalk, the largest global social event for photographers, which brings tens of thousands of photographers together on one day each year to shoot in over a thousand cities worldwide.

For more information on Scott, visit him at:

His daily blog: **http://scottkelby.com**
Twitter: **@scottkelby**
Facebook: **www.facebook.com/skelby**
Google+: **Scottgplus.com**

Chapter Three 43

Pro Tips for Getting Sharp Photos

If Your Photos Aren't Sharp, the Rest Doesn't Matter

Chapter Four 53

Using Your Studio Like a Pro

Build It From Scratch, Then Take It Up a Notch.

Chapter Five 81

Shooting Portraits Like a Pro

Tips to Make People Look Their Very Best

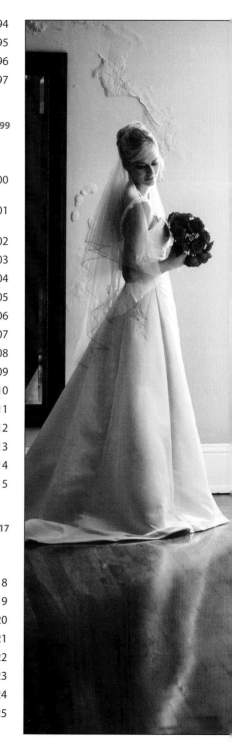

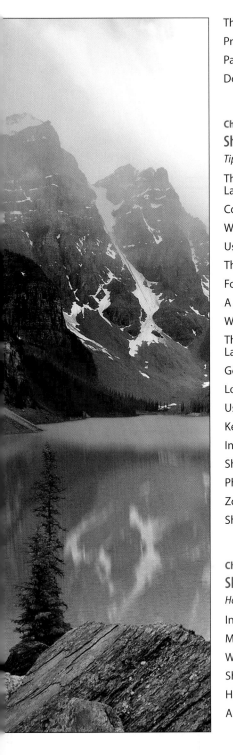

Chapter Ten

Shooting Other Stuff Like a Pro

Tips for All That Other Stuff We Shoot

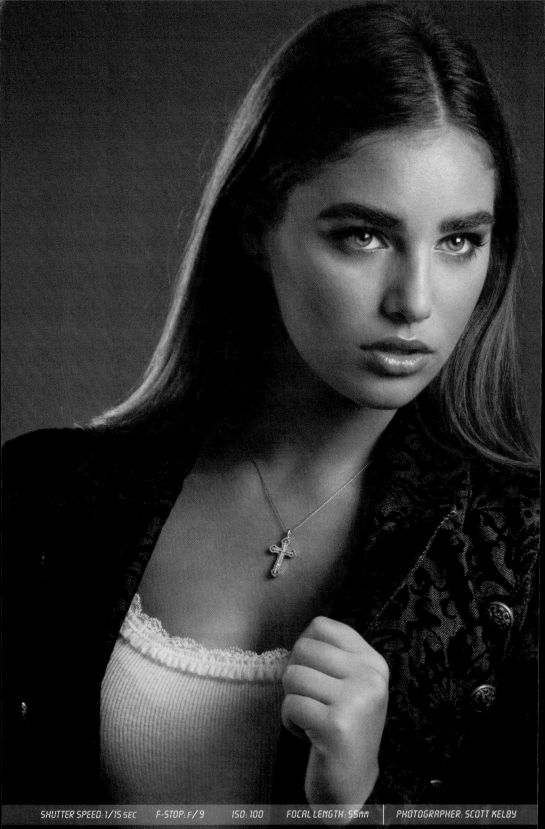

Chapter One

Using Hot Shoe Flash Like a Pro

If You Hate the Way Photos Look with Flash, You're Not Alone

If you've taken a photo with your camera's pop-up flash, you're probably wondering how camera manufacturers list pop-up flash as a feature and keep a straight face. It's probably because the term "pop-up flash" is actually a marketing phrase dreamed up by a high-powered PR agency, because its original, more descriptive, and more accurate name is actually "the ugly-maker." You'd usually have to go to the Driver's License Bureau to experience this quality of photographic light, but luckily for us, it's just one simple push of a button, and—BAM—harsh, unflattering, annoying, blinding light fires right into your subject's face. Seriously, does it get any better than that? Actually, it does. You just have to get your flash off your camera. Now, the first time you actually use pop-up flash and you see the quality of light it creates (and by "quality" I mean "a total lack thereof"), you'll be tempted to do just that—rip that tiny little flash right off the top of your camera (I'm not the only one who did that, right?). I have to figure that camera manufacturers include a pop-up flash on most camera models to do one thing and one thing only: spur sales of dedicated off-camera flash units (which are actually fantastic). Because as soon as you see the results from your pop-up flash, you think, "There has just got to be something better than this!" or maybe "I must be doing something wrong," or "My camera must be broken," or "This camera must have been stolen from the Driver's License Bureau." Anyway, this chapter is for people who figured there must be something better, and if someone would just show them how to use it, they could love flash again (not pop-up flash, mind you, but off-camera flash, which is a gas, gas, gas!).

Seven Things You'll Wish You Had Known...

(1) Here's how this book works: Basically, it's you and me together at a shoot, and I'm giving you the same tips, the same advice, and sharing the same techniques I've learned over the years from some of the top working pros. When I'm with a friend, I skip all the technical stuff, so for example, if you turned to me and said, "Hey Scott, I want the light to look really soft and flattering. How far back should I put this softbox?" I wouldn't give you a lecture about lighting ratios or flash modifiers. In real life, I'd just turn to you and say, "Move it in as close as you can to your subject without it actually showing up in the shot. The closer you get, the softer and more wrapping the light gets." I'd tell you short and right to the point. Like that. So that's what I do.

(2) There are extra tips at the bottom of a lot of pages and sometimes they relate to the technique on that particular page, and sometimes I just had a tip and needed to fit it somewhere, so I put it on that page. So, you should probably at least take a quick glance anytime you see a tip box on the bottom of a page—ya know, just in case.

...Before Reading This Book!

(3) Sometimes you have to buy stuff. This is not a book to sell you stuff, but before you move forward, understand that to get pro results, sometimes you have to use some accessories that the pros use. I don't get a kickback or promo fee from any companies whose products I recommend (rats!). I'm just giving you the exact same advice I'd give a friend.

(4) I wound up making you some video tutorials. Some of the post-processing stuff for some of the shots is kind of hard to explain with just text, so I made some videos for you that show exactly what was done. Luckily none of it is hard — you'll be able to do every single thing I teach you because the videos are all simple, clear and step-by-step. I use Lightroom a lot (it's my main tool), but sometimes I have to use Photoshop (if you're a Photoshop Elements user, you won't be left behind—nearly everything I show in a video can also be done there, too). Also, if you use Photoshop's Camera Raw plug-in (instead of Lightroom) that's okay because Lightroom has Camera Raw built right in (it has the same sliders, in the same order, that do the same exact things). I put up a webpage with all the videos and links to any gear I mentioned, and this was all created expressly for this book, and exclusively for you my awesome, awesome reader and new best friend in the whole wide world. Here's the link: http://kelbyone.com/books/bestof (but turn the page, you've still got a few more important things to go!

Two More of Those Things

(5) If you're shooting with a Sony or Olympus or a Fuji digital camera, don't let it throw you that a Canon or Nikon camera is pictured. Since most people are shooting with a Canon or Nikon, you'll see both (although I shoot primarily Canon cameras and lenses these days), but either way—don't sweat it—most of the techniques in this book apply to any digital SLR camera, and even many of the point-and-shoot digital cameras, as well.

(6) WARNING: The intro page at the beginning of each chapter is just designed to give you a quick mental break, and honestly, they have little to do with the chapter. In fact, they have little to do with anything, but writing these quirky, off-the-wall chapter intros is kind of a tradition of mine (I do this in all my books), but if you're one of those really "serious" types—I'm begging you—skip them because they'll just get on your nerves. By the way, if you somehow are into these quirky chapter intros, I made an entire eBook of nothing but my favorites compiled from all my books, and it's called *Buy This Book of Chapter Intros Even Though You Won't Learn Anything*. 100% of the profits from the sale of the eBook goes to support the Springs of Hope Orphanage in Kenya, which is an orphanage that was built from the ground up with the gracious support of people who read my daily blog and take part in my annual Worldwide Photo Walk. You can find it on Amazon for the Kindle or Apple's iBook Store. You'll really dig it (or hate it with the passion of a thousand burning suns), but either way, you're helping some orphans so you still get lots of good Karma and, in the end, everybody makes out (stop snickering! You know what I meant).

One Last Thing

(7) Keep this in mind: This is a "show me how to do it" book. I'm telling you these tips just like I'd tell a shooting buddy, and that means, oftentimes, it's just which button to push, which setting to change, where to put the light, without all the technical explanations. I figure that once you start getting amazing results from your camera, you'll go out and buy one of those "tell me all about it" camera or lighting books that goes into all that technical stuff and you'll learn terms like "chromatic aberration" and "lens diffraction" and "hyper focal distance." I truly hope this "best of" collection ignites your passion for photography by helping you get the kind of results you always hoped you'd get from your photography. Now pack up all your gear, it's time to head out for our first shoot.

Pop-Up Flash: Use It as a Weapon

The pop-up flash built into your digital camera is designed to do one thing: give you the flattest, harshest, most unflattering light modern-day man has ever created. Here are some of the reasons to avoid using that flash: (1) The face of the pop-up flash itself (where the light comes out) is very, very tiny and the smaller the light source, the harsher the light it produces. (2) Since the flash is positioned right above your camera's lens, you get the same quality and angle of light that a miner gets from the light on the front of his helmet. (3) Using a pop-up flash is almost a 100% guarantee that your subject will have red eye, because the flash is mounted so close to, and directly above, the lens. (4) Because the flash hits your subject straight on, square in the face, they tend to look very flat and lack dimension all around. (5) You have little control over the light, where it goes, or how it lands. It's like a lighting grenade. These are the reasons so many people are disappointed with how their shots look using their camera's flash, and it's why using your pop-up flash should be absolutely, positively a last resort, only done in the most desperate of situations (okay, it can do a somewhat decent job if you're shooting outdoors, your subject has the sun behind them, and you need a little light so they're not just a silhouette). What should you use instead? That's on the next page.

💡 **LOWERING THE POWER OF YOUR POP-UP FLASH**

Most cameras let you lower your pop-up flash's power to use it as a fill flash. On a Nikon, hold down the flash mode button, then turn the sub-command dial so you see a negative number in the control panel on top. On a Canon, press the ISO/flash exposure compensation button, and turn the quick control dial until you see a negative number in the top LCD.

The Advantages of a Dedicated Flash

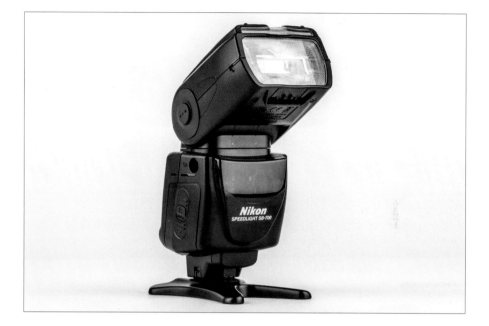

If you want to get pro-quality results from using flash, you're going to need to get a dedicated flash unit (like the one shown above). What makes these dedicated flashes so great is:

(a) You can aim the flash in different directions (a pop-up flash just blasts straight ahead);

(b) You can angle the flash upward (this is huge—you'll see why later in this chapter);

(c) You can take this flash off your camera to create directional light;

(d) Even when mounted on your camera, because it's higher, you'll get less red eye;

(e) You get control, a more powerful flash, and most importantly, a better quality of light.

Best of all—today's dedicated flashes do almost all the work for you.

💡 IF YOU DON'T ALREADY OWN A DEDICATED FLASH

Nikon and Canon both make really great, pro-quality dedicated flashes (we call them "hot shoe flashes" because they're designed to sit in the hot shoe flash mount on top of DSLR cameras). But, if you're not sure you want to plunk down a few hundred bucks for a Nikon or Canon entry-level flash, you might want to consider a Yongnuo YN-560 IV flash for around $71. They actually work well and do a pretty darn good job.

The Pro Look: Get It Off-Camera and Soften It

There are really just four things you need to do to get professional-looking images using a dedicated flash, and the two that are the most essential are: (1) you've got to get that flash off the top of your camera, so you can place it where it's much more flattering for your subjects (which you'll learn in a minute, and there are a number of ways to do just that), and (2) you've got to find a way to soften and diffuse the light from the flash to make it beautiful (and there are a number of ways to do that, as well). Otherwise, these flashes create really bright, really harsh, really unflattering light. So, just so you know going in, these are the two hurdles we're going to focus on, because they pretty much are the key to great-looking flash images. If you keep that in mind (and don't overthink everything), the whole hot shoe flash thing becomes pretty easy and fun. Remember: Our goal is to get the light off the top of the camera, and then make it soft and beautiful. That's what the rest of this chapter is about.

💡 THE PAID-GIG FLASH INSURANCE POLICY

If you're hired to do a paid gig, you want to make darn sure you have a backup flash, because if, for whatever reason, your first flash dies, at least you can grab the backup. You also want to make sure the flash you use as a backup is the same make and model as your main flash. That way, if you suddenly have to switch flashes in the middle of the shoot, you're not trying to figure out how it works, or what the settings should be, or anything else that might freak you out because you're not used to working with that model of flash.

Using Pop-Up Flash as a Trigger

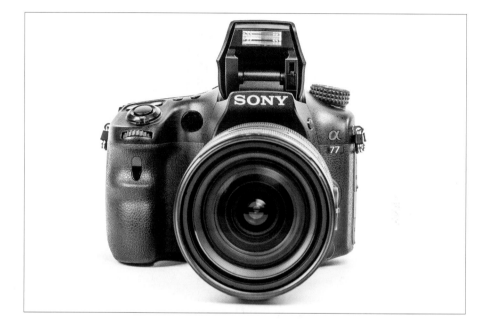

If your DSLR camera has a built-in pop-up flash, you can configure that pop-up flash so it doesn't light your subject, but instead sends out a dim, mini pre-flash that fires your big dedicated flash wirelessly (and you don't have to worry about your flash sync cord breaking or getting lost. In fact, you don't have to worry about dealing with cables at all). However, for this to work, the dedicated flash has to be able to "see" the mini pre-flash from your pop-up flash (that's why this type of wireless flash triggering is called "line of sight"—if the dedicated flash can't see the light from the pop-up flash, it won't fire). This won't ever be a problem until the one time where you really, really need it to fire, which is why there is a second way to fire your flash wirelessly (on the next page).

> **HOW TO USE YOUR HOT SHOE FLASH'S MODELING LIGHT**
>
> Most hot shoe flashes don't have a continuous modeling light, but can create a temporary one. For Canon flashes, turn it on by pressing-and-holding the custom function setting button until its icon shows on the flash's LCD. Then, turn the Select Dial and select the Modeling Flash (Fn 02) function. On a Nikon flash, press the Menu button, scroll down to Flash/Modeling, and press OK. Scroll to Modeling and press OK again. You fire it (sending a series of very fast flashes at your subject) by pressing the Test Firing button.

Using a Wireless Triggering System

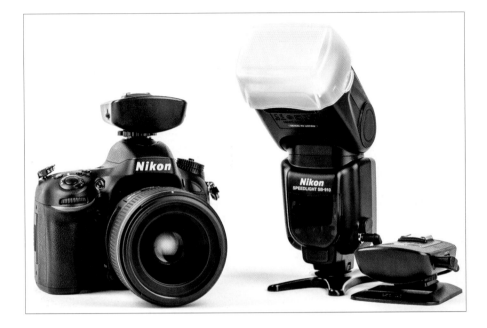

You can consistently fire your wireless flash using a wireless triggering system (these work the best and, of course, they're the most expensive). There are two parts to this: (1) a wireless flash transmitter (which sits in your camera's hot shoe flash socket on top of your camera) and (2) a wireless receiver that attaches to a small socket on your dedicated flash itself with a very small utility cable (only a few inches long). This used to be a very expensive proposition, but today you can buy a decent set (both a transmitter and a receiver) for around $75. That's a steal. Just a few years ago, it was more like $400. What's great about these is they're *not* line of sight. These are real radio transmitters, so you can put them wherever you need them, even a few hundred feet away, and they'll still fire every time. The downside: you change the power of the flash by walking over to the flash and turning the power up/down (although there are some transmitters that will let you change power from the transceiver itself).

"Drag the Shutter" to See More Background

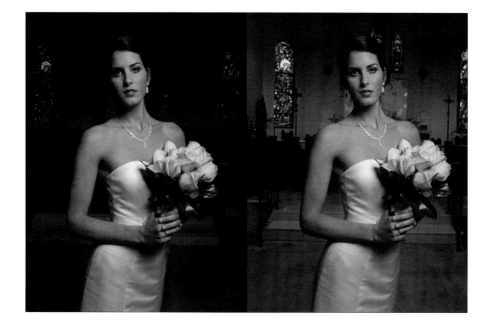

Like I mentioned, there are four big things the pros do to get beautiful quality light (and professional-looking images) from their dedicated flash units. One, you've already learned, is getting the flash off the camera so you can create directional light. The second is to set up your flash so it blends in with the available light already in the room, so the background behind your subjects looks natural. Without using this technique, you'll get what everybody else gets—the background behind your subjects turns black, they look harsh, and the shot will look pretty awful, which is why most people hate flash shots. The technique is called "dragging the shutter," and what you're doing is slowing down your camera's shutter speed so it allows in the existing light, then your flash fires to light your subject. Although this sounds complicated, it's incredibly simple. First, set your camera to shoot in program mode. Then, aim at your subject and hold the shutter button down halfway, so your camera takes a meter reading of the scene. Look in your viewfinder and see the f-stop and shutter speed your camera chose to properly expose your subject, and remember those two numbers. Now, switch to manual mode and dial in those same two numbers. If the camera showed a shutter speed of 1/60 of a second, to drag the shutter you'd need to use a slower shutter speed, right? So try lowering the shutter speed to 1/15 of a second and take the shot. Don't worry—your subject won't be blurry, because when the flash fires it will freeze your subject. You'll be amazed at what just lowering the shutter speed like this will do to the quality of your flash photos.

How to Soften the Light from Your Flash

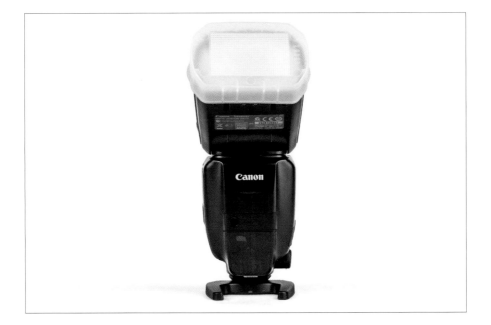

Okay, so you've used all the tricks we've covered so far, and your flash photos look better, but there's still a problem. The light is still harsh because the flash itself is very small, and the smaller the light source, the harsher the light. To get softer, more flattering light, you need to make your light source larger. There are a number of different tricks for doing this, and each pro does it differently, but they all use tricks to soften and diffuse the light from their flash (it's the third thing [and second most essential one] to do to get professional-looking light from your dedicated flash). Probably the quickest and easiest way to soften the light is to snap a diffusion dome cap over the end of your flash (like the one shown above). Considering how small and light it is, it does a pretty decent job. Once this cap is on, you aim your flash head upward at a 45° angle and it takes care of the rest. Some Nikon flashes come with a diffusion dome but for Canon or other flashes, you can buy a diffusion dome separately, and the one I recommend is the Sto-Fen Omni-Bounce, which does a great job and is a favorite with pro wedding and event photographers (it sells for around $10 at B&H Photo). *Note:* Adding this diffusion dome works great indoors, but outdoors where there's really nothing much for the light to bounce off of, it doesn't do much at all.

💡 WHEN NOT TO USE A DIFFUSION DOME

There are times when you don't want a diffusion dome on your flash, and it's not just when you want hard, edgy light. For example, if your flash is far away from your subject, take the dome off, because when you're back that far, it drains your batteries much faster, and since the light is far back, it's going to spread and soften a bit anyway.

Make It Softer Light by Bouncing It

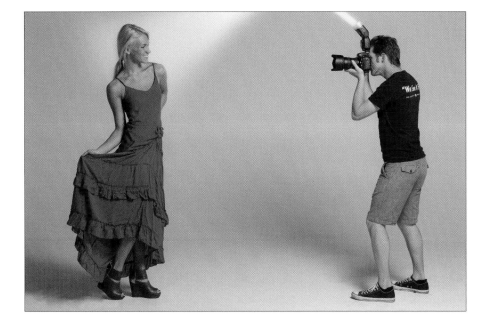

Another popular way to soften the quality of your light is to bounce it off a ceiling. This does three wonderful things: (1) When your small, direct flash of light hits the large ceiling, it spreads out big time, so the quality of the light that falls back onto your subject is much wider and softer, taking the harshness out of your flash and giving you better quality light. (2) Because the light is coming from above, it's no longer that one-dimensional, straight-on flash—now it's directional flash, which creates nice shadows and lots of dimension for your subject's face, and as a bonus (3) it keeps you from having harsh shadows on the wall behind your subject. Because the light is coming from above (down from the ceiling), the shadows appear on the floor behind your subject, instead. Plus, because the light is softer, the shadows are softer, too. So, why don't we use this technique all the time? Well, (1) there's not always a ceiling you can bounce off (sometimes you're outdoors), or (2) the ceiling is too high to bounce off of. If the ceiling is much higher than about 10 feet, the light has too far to travel up and back, and your subject doesn't get properly lit. Of course there's also (3) the fact that light picks up the color of what it hits, so if the ceiling is yellowish, your light becomes yellowish, and your subject will appear yellowish! But, if it's an 8'or 9' white ceiling, you're set.

💡 HOW TO STAND BACK FARTHER THAN 10 FEET

If you need to stand back more than 10 feet from your subject, you can extend the power and range of your flash by raising your camera's ISO setting (making it more sensitive to light). So, if you raise it from 100 to 200 ISO, you effectively double the power (and range) of your flash. Otherwise, you'll need to remove the diffuser cap from your flash.

Softbox-Quality Softening from Your Flash

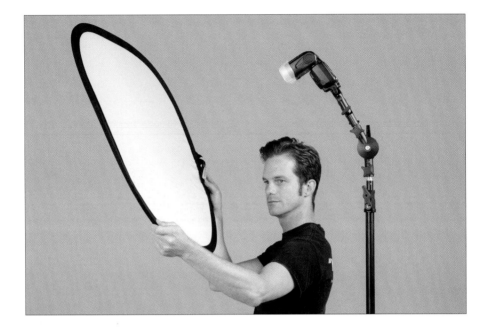

If you want to take this whole softening thing to the next level (quality-wise), you could buy a small softbox that mounts over your flash, but the problem is they're small, so the light doesn't spread and soften all that much. So, one really easy way to spread and soften your light is to shoot your flash directly through a large diffusion panel. These panels are made of white translucent stretched fabric (usually round or square with rounded corners like the one you see above), and they spread and diffuse the light from your flash. Since they're just fabric, they're super-lightweight—they're designed to collapse down into a very small, flat size, so they're easy to take with you (they come with a small, flat carrying pouch)—and best of all, they're a bargain! You can get a Westcott 30" 5-in-1 Reflector (the same one I use), which includes a 30" diffuser, for around $30 (plus, now you have a great reflector, as well. Actually, you'll have four reflectors—more on them later). For the best quality, softest, most flattering wraparound light, have an assistant (or a friend, spouse, etc.) hold the panel as close to your subject as possible without it being seen in the photo, and about 1 foot or more in front of your flash. That way, when the tiny light from the flash hits the panel, it causes the light to spread out dramatically, which gives you much softer, smoother, more flattering light. (Just know that the farther away you move the flash, the lower the power of the light will become, so if you move the flash far away, you'll have to increase its power.) If you don't have an assistant or a friend nearby, you can clamp your diffuser on a second light stand using a Manfrotto 275 Mini Clip Clamp for around $16. If you want to invest in a pro-quality diffusion panel, check out Lastolite's 30" TriGrip Diffuser, One Stop (with a built-in handle) for around $65.

Rear Sync Rocks (& Why You Should Use It)

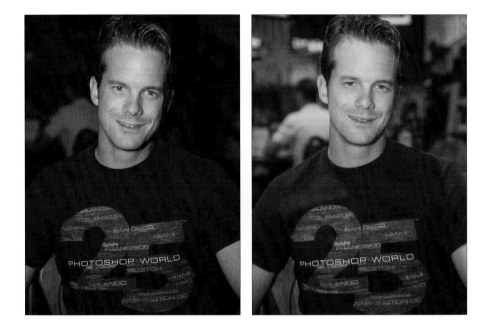

There's a setting on your camera that will help you get better-quality photos using flash. In fact, your flash shots will get so much better that you'll wonder why this feature isn't turned on by default (but it's not—you'll have to go and turn it on yourself). It's called Rear Sync, and what it basically does is changes when the flash actually fires. Usually, your flash fires the moment you press the shutter button, right? So it does freeze any action in the scene, but it also generally makes everything solid black behind your subject (like you see in most snapshots). Changing to Rear Sync makes the flash fire at the end of the exposure (rather than the beginning), which lets the camera expose for the natural background light in the room first, and then at the very last second, it fires the flash to freeze your subject. Now your background isn't black—instead, it has color, depth, and detail (as seen above right), and this gives you a much more professional look all the way around. In the example above, the shot on the left is using the normal default flash setting (notice how dark the background is, and how washed out the flash makes him look). For the shot on the right, I only changed one single thing—I switched the flash to Rear Sync. Give it a try and you'll see what I mean (just remember to keep the camera still when shooting in Rear Sync mode, because the shutter stays open longer—enough to expose for the background. This can create some cool effects if your subject is moving while your shutter is open, or it can create some irritating effects if they're moving and you don't want them to).

The Fourth Secret to Pro Flash Results

The fourth of the four pro flash tricks is one you can use to make your flash look like natural light. In fact, if you do it right, most folks won't be able to tell that you used a flash at all. Your goal is to create light from your flash that matches, and blends in with, the current lighting in the scene (the ambient light) and doesn't overpower it. Here's the trick: don't change your f-stop or shutter speed, just lower the power output of the flash until it matches the available light. To do that, first get the flash off the camera for directional light, and diffuse the light, then take a test shot. If your flash overpowers the existing light, go to your flash unit, lower the output power by one stop, and take another test shot. Look at the LCD on the back of your camera, and see if the light from your flash still looks obvious. If it does, lower the power of your flash another half-stop and shoot another test shot. Keep doing this (lowering the power and shooting a test shot) until you have just enough flash to light your subject, and no more. That way, it looks real, directional, and natural, instead of looking like flash. It might take you five or six test shots to dial in the right amount of power, but that's the beauty of digital cameras: it doesn't cost anything to do test shots.

💡 HOW HIGH TO POSITION YOUR FLASH

So, you've got your wireless flash set up, it's on a light stand (or a friend is holding it for you), and now you're wondering, "How high up do I put this thing and where do I aim it?" Position the flash where the sun would be. The sun is usually up in the sky, aiming down at us, so put your flash up high, and angle it so it's aiming down at your subject. If you're inside, pretend there's no roof.

Using Gels (& Why You Need Them)

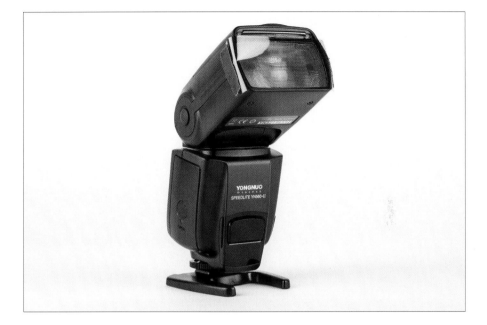

The light from your flash is always the same color—a nice, bright, white. That's great in most circumstances, but what if you're doing a portrait of someone in an office, or you're shooting in a locker room or meeting room? Well, that's a problem, because the color of the light from your flash won't match the color of the lighting in the room. This is why some flashes actually come with pre-cut gels that slide right onto the flash to let you change the color of its light. (*Note:* If your flash doesn't come with gels, you can buy a large sheet of Rosco CTO gel for around $6.50 from B&H Photo. You'll have to cut it down to fit over your flash head, but you'll have a huge supply of them. Or, check out Rosco's The Strobist Collection Flash Pack, which comes with 55 pre-cut gels, for around $22.) Amateurs just overpower the light in the room, but since you now know the pro tricks of how to balance the light from your flash with the ambient light already existing in the room, you'll need to do this. Believe me, for the 20 seconds it takes to slide that gel into place, it's worth it. Use a yellow gel for balancing your flash color with incandescent light (the standard light found in homes), and a green gel for balancing fluorescent lights (found in most office interiors). Just pop that tiny gel inside your diffusion dome, or tape it to your flash with some gaffer's tape, and you're ready to go!

> ### 💡 DON'T HAVE A GEL? CHANGE YOUR WHITE BALANCE
>
> If you're shooting outdoors, and you don't have a gel to put over your flash head (to make the color of the flash's light look more natural), try this: change your camera's White Balance setting to Cloudy. This gives your image an overall warm feel, and it helps make the light from your flash look warmer, too!

Using a Second Flash

If you want to add a second wireless flash (maybe you want to use it as a hair light, or to light the background, or…whatever), it's easy. When your first flash fires, it automatically triggers the second flash so they both fire at exactly the same time. Let's say you want to add a flash to light your subject's hair. First, position the flash behind your subject, but off to the right (if you're holding your other flash in your left hand while you're shooting or have it positioned to the left), as shown here. This is a perfect time to use one of those Justin Clamps mentioned in the tip below, so you can clamp your second wireless flash to anything nearby, or you can position your second flash on a light stand—just make sure you don't see the stand, or the flash unit itself, when you look through your camera's viewfinder. Set your second flash to wireless mode. Best of all, you can control the brightness of this second flash wirelessly from on your camera using groups (see the tip on page 23).

💡 MOUNTING FLASHES ANYWHERE

If you're going to wind up attaching your flash to something, pick up a Manfrotto 175F Justin Spring Clamp with Flash Shoe (better known as simply a "Justin Clamp"). With it, your flash slides into a little plastic hot shoe on the top of the clamp, which is connected to a miniature ballhead that lets you position your flash in any direction at any angle. It also has a large clamp on one end, so you can clamp it onto just about anything. These sell for around $61, and once you use it, you'll never go anywhere without it.

Shooting Sunset Portraits with Flash

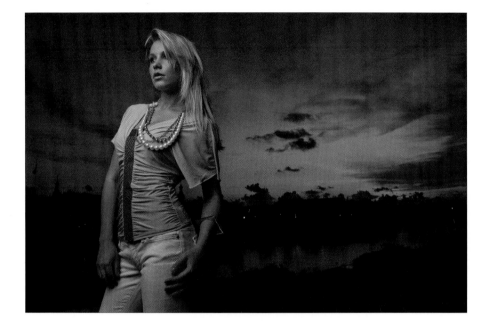

First, turn off your flash, then switch your camera to shutter priority mode (S), and dial in 1/125 of a second (a good, safe sync speed for our flash). Now, aim up at the sky (but not directly at the sun itself), and press-and-hold your shutter button halfway down, so your camera takes a meter reading of the sky. While that button is still held down, look in your viewfinder to see the f-stop your camera chose, and remember that number (in the example above, it read f/5.6, so remember that f-stop). Now, switch your camera to manual mode, dial in 1/125 of a second for your shutter speed, and dial in that f-stop your camera chose in shutter priority mode (which, in this case, was f/5.6). Next, position your subject so the sun is behind them. Your job is to turn your subject into a silhouette against the sky. Luckily this is pretty easy—just raise the f-stop by a stop or two (our f-stop was f/5.6, so we'll raise it to f/8) and take a test shot. If your subject isn't a silhouette yet, raise it another stop, and take a test shot. Usually that'll do it, but you might have to go as high as f/16 (or any one of those fractional f-stops in-between). When you choose a darker f-stop, the sky gets darker and richer. Once your subject is a silhouette, turn your flash on, switch it to Manual mode, choose a low power setting, and take a test shot. If the flash is too bright, try lowering the power again, then take another test shot. If the flash isn't bright enough, raise the power.

> **ONE WAY TO DEAL WITH THE DARK GRADIENT SHOOTING HIGHER THAN 1/250**
>
> If you shoot at higher than 1/250 of a second and you see that dark gradient appear on your image, remember you can crop it away later in Photoshop. That way, you don't lose any power, and you don't drain the batteries as fast on your flash. Hey, I'm just sayin'.

Shooting Your Flash in Manual Mode

The flash manufacturers won't be thrilled to read this, but I'm not a big fan of TTL flash (it uses "through-the-lens" [TTL] metering to give you a better flash exposure automatically). When it works, it works really well. The problem is that it doesn't always work, and you don't always know why. That's why, when I work with hot shoe flash, I work in Manual mode on the flash (where I raise and lower the power manually, rather than having the flash make the decisions for me). For a location shoot, I set my flash to Manual mode, then I start with my power setting at 1/4-power and do a test shot. If the flash is too dark, I crank it up to 1/2-power and take another test shot. If it's too bright, I drop it to 1/8-power and take a test shot. It normally takes me just a minute or two to find the right amount of flash to balance with the existing light in the location I'm shooting, so the light looks natural. Personally, I think TTL usually makes the flash too bright and too obvious, so if I have to override it anyway, I might as well just control the power myself. But hey, that's just me—there are people who love it. The cool thing is, you can try both methods and see which one fits your style (subliminal message: go Manual and you'll never go back).

> ## 💡 WHAT YOUR FLASH'S CHANNELS ARE FOR
>
> As long as you're by yourself, just you and your flash, things are good. But what happens if you have a second (or third) photographer shooting along with you? Sometimes, the second shooter's camera would trigger and fire your flash (and vice versa). That's why your flash has different channels. You set the channel in two places: (1) on the wireless flash unit itself, and (2) on whatever you're using to trigger your flash.

The Advantages of Using Flash in Daylight

Without Flash

With Flash

A lot of people ask the question, "Why would I use a flash outdoors in the first place?" The simple answer is that it usually looks better, but there's more to it than that. First, you don't have much control over the position of the sun, and oftentimes it's in the worst place possible—right overhead. By using flashes outside, you get to create directional light, unless it's sunset, which is generally prettier light, although you may need flash to fill in a little. Plus, you get to use the sun as your backlight, lighting your subject's hair and giving you a beautiful rim light around them (just position your subject so the sun is behind them, if at all possible). Flash offers another benefit over using just a reflector outside, and that is your subject won't be squinting, like they usually do if you light them with a reflector and send a constant beam of sunlight back at their face.

WHERE YOU FOCUS AFFECTS YOUR FLASH EXPOSURE

Today's small off-camera flashes adjust their power output based on the exposure for the shot. Your flash is going to help make the exposure based on what you focus on in the photo. So, if you focus on your subject, it's going to try to give you a proper exposure for your subject; if you focus on something else, it'll try to light that area instead. This is why, when using small off-camera flash, you need to make sure you focus on the area you want to look best.

Get More Control Using a Portable Softbox

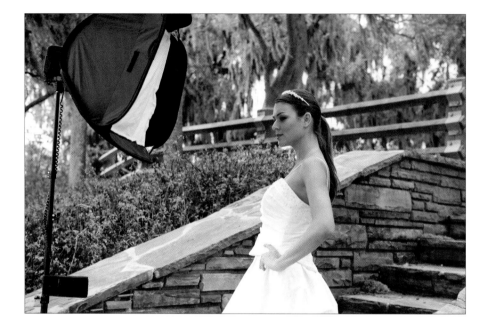

If you've got a few more bucks to spend, then you can add a small softbox designed for off-camera flash. There are two big advantages to using one instead of a shoot-through umbrella: (1) The light is more contained and directional than with a shoot-through umbrella, so it's easier to get more dramatic light, since it only goes where you aim it. (2) They don't seem to blow over as easy when using them outdoors. This is bigger than it sounds, because umbrellas catch the wind like you can't believe, and even the slightest wind can send the whole thing (umbrella, stand, and your flash) crashing over. Here, I used the Lastolite Ezybox. I like that it's so small and portable—it collapses down to a small round shape (like a reflector)—and it sets up without having to use steel rods, so it only takes two minutes. You can also have a friend (bridesmaid, assistant, etc.) hold the flash and Ezybox using a special accessory, a small (24" tall), lightweight, handheld stand with a handle on the bottom, turning your friend into what has become known in flash circles as a VAL (the acronym for a voice-activated light stand). Plus, I love the quality of its soft, directional light. I use the 24x24" size.

💡 USING GELS TO GET THAT SI LOOK

There's a very cool trick you can do using just a yellow gel that I learned from *Sports Illustrated* photographer Dave Black. You have to do two things: (1) set your camera's white balance to Tungsten, then (2) pop a yellow gel onto your flash. You want to shoot this near dusk. The Tungsten white balance setting makes the sky look moody and blue, but the yellow light (from the gel on your flash) hits your subject with a warm light.

Typical Power Settings for Your Flash

If you're using your flash indoors, or outdoors in anything other than bright daylight, you'll be running your flash 99% of the time at less than half-power. In fact, you'll probably be often running it at 25% power (I'm sometimes at 1/8 or 1/16 power during a typical shoot). Why so low? Because the idea is to balance the light from your flash with the existing light already in the room (or already available outside), so you usually want just a little bit of flash (or your flash will look like flash). The goal is to make your flash look like natural light, so your power setting will probably stay real darn low.

WHAT YOUR FLASH'S GROUPS ARE FOR

If you want to control your wireless flashes independently of each other, then you need groups. So, let's say that you have one flash lighting your subject and one lighting the background. You'll want to control their power individually, so you can turn one down without turning the other down, as well—you'd assign one flash to Group A and one to Group B. You can have more than one flash in each group (all flashes in a group move up/down in power together). You assign groups on the flash unit itself.

Making the Light Even Softer

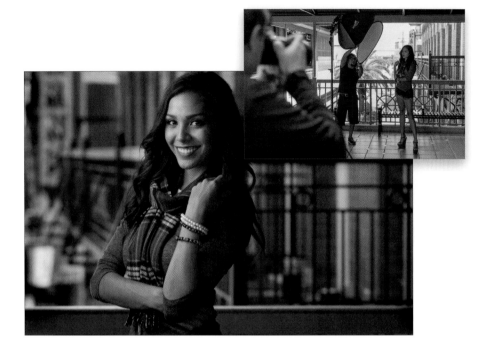

Here, we're using our flash with an Impact Quikbox pop-up softbox, but we're also holding a Westcott diffuser in front of the softbox, so the light is actually firing through two diffusers before it reaches our subject. The lens is a 70–200mm f/2.8 and I'm zoomed in tight to around 120mm with my f-stop at f/5.6. I wanted the background to be just a little out of focus (to help separate her from the background), but still wanted you to be able to see the railings behind her. We're shooting in the shade, so I had to increase the ISO to 200 to get my shutter speed up to 1/160 of a second to handhold. The diffuser on the front of your softbox is designed to spread and soften the light, but what if you take a test shot and you don't think it's quite soft enough? Well, the first thing you'd do is move the softbox as close as you possibly can to your subject without actually seeing it in the shot because the closer the softbox is to them, the softer the light will be. What if you do that and it's still not soft enough? Well, you diffuse it some more by adding another diffuser. It's around $20 to pick up a handheld diffuser like this and it creates really soft light. Of course, when you shoot through two diffusers, you're going to have to turn the power of your flash up a bit so the same amount of light gets all the way through both. Here, I started with my power setting at 1/4-power (my usual starting place), but once I added the second diffuser, I had to increase the power to 1/2-power to get the same amount of light. I finished it off with the standard portrait retouching stuff (removing minor blemishes, brightening eyes, etc.). A note about the composition: If you look directly behind our subject in the inset, you can see a lot of bright natural light back there. When I first composed the shot, I could see that behind her and it really drew my eye, so I moved a step or two to the left and recomposed the shot so I wouldn't see those distracting bright areas. Something to keep in mind: the background matters.

The "Instant Black Background"

We're out on the street downtown and we've set up my flash lighting with the Impact Qui-kBox. The settings for this particular outdoor shoot are very different than usual because we're trying to do something very different: make a regular daylight background turn solid black. I'm shooting my 70–200mm f/2.8 lens (that part is pretty much the same as always), but my f-stop is set to f/22. My ISO is set to 100 and my shutter speed is 1/250 of a second. The name and idea for this technique comes from my buddy, UK-based photographer and trainer Glyn Dewis. The idea is you set your camera's settings so that so little light comes into the camera that when you take a shot, all you get is a solid black image. Then, when you turn on your flash at full power, the only thing you'll see in your image is whatever is lit with the light from that full-power flash—that's all that lights your subject. There are three things we can do to limit the light that reaches our sensor: (1) Raise the f-stop. In my case, my lens only goes to f/22, but some go to f/32. The higher the number, the darker your scene will be. (2) Lower your ISO to its lowest setting. The lower the number, the less your camera is sensitive to light. (3) Raise your shutter speed to 1/250 of a second (that's the highest normal sync speed for most hot shoe flashes, but at that speed it lets in the least amount of existing light. Now, you may not need to do all three of these to create a solid black image, but you'll know it's right when you take a photo and there's no image, just solid black. That's your cue to turn your flash on at full power. Thanks to Glyn for this awesome technique. I finished it off with just standard portrait retouching stuff (removing blemishes, brightening the eyes, and so on) and, of course, sharpening with the Unsharp Mask filter in Photoshop (I used: Amount 120%, Radius 1, Threshold 3).

SHUTTER SPEED: 2.5SEC F-STOP: F/8 ISO: 100 FOCAL LENGTH: 31mm | PHOTOGRAPHER: SCOTT KELBY

Chapter Two

The Truth About Lenses

Which Lens to Use, When, and Why

One of the questions I get asked most is, "Which lens should I buy next?" Of course, I have to ask a question of my own before I can answer that question, and that is, "How stable is your marriage?" I ask that because if you have a really stable marriage—one that's based on trust, caring, compassion, and a healthy fear of handguns—it's entirely possible that it can endure having one of you become a serious photographer. Otherwise, I refuse to answer the lens question, because having a serious photographer in the family is going to seriously test the strength of your marriage. For example, there will come a day when you'll be faced with the decision of whether to get that new super-sharp, fast f/2.8 lens or to stay married. That's because, in most marriages, one spouse controls the funds, and it should never be the spouse that's into photography, because there will come a day, mark my words, when you'll be holding your mortgage payment book in one hand and the B&H Photo catalog in the other, and you're going to be faced with a moral dilemma that will test the very mettle of your commitment to your spouse, family, and friends. You'll start to ask yourself crazy questions like, "How would we do living on the streets?" and "Would our friends sneak us food?" and "I wonder if they'll throw in a free polarizing lens?" These are not the kinds of questions you want to be asking yourself at this stage of your life (by the way, the more expensive the lens, the more free stuff you should try to get thrown in). Anyway, if one day you're faced with one of these really tough decisions, I'll give you the same advice I gave my own daughter, "Honey, you can always find another husband, but a great sale on some really fast glass only comes along once in a lifetime." (I didn't say those exact words, but it was definitely implied.)

When to Use a Wide-Angle Lens

A regular wide-angle lens (as opposed to a "super wide") is around 24mm to 35mm, and it's just about a must if you're shooting landscapes, because the wide aspect takes in more of the scene (think of how much more wide-screen video takes in—it's kind of like that). Wide angle is also very popular for shooting environmental portraits (the type of images you see in magazines when they're doing a feature on a celebrity, politician, or a business exec, where the portrait takes in a lot of their surroundings). For example, if you're shooting a fireman in the fire station, with wide angle, you include a little, or a lot, of a fire truck in the shot, as well. They're also great anytime you want to create a view of something—just get in real close and things get interesting. You can buy wide-angle zooms (which are what I prefer) that zoom from wide-angle to normal (like a 24–70mm), or even a super-wide zoom that goes from 12–24mm. I GRAB THIS LENS FIRST WHEN...I'm going to shoot landscapes using a non-full-frame camera body.

When to Use a Fisheye Lens

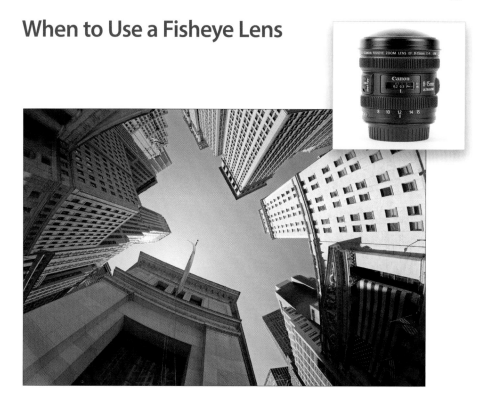

These are well named, because they give you an incredibly wide, almost circular view (and the lens itself bulges out like a fish's eye, but honestly I don't know if the lens was named for how the lens looks, or for how the photo it takes looks). This is definitely a special-effects lens that you want to use occasionally, because the fisheye look can get old fast if you use it too much. However, in the right circumstance, it looks really fascinating (try holding it up high over your head when you're in a crowd, or at dinner in a restaurant, and shooting straight down). One thing about fisheye lenses is that they do distort the horizon line quite a bit. For the minimum amount of distortion, try to keep the lens level in front of you, but if you want more creative looks, then all bets are off—just have fun with it. I GRAB THIS LENS FIRST WHEN…I'm going to be in a crowd, when I'm shooting up high in a sports stadium and want to take the whole thing in, or when I'm shooting skyscrapers and want to get them all.

When to Use Super-Fast Lenses

If you want to shoot indoors without using flash (like in a church, museum, theater, or any-where flash and/or tripods aren't allowed), then you need a really fast lens (which just means a lens whose f-stop goes to a very low number, like f/1.8 or, better yet, f/1.4. The lower the number, the lower light you'll be able to shoot in without using a tripod). Here's why this is so crucial: when you shoot in a dark place, the only way your camera can make a photograph is to slow down your shutter speed, so more light makes its way into your camera. That's not a problem if your camera is mounted on a tripod, because it's perfectly still, however, if you're handholding your camera (which is going to be the case in almost every church, museum, etc.), and your shutter speed falls below 1/60 of a second, you're going to have photos that look okay on the back of your camera, but when you open them later on your computer, or have them printed, they will be incredibly blurry and basically unusable. So, by setting your camera to f/1.8 or f/1.4, you'll be able to handhold in lots of places and have sharp, clear images where normally they'd be blurry as heck. In this case, less (a lower number) is more. I GRAB THIS LENS FIRST WHEN...I'm shooting a wedding.

IF YOU'RE REALLY SERIOUS ABOUT GETTING SHARPER IMAGES, TRY THIS TRICK!

You can use the same technique sharpshooters (with rifles) use to minimize any movement while firing—they hold their breath. That's right. When handholding, some pro photogra-phers only shoot after they exhale (or they take a deep breath and hold it, then shoot). This minimizes body movement, which minimizes camera shake.

When to Use an "All-in-One" Zoom

18–200mm

The most popular Nikon and Canon lenses are their 18–200mm zooms, because they do it all. They go all the way from a nice wide angle to a tight telephoto and you never have to change lenses at all. Best of all, they're compact, pretty lightweight, and relatively inex-pensive compared to some of the more expensive zooms with a smaller range. These are ideal lenses for travel photography (where you don't want to lug a camera bag around with you all day), or for photo walks, for city shooting, and even for landscapes you'll be shooting on a tripod. I have one of these 18–200mm lenses and, honestly, I love mine dearly. Now, you will see some photographers in forums online saying that these lenses are basically beneath them, because they're not as sharp as they could be, or they're not as rugged as the more expensive lenses, etc. Don't let that throw you. I don't know a single photographer that actually has one of these that doesn't love it, mostly because when it's on your camera, you're never going to say, "Oh, I missed that shot because I didn't have the right lens," because it does it all in one lens. As for quality, I have a 30x40" print of a photo I took with that lens while on vacation, framed, and hanging in my home. Everybody loves it, and it looks perfectly sharp and crisp all the way through. I GRAB THIS LENS FIRST WHEN...I'm going on vacation.

💡 HOW TO CLEAN A LENS

It's important to clean your lenses before shooting, and anytime you see a little "junk" on your lens. You can use a simple lens cleaning cloth, but it's best to first start by blowing any junk off the face of your lens using a little hand-squeezed blower bulb.

Using a Teleconverter to Get Even Closer

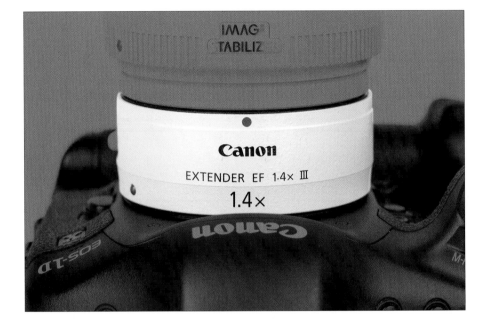

I talked briefly about teleconverters back in part 1 of this book series, because they're such a handy and relatively inexpensive way to get you in tighter to the action. What these do is zoom your whole lens in a little closer, usually either 1.4x closer, 1.7x closer, or even 2x closer (though I only recommend the 1.4x teleconverter, because the quality doesn't change noticeably like it does with a 1.7x or 2x extender). As long as you buy a quality teleconverter (both Nikon and Canon make very good ones), there's only one potential downside, and that is you lose around one stop of light for a 1.4x (more for higher ones). So, if the lowest number your lens would go was f/2.8, when you add a teleconverter, now the lowest number is f/4. I say potential downside, because if you shoot in broad daylight, losing a stop of light isn't a big problem for you. But, if you shoot under stadium lighting at night, then it's a problem, because you can't afford to lose that stop of light—it might mean the difference between sharp shots and blurry movement. I GRAB A TELECONVERTER FIRST WHEN...I'm shooting sports or wildlife in bright daylight.

💡 TELECONVERTERS DON'T WORK WITH EVERY LENS

Before you buy a teleconverter, make sure it works with your lens—not every lens will work with a teleconverter. Look on the order page for the teleconverter and it will usually list the lenses that it either will or won't work with.

Lenses with VR or IS Built In

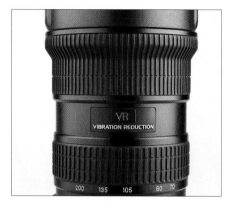

Nikon

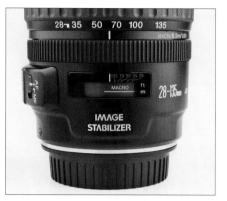

Canon

Lens manufacturers know that people have a hard time handholding their cameras in low-light situations, so they started adding features that automatically help keep the lenses from moving, so you get sharper shots in low light. Nikon calls their brand of this "anti-movement" technology VR, for Vibration Reduction, and Canon calls theirs IS, for Image Stabilization. They're both well-named, because that's what they do—they hold your lens steady for you, so you get sharper shots, but it really only makes a difference when you are shooting at a slow shutter speed (you'll get no improvement when you're shooting in broad daylight, because your shutter speed will be so fast [which freezes any motion], that there's no reason for VR or IS to kick in). What VR and IS do is let you handhold in lower light situations, so if you wind up shooting a lot in churches, museums, theaters, and other low-light locations, you should probably keep an eye out for VR or IS lenses (they usually cost a little more). Also, you won't often find this feature in already very fast lenses, like an f/1.8 or f/1.4. One more thing: if you're shooting on a tripod, you should turn VR or IS off (there's a switch on the lens) to reduce any shake caused by the VR or IS searching for movement.

💡 USING ACTIVE VR FOR NIKON USERS

If you're a Nikon shooter, your VR lens may have a setting called Active, and that only needs to be turned on when what you're standing on is moving (if you're shooting from a boat, or a moving car, or a suspension bridge, etc.).

The Deal on Lens Hoods

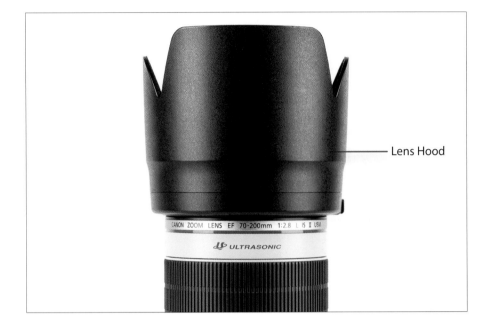

Lens Hood

Besides making your lens look longer and "more professional," a lens hood serves two very important roles (one advertised, one not as much). The first is that the lens hood helps keep lens flare from the sun, or from a flash, from getting to your lens and washing out your photos. Most good quality lenses these days come with a lens hood that is specifically engineered to work with that particular lens. The other, less publicized, use is to protect your lens from getting scratched or broken while it's slung over your shoulder as you walk around. I can't tell you how many times I've banged my lens against a chair, the end of a table, even a wall when coming around a corner, but all I ever hear is the sound of plastic, and it bouncing right off. If I didn't have a lens hood, I'm certain I would have had a number of scratched or broken lenses, but so far—not a one. I keep my lens hood on all the time. Besides, they look cool (don't tell anyone I said that). By the way, you can turn your lens hood around, facing back toward you, when storing it in your camera bag, or when it's not in use. I GRAB A LENS HOOD...anytime one comes with my lens, and I keep it on always.

💡 WHY YOU MIGHT WANT TO SHOOT MACRO INDOORS

A lot of nature macro photography is actually done indoors, rather than outside (in most cases, you're going to be so close in, you don't have to worry much about anyone realizing that you're in a studio). One of the main advantages of shooting macro indoors is that there's no wind—the tiniest bit of wind will make your photos soft and out of focus. Another advantage is that you can control the light, and the key to lighting macro shots is to have nice even lighting across the entire image.

Why Some Lenses Have Two f-Stops (Like f/3.5-5.6)

When you see a zoom lens that has two different f-stops, what that means is that at the shorter range (let's say it's an 18–200mm lens, so we'd be talking about when you're at 18mm), the f-stop can go as low as f/3.5, but when you zoom it out to 200mm, the fastest it can go is f/5.6. When you're in between the two, the f-stop will gradually increase (so at 100mm, you might be at f/4). What this tells you is two things: (1) If you shoot at the wide-angle end (18mm), you'll be able to shoot in much lower light than you can zoomed in at 200mm (the lower the f-stop of the lens, the darker light you can handhold your camera in and still get sharp photos). This also means (2) that this is a less-expensive lens. Really "good glass" (as it's called) has a constant aperture (the same f-stop all the way through the zoom range), so the lens would be at, say f/2.8, whether you're out at wide angle or zoomed in tight (for example, Nikon's 70–200 f/2.8 VR lens can shoot at f/2.8 whether you're zoomed out at 70mm or zoomed in tight at 200mm).

WHEN YOU NEED TO FOCUS REALLY FAST, TURN THE FOCUS LIMIT SWITCH ON

Each time you use autofocus, your lens searches everything it sees, from a few inches in front of you to miles in the distance, and then it locks on what it thinks you're aiming at. This takes just a second or two, but if what you're shooting is really far away (you're shooting sports or a bird up in a tree), you can switch your lens from Full focus to Limit, which tells it not to even try to focus on anything closer than around eight feet away. That way it focuses even faster, so you don't miss the shot.

What You Need to Know About Lens Compression

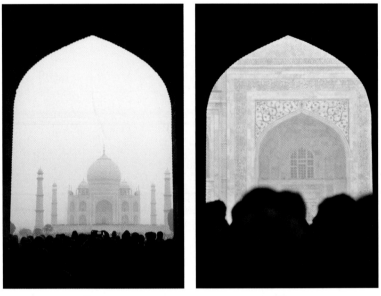

<div align="center">42mm 210mm</div>

You may have heard a lot of talk, especially when it comes to shooting portraits, about "lens compression" and how different focal lengths offer different types of lens compression. This is basically about one thing: the background behind your subject, and how far away it seems to be. For example, when you're shooting a portrait of somebody (or something, like the archway above) at a wide angle, like 28mm or 35mm, the background is going to look like it's way behind them. So, if you want it to look like a huge sweeping scene with lots of depth between your subject and the background, shoot at a wide angle. However, if you zoom your lens to around 120mm and shoot the same subject at around the same size (you'll probably have to take a few steps back, since you just zoomed in), the background will now look quite a bit closer to your subject (even though your subject and the background are in the same place). Now, zoom in even tighter on your subject (to around 200mm), and the background looks like it's even closer. This is because when you zoom in tight like this, the compression effect the lens creates makes the distance between your subject and the background seem much shorter or more compressed.

💡 **FIXED-LENGTH PRIME LENSES VS. ZOOMS**

This is going to send people who want to believe there's a big difference into a rage, but I've talked directly with manufacturers who make both the prime and zoom lenses themselves, and they've told me, point blank, that with today's higher-quality zoom lenses, there is no visible sharpness difference between zooms and primes.

Shoot at the f-Stop You Bought the Lens For

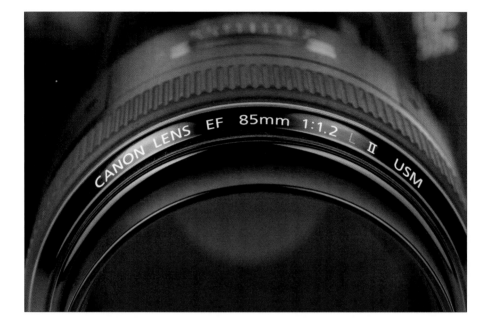

Fast lenses are pretty darn expensive these days (take a look at fast prime lenses, like the Sigma 85mm f/1.4 for Canon, which runs almost $1,000, or Nikon's 85mm f/1.4, a hugely popular lens with wedding and portrait photographers, yet it costs around $1,700). If you bought one of those lenses (or any fast lens, like a zoom that's f/2.8), you didn't buy it to shoot it at f/8 or f/11. You paid that money for the f/1.4, so when you pull out that lens, you want to be shooting it at f/1.4. That's the look, that's the f-stop, and that's the effect you paid for when you bought that expensive lens. So, make darn sure you're getting your money's worth by shooting it at the f-stop you bought it for.

💡 WHEN TO USE THE MANUAL FOCUS RING

Most lenses let you turn off the autofocus feature and manually focus your lens, but a lot of today's lenses actually let you do both: start by letting autofocus set your initial focus, but then override it and tweak your focus using the manual focus ring (usually found at the far end of the lens). There are photographers who do this every time (start with autofocus and then tweak it), but most (like myself) just rely on today's excellent autofocus capabilities to do the work for them. If you want to tweak the focus yourself using the manual focus ring, just let autofocus do its thing first, and lock onto your subject before you start tweaking the manual focus ring.

How to Focus Your Lens to Infinity

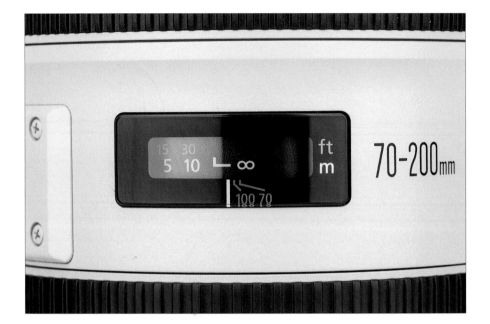

If you're going to try to shoot something that's particularly hard to focus on (for example, let's say you're photographing fireworks, or a lightning storm way off in the distance [and by the way, that's exactly where you want to be when photographing lighting—way, way off in the distance]), then you can set your focus to a setting called "infinity," where everything way off in the distance will be in focus. To use this infinity focus, start by focusing on something visible a little way in front of you, then switch your lens to Manual focus mode (you do this on the lens itself—just switch from Auto focus to Manual). Now, turn the focusing ring on the lens itself (it's usually down closer to the end of the lens) all the way to the right (on Nikons) or all the way to the left (on Canons), until you see the infinity symbol (∞) appear on the distance scale on the top of the lens. Now you're focused out to infinity and things off in the distance will be in sharp focus, even if they're too far away to actually focus on (like the moon, or stars, or Justin Bieber).

💡 **AVOID SENSOR DUST FROM YOUR BODY & LENS CAPS**

When you take the cap off the body of your camera, and the rear lens cap off the end of your lens that connects to the camera (the mount), here's a great tip to keep junk (and lint, and other stuff) from getting in either cap: screw them together. That's right—turn the two caps so they face each other, and twist to screw them into each other. Now nothing gets in there.

When to Use a Macro Lens

Pull out this lens when you want to shoot something really close up. Ever see close-up photos of bees, or flowers, or ladybugs? That's macro. Dedicated macro lenses just do that one thing, but they do it really well. A couple things about macro lenses: (1) They have an amazingly shallow depth of field—you can be shooting a flower, and the petal in the front will be sharp and in focus, and a petal on the other side of the flower will be so out of focus you can barely make out what it is. That shallow depth of field is one of the things that I love about macro lenses, but it's also a challenge when you're trying to get more things in focus. Try keeping your lens horizontal, and not angling it up or down, to get a little more depth. Lower your tripod to the point where you are aiming directly at the subject without tilting the lens. (2) Any little movement or vibration will mean an out-of-focus photo, so definitely shoot on a tripod if at all possible. Using a remote shutter release of some sort, so you don't actually have to touch the camera (possible vibration maker), will also help (more on these in Chapter 3).

💡 THIS IS TRIPOD TERRITORY

Although there are macro lenses that have built-in image stabilization (IS) or vibration reduction (VR), if you're serious about macro, you'll be serious about how sharp your images are, which means you seriously need a tripod. A tripod may well be the single most important piece of your "making great macro shots" puzzle, so although you can cut a lot of corners in other areas, shooting on a tripod is one thing you absolutely, positively should do. They haven't yet come up with a built-in stabilizer that holds a camera as steady as even the cheapest tripod.

Which f-Stop Works Best for Macro

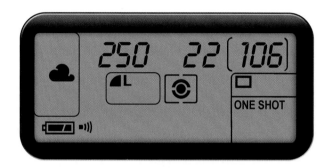

Is there an f-stop that works best for macro shots? Well, yeah. It's f/22. Because the depth of field of macro lenses is so shallow (meaning, the front of that flower you're shooting can be perfectly in focus and the petal just one inch behind it can be totally out of focus), you need to get as broad a depth as possible, and that comes when your aperture setting is at something like f/22. You could get away with f/16, or maybe even f/11, but to get the maximum amount of your subject in focus, try f/22 (or higher if your lens will allow). The higher the number, the more of your photo will be in focus.

FOCUS ON THE EYES

In portrait photography, we always focus on the eyes to get the sharpest image. Same thing in wildlife photos. Same thing in macro shots of insects or butterflies, or any little critters that wind up in your viewfinder.

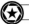

Why You Should Turn Autofocus Off

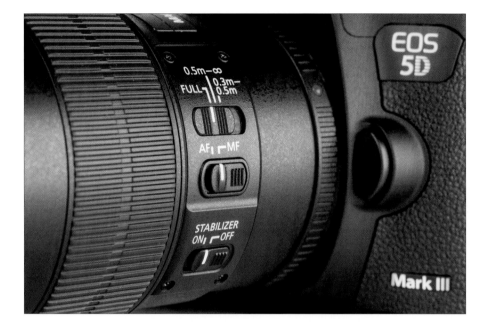

One of the big challenges of macro photography is getting things sharp and in focus. You're about to come to one of the things that can be the most frustrating, and this is using autofocus when you're as close in on your subject as you are with macro shooting. If I can give you one tip that will lower your frustration level by a hundred, it's to turn off the autofocus on your camera's lens and manually focus instead. I know, you hate to give up the autofocus feature because, honestly, on today's cameras it's really amazingly accurate. That is, until you shoot macro. What will happen is your camera will try to find a focus point, and you'll hear the whirring of the lens as it tries to snap onto something, anything to focus on, and while it's getting frustrated—so are you. Just switch over to Manual focus, and you'll both be better off.

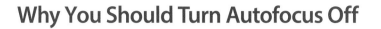

DON'T TOUCH THAT SHUTTER BUTTON!

If you're going through the trouble of putting your camera on a tripod (and you absolutely should), you can still get a "less-than-tack-sharp" photo from the vibration that happens when you push the shutter button. That's why, when shooting macro, you should either use a remote shutter release (a wired or wireless remote that lets you take a shot without touching the shutter button on the camera itself) or use your camera's self-timer, which takes the shot for you about 10 seconds after you press the shutter button, so any vibration caused by your pressing the shutter button will be long gone.

Chapter Three

Pro Tips for Getting Sharp Photos

If Your Photos Aren't Sharp, the Rest Doesn't Matter

Having photos that are sharp and in focus is so vitally important to pro photographers that they actually have coined a term for them. They call them "tack sharp." When I first heard that term tossed around years ago, I naturally assumed that it was derived from the old phrase "sharp as a tack," but once I began writing this book and doing some serious research into its history, I was shocked and surprised at what I found. First of all, it's not based on the "sharp as a tack" phrase at all. Tack sharp is actually an acronym. TACK stands for Technically Accurate Cibachrome Kelvin (which refers to the color temperature of light in photographs), and SHARP stands for Shutter Hyperfocal At Refracted Polarization. Now, these may seem like highly technical terms at first, but once you realize that I totally made them up, it doesn't seem so complicated, does it? Now, you have to admit, it sounded pretty legitimate at first. I mean, I almost had ya, didn't I? Come on, you know I had you, and I'll bet it was that "color temperature of light" thing I put in parenthesis that helped sell the idea that it was real, right? It's okay to admit you were fooled, just like it's okay to admit that you've taken photos in the past that weren't tack sharp (just in case you were wondering, the term "tack sharp" is actually formed from the Latin phrase *tantus saeta equina* which means "there's horsehair in my tantus"). Anyway, what's really important at this point is whatever you do, keep your spotted palomino away from anything with a sharp, pointy end used to attach paper to a bulletin board. That's all I'm saying.

Getting "Tack Sharp" Starts with a Tripod

There's not just one trick that will give you the sharp photos the pros get—it's a combination of things that all come together to give you "tack sharp" shots. (Tack sharp is the term pro photographers use to describe the ultimate level of sharpness. Sadly, we aren't the best at coming up with highly imaginative names for things.) So, while there are a number of things you'll need to do to get tack-sharp photos, the most important is shooting on a tripod. In fact, if there's one single thing that really separates the pros from the amateurs, it's that the pros always shoot on a tripod (even in daylight). Yes, it's more work, but it's the key ingredient that amateurs miss. Pros will do the little things that most amateurs aren't willing to do; that's part of the reason their photos look like they do. Keeping the camera still and steady is a tripod's only job, but when it comes to tripods, some do a lot better job than others. That's why you don't want to skimp on quality. You'll hear pros talking about this again and again, because cheap tripods simply don't do a great job of keeping your camera that steady. That's why they're cheap.

Don't Press the Shutter (Use a Cable Release)

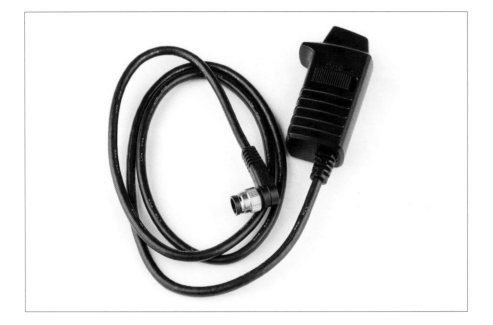

Okay, so now you're lugging around a tripod, but your photos are looking much sharper. Not tack sharp yet, but much sharper. What will take you to the next level of sharpness? A cable release. This is simply a cable that attaches to your digital camera (well, to most semi-pro or high-end consumer DSLRs anyway) that has a button on the end of it. When you press the button, it takes the photo, but without you actually touching the shutter button on the camera itself. Why is this such a big deal? It's because, believe it or not, when you press the shutter button on the camera, it makes the camera move just enough to keep your photos from being tack sharp. I know, it sounds like a little thing, but it's bigger than it sounds. Using it is easier than you might think, and these days most cameras support wireless remotes, too, and they're fairly inexpensive. Now, you're better off getting an electronic cable release rather than one that presses the shutter button with a plunger-style wire, because, even though you're not pressing the button with your big ol' stubby vibration-causing finger, it's better not to touch the camera at all.

💡 **FORGOT YOUR CABLE RELEASE? USE A SELF TIMER**

If you don't want to spring for a cable release (or wireless remote), or if you forgot yours, the next best thing is to use your digital camera's built-in self timer, which takes the shot without you touching the camera. If you hate waiting, then see if your camera allows you to change the amount of time it waits before it shoots.

Avoid Increasing Your ISO on a Tripod

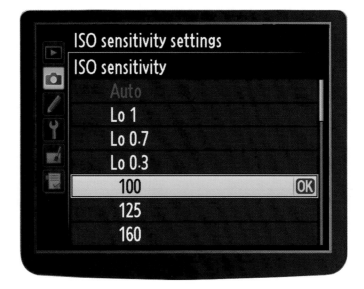

When you're shooting on a tripod, even in very dim or low light, don't increase your ISO (your digital equivalent of film speed). Keep your ISO at the lowest ISO setting your camera allows (ISO 200, 100, as shown above, or 50, if your camera's ISO goes that low) for the sharpest, cleanest photos. Raising the ISO adds noise to your photos, and you don't want that (of course, if you're handholding and have no choice, like when shooting a wedding in the low lighting of a church, then increasing the ISO is a necessity, but when shooting on a tripod, avoid high ISOs like the plague—you'll have cleaner, sharper images every time).

BREAKING THE RULES

So what do you do if you can't use a tripod (e.g., the place where you're shooting won't allow tripods)? In this case, if there's plenty of light where you're shooting, you can try using very fast shutter speeds to minimize handheld camera shake. Set your camera to shutter priority mode and choose a speed that matches or exceeds the focal length of your lens (a 180mm lens means you'll shoot at 1/200 of a second).

Tuck in Your Elbows for Sharper Shots

Another technique for getting sharper photos when handholding your camera is to steady the camera by holding it with your elbows tucked in toward your body. This helps anchor the camera to your body, keeping it steadier, and giving you sharper photos. This is an easier change to make than you'd think, and once you see the results, you'll be glad you did it.

WHAT TO DO IF YOUR IMAGE ISN'T QUITE GOOD ENOUGH TO PRINT

If you've taken a shot that you really, really love, but is not as sharp as you'd like it to be, or you don't have enough resolution to print it at the size you'd like, print it to canvas. With its thick texture and intentionally soft look, it covers a multitude of sins, and images that would look pretty bad as a print on paper, look absolutely wonderful on canvas.

Turn Off Vibration Reduction (or IS)

The big rage in digital lenses these days are the Vibration Reduction (VR) lenses from Nikon and the Image Stabilization (IS) lenses from Canon, which help you get sharper images while handholding your camera in low-light situations by stabilizing the movement of your lens when your shutter is open longer. If you're in one of those situations, I highly recommend these VR or IS lenses, but depending on which one you use, there are some rules about when you should turn them off. For example, we'll start with Nikon. If you are shooting on a tripod with a Nikon VR lens, to get sharper images, turn the VR feature off (you do this right on the lens itself by turning the VR switch to the Off position). The non-technical explanation why is that these VR lenses look for vibration. If they don't find any, they'll go looking for it, and that looking for vibration when there is absolutely none can cause (you guessed it) some small vibration. So just follow this simple rule: When you're shooting on a tripod, for the sharpest images possible, turn VR or IS off. Now, there are some Nikon VR lenses and some older Canon IS lenses that can be used on a tripod with VR or IS turned on. So, be sure to check the documentation that came with your lens.

○ SHOOT AT YOUR LENS' SHARPEST APERTURE

Another trick the pros use is, when possible, shoot at your lens' sharpest aperture. For most lenses, that is about two full stops smaller than wide open (so the f-stop number you use will go higher by two stops). Now, this isn't true for all lenses, and if that's not the case with your lens, you'll find your lens' sharpest aperture by keeping an eye out for which aperture your sharpest images seem to come from.

Zoom In to Check Sharpness

Nikon Canon

Here's a sad fact of digital photography—everything looks sharp and in focus when you first look at the tiny LCD screen on the back of your digital camera. When your photo is displayed at that small size, it just about always looks sharp. However, you'll soon learn (once you open your photo on your computer) that you absolutely can't trust that tiny little screen—you've got to zoom in and check the sharpness. On the back of your camera there's a zoom button that lets you zoom in close to see if the photo is really in focus. Do this right on the spot, right after you take the shot, so you still have a chance to retake the photo if you zoom in and find out it's blurry. The pros always check for sharpness this way, because they've been burned one too many times. Some of today's digital SLR cameras even have a quick zoom option, where you can set a particular amount you want your zoom to zoom in to. Check your owner's manual to see if your digital camera has a custom quick zoom setting.

💡 HANDHELD SHARPNESS TRICK

Anytime you're handholding your camera in less than optimal light, switch to continuous shooting (burst) mode and hold down the shutter release to take a burst of photos instead of just one or two. Chances are at least one of those dozen or so photos is going to be tack sharp, and if it's an important shot, it can often save the day.

Sharpening After the Fact in Photoshop

If you've followed all the tips in this chapter thus far, and you've got some nice crisp photos, you can still make your photos look even that much sharper by adding sharpening in either Adobe Photoshop (the software darkroom tool the pros use) or Adobe Photoshop Elements (the semi-pro version). Now, which photos need to be sharpened using Photoshop? All of them. We sharpen every single photo we shoot using Photoshop's Unsharp Mask filter. Okay, it sounds like something named "unsharp" would make your photos blurry, but it doesn't—the name is a holdover from traditional darkroom techniques, so don't let that throw you. Using it is easy. Just open your photo in Photoshop, then go under Photoshop's Filter menu, under Sharpen, and choose Unsharp Mask. When the dialog appears, there are three sliders for applying different sharpening parameters, but rather than going through all that technical stuff, I'm going to give you five sets of settings that I've found work wonders.

(1) **For people:** Amount 150%, Radius 1, Threshold 10

(2) **For cityscapes, urban photography, or travel:** Amount 65%, Radius 3, Threshold 2

(3) **For general everyday use:** Amount 120%, Radius 1, Threshold 3

(4) **For super-sharpening** (for sports photos, landscapes, stuff with lots of details): Amount 95%, Radius 1.5, Threshold 1

(5) **For images I've already made smaller and lower resolution,** so I can post them on the web: Amount 85%, Radius 1, Threshold 4

Sharpening Your Images for Print

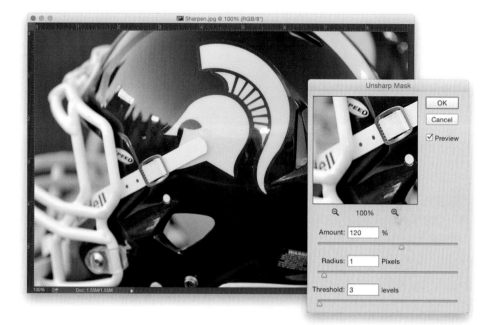

This should really be called "Oversharpening Your Images for Print in Photoshop," because that's pretty much what you do. You lose some of the sharpness you see onscreen during the printing process, so to get around this, we oversharpen our images in Photoshop. Here's what to do: First, get the sharpening so it looks good onscreen (I use Photoshop's Unsharp Mask filter), then start slowly dragging the Amount slider to the right, increasing the amount of sharpening, and as soon as you think "Ewwww, that's too sharp…" just stop. Don't backtrack the Amount slider—just stop. If you're thinking, "This looks a bit too sharp," your sharpening is probably right on the money. Also, if you're going to use this same image on the web and in print, before you apply this sharpening for print, duplicate the Background layer and apply your sharpening just on that layer (and rename this layer "Sharpened for print," so you'll know it's oversharpened). That way, you'll still have the original Background layer that's not oversharpened.

 DID YOU RESIZE THAT FOR WEB? THEN RESHARPEN!

If you sharpen an image in Photoshop (or Photoshop Elements), and then lower the image size and resolution so you can post it on the web, you need to apply a little bit of sharpening again. When you lower the image size and resolution, it loses some of its sharpness during that resize. In the Unsharp Mask filter, start with: Amount: 70%, Radius: 1.0, Threshold: 10.

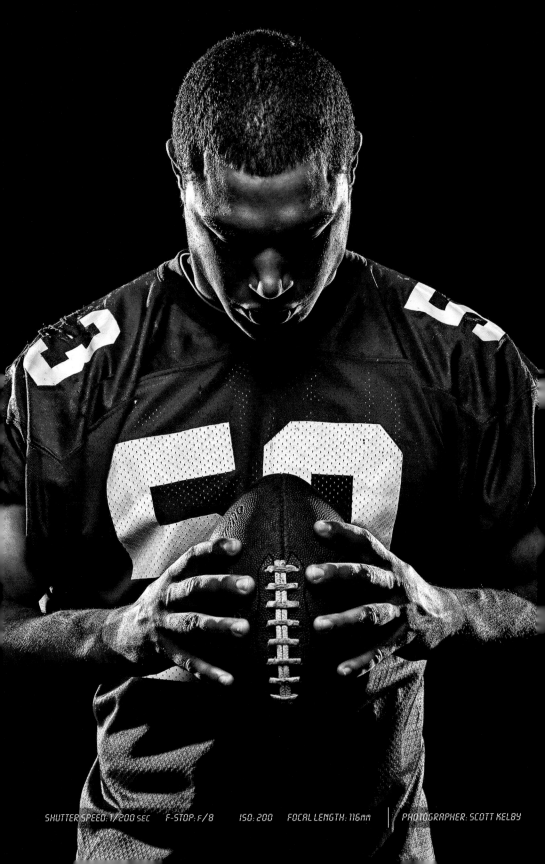

Chapter Four

Using Your Studio Like a Pro

Build It From Scratch,
Then Take It Up a Notch.

Back in part 2 of this book series, I showed you how, using just a simple, thin piece of plastic that fits easily in your wallet, you can completely and fully outfit a one-light studio from scratch. Well, after I wrote that chapter, people who read it wrote me and asked some really thought-provoking and soul-searching questions like, "What if we want to use two lights?" or "What if we want to add a second light?" and even "What if we have one light, but think we might need another?" I'm not gonna lie to you. I was pretty freaked out. I thought we covered so much in part 2 that there was no way anyone would want to learn more, so when I originally wrote the outline for part 3, not only did I not have a chapter on more studio techniques, I specifically didn't mention the word studio, or techniques, or use any words with either an "s" or "t" in them, just in case. But then I realized writing a book without an "s" or "t" in it would preclude me from using my first name, and if that happened, I wouldn't be able to refer to myself in the third person (like, "Scott doesn't want to share more studio techniques" or "Scott made bail"). So, I really had to revisit the whole concept with a fresh set of eyes, and once I did, I realized that not only would I have to include a studio chapter that picked up where part 2 left off, but I would actually have to rebuild my original studio from scratch, because after part 2 was complete, and the chapter was done, I built a huge bonfire and destroyed all my gear. That's how "done" I thought I was with studio techniques, but apparently, that's not the case. Scott doesn't like to have to rebuild everything. Scott doesn't like to pull out the thin piece of plastic from his wallet. Scott needs a second job.

Using Studio Flash (Called Strobes)

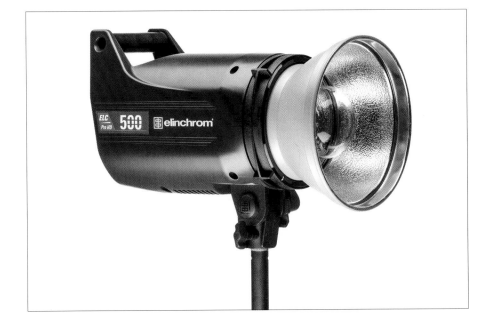

A lot of people are intimidated by studio lighting, thinking it's complicated or too techni-cal for them, but in reality, most studio lights are just bigger versions of the hot shoe flash you're already used to using off-camera (in fact, they are flashes, but in the industry they're usually called "studio strobes" or just "strobes"). The main differences between hot shoe flashes (like a Nikon Speedlight or a Canon Speedlite) and studio strobes are: (1) studio strobes usually plug into the wall rather than running on batteries; (2) studio strobes are much more powerful (they put out a lot more light) than the hot shoe flashes; (3) they have a modeling light; (4) they're designed to have lighting accessories, like soft-boxes, attached right to the front of them; and, (5) since they're designed to be mounted on top of a light stand, they have a light stand mount right on the bottom of the strobe itself (to mount a hot shoe flash on a light stand, you usually will need some sort of separate adapter or swivel head).

USING CONTINUOUS LIGHT INSTEAD

An alternative to studio strobes is continuous lights. With these lights, there is no "flash of light"—instead, the lights just stay on continuously. This makes studio lighting incredibly easy, because what you see is what you get. They're naturally softer than studio strobes, but still need a softbox attached. A speed ring is built right in, though, and they're fairly inexpensive. There's one downside: since there's no flash to freeze things, things need to be fairly still, because the fluorescent lights aren't as bright as the light from a strobe.

What to Do When You Can't Turn Your Strobe Power Down Any Further

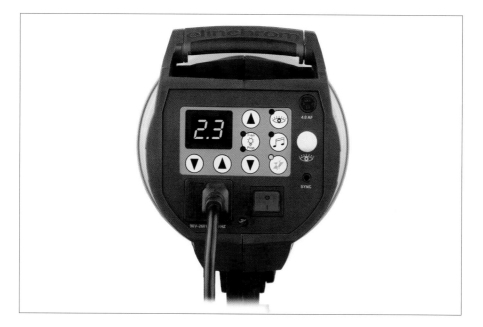

The bigger the softbox, the softer and more beautiful the light. But what if you want even softer light? Well, the trick is to move that light as close as possible to your subject (without it actually appearing in the frame), because the closer the light, the bigger it becomes, which makes it even softer and more beautiful. One other thing happens when you move a light in this close: it gets much brighter. So, as you move the light closer to your subject, you'll need to lower the power of your strobe so it's not so bright, right? Right. Now, what happens when you've lowered the power of your strobe as low as it can go, and it's still too bright? When this happens, just raise your f-stop. That's right. If you were at f/8, raise it to f/11. If you started at f/11, raise it to f/14. This cuts the amount of light falling on your subject, so you get the best of both worlds—you're still getting super-soft light by moving it close to your subject, but you're not blowing them out with too much light because it's so close. You might even need to increase your f-stop by two stops or more, but if that's the case, don't sweat it—just do it.

💡 WHY I PREFER SOFTBOXES TO UMBRELLAS

With a softbox your light is pretty much contained within a box—you aim it in a direction and it pretty much goes right there. But with an umbrella, you have less control over what happens once the light leaves your umbrella. I think of it more like a lighting grenade—you throw it in the general direction of what you're trying to light, and it'll probably light it. So, while an umbrella does take the harsh light from your strobe and create soft, pretty light from it, it kind of goes everywhere. Whereas, a softbox is more directional.

Firing Your Studio Strobe Wirelessly

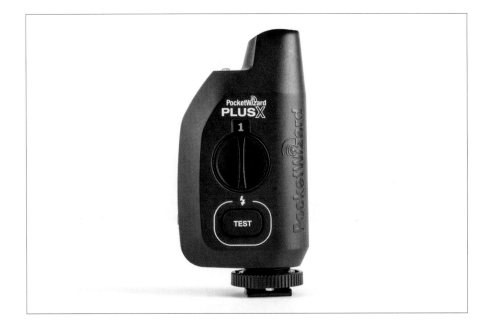

Besides avoiding the potential for broken glass (well, broken everything actually), there's another thing using a wireless flash setup gives you—freedom. You're no longer tied (well, actually tethered) to your strobe. You're free to move around the studio, completely untethered, unencumbered, unfettered (insert your own "un" word here), without being on a leash (so to speak). Now, many current models of studio strobes have built-in receivers and come with triggers that let you fire the light wirelessly from your camera, but if you have a strobe that doesn't have this, then you'll need two of these wireless devices—one sits on the top of your camera (in your camera's hot shoe) and transmits the wireless signal to the other wireless unit, which plugs into the sync input on your strobe. What I love about them is you just plug them in, turn them on, and they do their thing. There's no real configuring or messing around for this simple setup. Now when you press your shutter button, it instantly fires your strobe, even if it's across the room (even way across the room). The most popular wireless units are from a company called PocketWizard, and their PocketWizard PlusX is a small, thin, lightweight model of simplicity that is incredibly reliable and very well made. They go for around $85 each (and you need two of them, so $170 for the set. They also make more expensive units with more features and stuff, but at this point, you don't need 'em). If you want a cheaper alternative, go with the Cactus Flash Transceiver V5 Duo. They're a bargain at around $75 for a set of two (so, $37.50 each), and they actually work really well. Perhaps they're not quite as rock-solid as the PocketWizard, and they may not have the 300+ foot range of a PocketWizard, but they're pretty darn reliable and about $95 cheaper.

Softening Harsh Studio Strobes

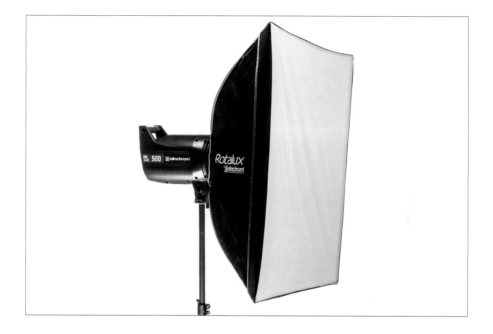

So, if the light from your regular off-camera flash is harsh, imagine how harsh the light will be from a brighter, more powerful flash (your studio strobe). Right, it's harsh city. To diffuse that light and make it softer, you have to make the light that comes from your strobe larger, because the rule is: the larger the light source, the softer the light. So, we have to put something big between our studio strobe and our subject to spread and soften that light, and for that I recommend a softbox. They're aptly named because they soften the light from your strobe big time, and they are very popular with professional studio photographers (in fact, it's the softening device of choice for most top pros). They fit right over your studio strobe (they have a hole in one end) and your flash fires through the white diffusion material at the large end of the softbox. This spreads the light, so when it hits your subject, it's a bigger source of light, and that means it's a much more flattering, softer light. But this softer light isn't just for lighting people—even if your subject is a product, you still want nice, soft shadows throughout your image, and a softbox is your key to getting just that.

WHAT A SPEED RING DOES (& WHY YOU NEED IT)

A speed ring has four to eight holes on the edge where you insert the ends of the thin metal poles of your softbox. This gives your softbox its form, and you attach this whole rig (the speed ring with your softbox attached) to your strobe. If your softboxes don't come with one built in, make sure you get one designed to fit your brand of strobe.

Where to Position Your Main Light

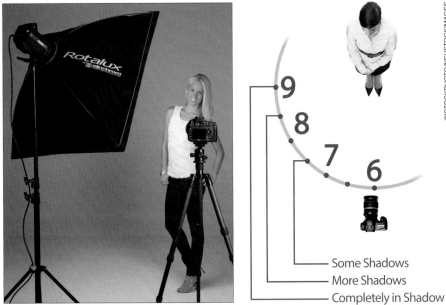

©ISTOCKPHOTO/NEUSTOCKIMAGES

Some Shadows

More Shadows

Completely in Shadow

Your strobe should be up high on a light stand, aiming down at an angle (kind of like the sun aims down on us), so it creates a more flattering look to our light. Also, keep in mind that the closer the light is to your subject, the softer the light is. Now, there is no absolute "right" place to position your lights, so it really comes down to your personal preference about how you want the shadows to look on your subject. Shadows are what create depth and dimension on a person's face (and having soft shadows on your subject's face is usually very flattering), so I usually position my main light so it's at a 45° angle to the subject. So, for example, if your subject was standing at the center of a clock face, and the camera is straight in front of them at 6:00, then you'd place the light at around 7:30. This creates some nice soft shadows on the side of their face that's farthest away from the light (the side opposite the light). If you want more shadows on that side of their face, you'd move the light to around 8:00. Want more shadows? Move it to 8:30. Want that whole side of their face totally in shadow (often seen in dramatic portraits of men)? Put the light right beside them at 9:00. Okay, what if you actually want less shadows on that opposite side of their face—maybe just a hint of shadows? Then, move the light closer to the camera position—to around 7:00. If you move the light right in front of the subject, their whole face will be lit evenly with no shadows on their face. This is "flat lighting" and it usually looks okay on someone with really good skin. Okay, so which one of these positions is the "right" position? The one you choose—it's totally up to your personal preference (my preference has me positioning my light at between 7:30 and 8:00 most of the time).

Adding a Hair Light

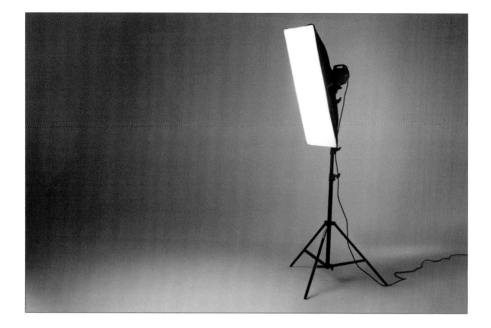

Thinking of adding a second light to your studio? It should probably be a hair light. This is just another strobe, but it's generally aimed directly at your subject's hair (did I even have to say that?), which helps to separate your subject from the background and give your portraits a more professional look all around. For lighting hair these days, we generally use a strip bank, which helps keep the light more directional (and lights just the hair and/or shoulders, instead of spilling over everywhere). Mine is 12x36". Also, I usually set my strobe's power for the hair light so it's around one stop brighter than my front light, so the light from my front light doesn't overpower it. A trick for checking the position of your hair light, to make sure none of the light from it is spilling onto your subject's face, is to turn off your main strobe (your front light), so nothing but the hair light is turned on. Your subject should be in complete silhouette, with no light on their nose, cheeks, or face whatsoever. If you see any light now, you'll need to reposition your hair light (maybe move it back a little bit, or to the side), until you only see light on their head and shoulders—none on the face. By doing a test shot with just one light on at a time, you'll see exactly what each one is doing. If you turn them all on from the beginning, the lighting won't look good, but you won't have any idea why. So, always start with just one light (I always do any back lights first), and then add another light, one at a time. If something doesn't look right when you add another light, turn the other lights off, adjust the one that didn't look right, then turn them on again, one at a time. Probably the most popular accessory for hair lights is an egg crate grid. This is a fabric grid that Velcros (or slips, depending on the brand) over the front of your strip bank. It narrowly focuses the light from your hair light so it doesn't spill out the sides, and it really does a wonderful job of focusing your light just where you want it. They come in different sizes, and there's one to match the exact size and shape of your strip light.

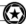

Getting a Different Look Without Moving the Lights

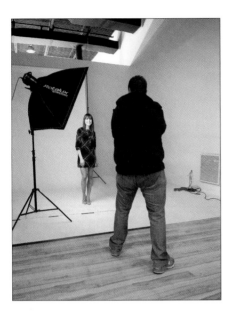

Once you've got your lights in place and you've got that first shot in the bag, try this: Don't move the lights. Don't move your subject. Instead, leave everything as is and move the photographer (kudos to Jeremy Cowart for this tip). If you were standing right in front of the subject, just move way over to one side or the other and take the shot again. You'll be amazed at how moving two or three feet in either direction can completely change the look of the lighting, even if you haven't touched a single light. Give this a try and you'll wind up with two or three lighting looks out of just one lighting setup.

💡 **CHOOSING THE SIZE FOR YOUR SOFTBOX**

There are a couple of considerations: what are you planning to shoot, and how soft do you want your light? If you're shooting product shots on a table, you can get away with a smaller softbox, yet it would still be big enough for head-and-shoulders portraits. If you're shooting people, and doing more than just head-and-shoulder-type stuff, then you'll need to go with a larger softbox. The larger the light source, the softer the light, so if you buy a very large softbox, you're going to get very soft light, and you're going to be able to light a larger area.

Want Softer, More Even Light? Feather It!

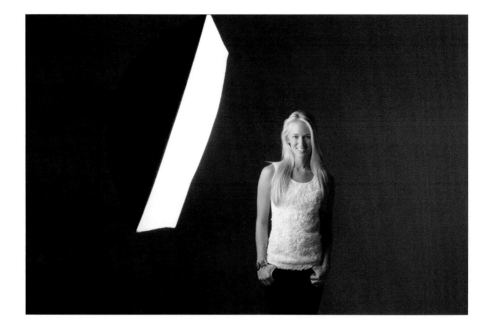

If you're already using a large softbox (one that's around 36x48" or larger), and you want softer, more even light than it delivers, then you can use a technique called feathering, which puts your subject in the softest and most even light your softbox can deliver. Feathering just means that you turn the light away from your subject, so they are now lit by just the edges of the light. They won't be getting the full intensity of the light when you feather it, so you might have to adjust your exposure so it's not too dark (use a lower number f-stop on your lens—like f/4 or f/3.5, etc.—or better yet, use your light meter and it will tell you exactly which settings to use when feathering your light). This light out at the edges of your softbox is very even, very soft, and very flattering (since the light in the center of the softbox is usually brighter and less even), so when you really need that super-soft, even light—now you know where to get it. This technique looks great on portraits of young children, a mother/daughter shot, or when you want a very soft, glamorous look to your lighting.

Studio Backgrounds

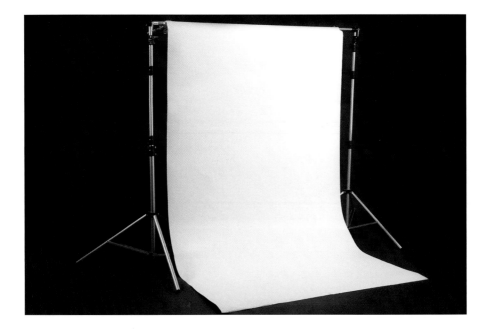

One of the least expensive, and most popular, studio backgrounds is seamless paper. This paper comes in long rolls, and the two most popular widths are just over 4 feet wide (53") and nearly 9 feet wide (107"). The nice things about seamless paper are: (1) It's cheap. A 53-inch-wide white roll that's 12 yards long goes for around $25 (at B&H Photo), and if you want the 9-foot-wide roll, it's only around $45. (2) It's seamless. There's no visible seam where the paper folds as it reaches the floor (or a tabletop), so the background looks continuous. (3) The stands to support seamless paper backgrounds are pretty cheap, too. For example, the Savage Economy Background Stand Support System, which supports both the 53" and 107" rolls, only costs around $79. That ain't bad. And, (4) this paper comes in a wide variety of colors, from solid white to solid black, to blue, green, and everything in between (hey, that rhymes). If you're building your first studio, this is a great way to start, because you can get your background and the supports to hold it up for around $100.

💡 **SO WHICH SHOULD I GET, THE 53" OR THE 107" SEAMLESS?**

If you're planning on shooting products on a table, or strictly just head-and-shoulder shots of people, you can get away with the 53" width. If you need to see more of your subjects, go with the 107".

Using a Pop-Up Collapsible Background

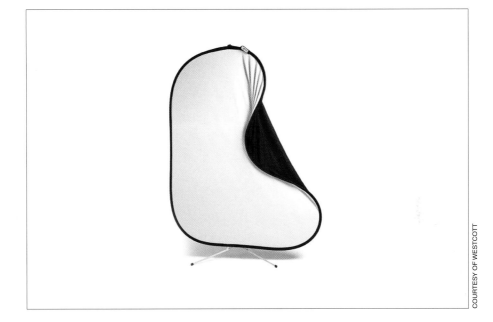

COURTESY OF WESTCOTT

Another quick and flexible studio background is a pop-up collapsible background that instantly folds up into a small, flat circle, but expands to be a full studio background in a matter of seconds. The one I use is a 6x7' Westcott Masterpiece 2-in-1 Collapsible Illuminator Background with white on one side and black on the other. It sells for around $220, and I also recommend buying the Illuminator stand to hold it up, which is another $90, but unless you can stand there and hold it up (or have somebody else hold it up), it's worth its weight in gold. So, with this background, anytime you want to shoot, you just open the round plastic case it comes in, pull it out, and it pops up, ready to go. You put it on the Illuminator background stand, and you're ready to go. Another advantage of this particular background (over the seamless paper route) is that it's very portable, lightweight, and you can set it up in literally seconds—by yourself. The only downside is it doesn't go all the way to the floor seamlessly, so it's fine for 3/4-body shots, but not full-body shots. One more thing: although I use the black/white version, these collapsible backgrounds come in all sorts of patterns, looks, sizes, and colors.

💡 USING OFF-CAMERA FLASH TO LIGHT BACKGROUNDS

If you want to add a light to your background (aiming back at your seamless paper), but you don't want to go through the extra expense of adding a second studio strobe, if you have a standard off-camera flash (like a Nikon SB-910 or a Canon 600EX-RT), you're in luck. You can set either of these off-camera flashes to become wireless slave flashes, meaning that when your studio strobe fires to light your subject, it automatically triggers your off-camera flash to light your background.

One Background, Three Different Looks

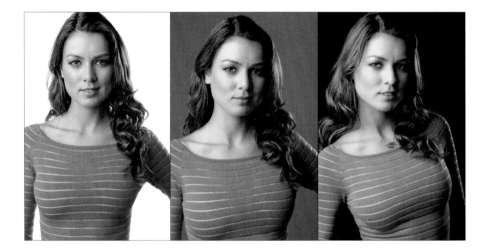

One nice thing about buying a white seamless background is, depending on how you light it (and what shutter speed you use), you can get three different looks. Here's how: (1) To have a white background, you have to light it, so position a light (or ideally one on each side) down low, aiming up a bit to light the background. That gives you white. (2) To have a gray background, just turn the background light(s) off. White paper needs light not to look gray, so when you turn those lights off, it gives you gray—your second color from the same white background. (3) To get a black background, leave the lights off, and increase your shutter speed to as high as your camera will allow (your maximum sync speed), which is probably 1/200 or 1/250 of a second. This makes your background go even darker—to at least a very dark gray or a solid black—just by changing the shutter speed. What you're essentially doing, by raising the shutter speed, is eliminating any light already in the room (called "ambient light").

💡 HOW FAR SHOULD YOUR SUBJECT BE FROM THE BACKGROUND?

About 8–10 feet (unless you're using the main light to light the background). Here's why: (1) By keeping them far away from the background, you avoid your front light spilling onto the background. (2) If you use a separate background light, the two lights will be very distinct in the final image. And, (3) You won't have to worry about your subject's shadow falling onto the background. Shooting in a tight space? Move your main light in really close to your subject (the main light gets brighter and the light falls off to black much faster), and change your aperture. So, if you were at f/8, change it to f/11 or f/14, so the front light won't affect your background very much, if at all.

Getting Super-Saturated Background Color

Want some really vivid, punchy colors as your background? Start on a background of black seamless paper (I know, it sounds weird that we start creating vivid colors with a black background, but believe it or not, this is the easiest way), and then position a light on the background. Now, for a background light you can use another one of the same strobes you already have (so, basically, you're going to need a second strobe if you want to light the background, or there's the trick you can pull to use your off-camera flash as a background light that we talked about a couple pages ago). Once you've got your black seamless paper in place and a second strobe (or off-camera flash) positioned behind your subject, aiming at the background, the trick is to put a vivid-colored gel (a translucent piece of plastic) over the front of your flash, and when your background flash fires, the color it produces is rich, vivid, and surprisingly colorful. You can get these gels (made by Lee or Rosco) from B&H Photo for around $6.50 for a 20x24" sheet (choose really vivid colors—reds, yellows, greens, etc.).

💡 LIGHTING A WHITE BACKGROUND

To get it to look solid white, you have to light it—usually just one or two lights will do it, and they don't have to be very high-powered strobes. There's also a little trick you'll want to use to make sure that the light does make the background look that nice solid white, but without blowing out the background so much that the back light starts to wash out the edges of your subject: use a light meter. You want the background to be around one stop brighter than the light on your subject. So if your meter showed f/11 for your subject, you want the background to read one stop brighter (like f/16).

Reflectors: When to Use Silver or White and Where to Position It

The most popular reflectors are white, silver, and gold (although gold is usually used outdoors, because it adds warm yellow light). So, that leaves silver and white. Which do you use when? Silver reflects much more light, so you'll use silver when you position the reflector back away from your subject. If you need to get a reflector right up close, then use white, because it doesn't reflect nearly as much light as silver. Now, where do you put it? It's job is to bounce some of the light from your main light (your flash) back into the shadowy areas of your subject, so you'll need to position it where it can do its job. You can place the reflector directly beside your subject (on the opposite side from your studio flash), then move it a bit forward so it extends a little in front of the subject to catch the light and fill in the shadows. Make sure that: (1) it is indeed in front of them a bit, and not right beside them, and (2) it's not positioned up higher than they are—it should be at their height. Another popular place to position a reflector for head shots is directly in front of your subject, usually right below your subject's head and shoulders, so the light bounces back to lighten the shadows on their face—in particular, the areas under their eyes and neck. You can have your subject hold the reflector flat in front of them, or you can position it on a reflector stand, or even lay it on the floor in front of them. And, one other popular position is to place it out in front, where you'd place a second light (on the opposite side from your studio strobe), so it bounces light back toward your subject. The key thing to remember is: if the light isn't hitting the reflector fairly directly, it has nothing to bounce, so make sure that wherever you position it, the light from your strobe is hitting it directly. A quick trick for helping you position the angle of your reflector, so you know the light is hitting where you want it to: hold the reflector by its side and tilt it up and down a few times as you're facing your subject, and you'll see the reflected light move across their face.

Using Grid Spots

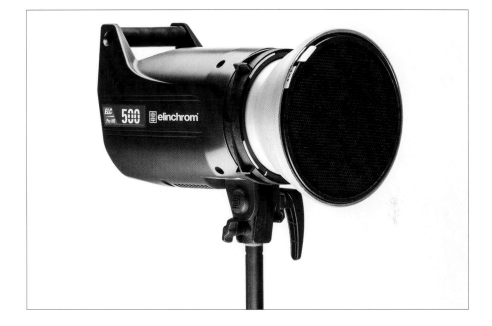

If you took your softbox off your strobe, the light from the flash bulb would pretty much just go everywhere. That's one of the reasons we use softboxes in the first place—to help us put the light where we want it and greatly soften it, of course, but softboxes are, by nature, soft. That's where grid spots come in. These attach right over your strobe's reflector, and have a metal honeycomb pattern that gives you a narrow, focused beam for very dramatic effects (the light will be hard-edged, because there's no softbox—it's a bare bulb with a metal reflector and a grid spot). Right now, you see these grid spots used big time as back-edge lights in portraits. These come in different degrees (like a 10° grid, a 20°, and so on), and the lower the number, the tighter the beam (I usually use a 20° or 30° grid). There's not much to using them. You just snap them into place and that's it—your beam is greatly narrowed. Put one on either side of your subject, aim them at the sides of their face, then use a strobe up front to put some fill light into their face, and—voilá—you've got the look.

💡 **WHY YOU NEED SANDBAGS**

I don't care how sturdy a boom stand you buy, one day (probably soon), it's going to go crashing over. That's why you absolutely need to have some sandbags, and to use them religiously when you've got anything on a boom or if you take anything outside on a shoot (where the wind can blow it over).

How to Use a Light Meter

Before you get started, there are three simple things you'll need to do before you measure the light from your flash: (1) Enter the ISO that your camera is set to into your light meter (so, if you're shooting at 100 ISO, you enter 100 ISO). (2) Enter the shutter speed you're going to be using (in a studio, I generally use 1/125 of a second—a good, safe shutter speed for working with studio flash. So, go ahead and enter 1/125 of a second). And, (3) make sure the round white plastic dome on the meter is extended (turn the wheel so it extends out). That's it—you're ready to put it to use. Most people aim the light meter at the light itself, but today's meters are actually designed so they work with that white plastic dome aiming back directly at your camera's lens. If you're metering a person for a portrait, position the meter directly under their chin, with the dome aiming back directly at the camera. Now, push the measurement button on the meter, and then fire the flash (if you're firing your flashes wirelessly, make sure you get a light meter that has a wireless trigger built right in, so when you push the measurement button, it fires the flash for you. Otherwise, you'll have to have your subject hold the meter under their chin and push the measurement button, so you can walk back to your camera to take a test shot, which fires the flash). When the flash fires, it instantly tells you the exact f-stop you need to dial in on your camera for a perfect exposure. Go over to your camera, make sure you're in manual mode, set your f-stop to what it said (make sure your shutter speed is still set at 1/125 of a second) and you've got it—perfect exposure. As long as you don't move the light or change the power of the flash, you can continue to use those settings. If anything does change, just take a new meter reading the same way and dial in your f-stop just like before.

Which Mode Should You Shoot In?

When it comes to shooting with studio strobes or flashes, this is the one time I would absolutely recommend that you shoot in manual mode. The reason is you need to set both the f-stop and shutter speed independently, and manual mode easily lets you do just that. Start by setting your shutter speed at 1/125 of a second (a good, safe speed that will sync your camera with your flash unit, no sweat). This shutter speed, in a studio, is a "set it and forget it" setting. Now all you have to worry about is setting your f-stop. So, set your shutter speed to 1/125 of a second, your f-stop to f/11 (great for studio portraits because everything will be in focus), and then take a shot and see how it looks on your camera's LCD monitor. If it's too dark/too bright, don't change the settings. Instead, just raise/lower your flash power until the lighting looks right to you. Of course, you could just use a light meter to tell you exactly which f-stop to use for the power setting you currently have on your flash (if you'd rather not mess with changing the power of your flash).

WHY YOU'LL LOVE ROLLING LIGHT STANDS

At some point, you're going to wind up buying light stands for your studio. Make your studio life much easier and buy light stands with wheels. Two big reasons why: it's much faster and easier to roll them around than pick them up and move them, and they're much safer. Lights are top-heavy. When you pick one up to move it, it's easy to bang it into something, or lose balance and topple the whole rig over.

How to Set a Custom White Balance In-Camera

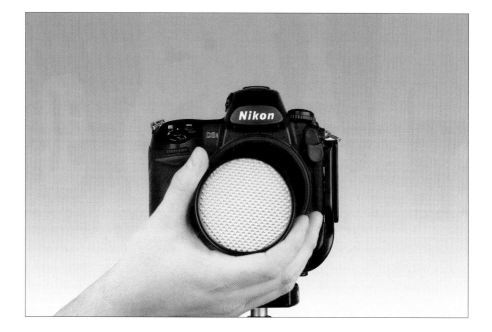

If you'd like to set a custom white balance in-camera, I would recommend using something like an ExpoDisc, which is a white balance tool used by a lot of pro photographers. Here's how it works: You start by putting the ExpoDisc over the end of your lens (it looks like a thick lens filter) and switching your lens to Manual focus (if you don't, your camera might not let you actually take a shot). Then, aim it at the light source (not at your subject—aim it directly at the main softbox you're using) and take a shot. Now, in your camera, you're going to assign that image you just took as your white balance reference image. Here's how: On Nikon DSLRs, before you take the shot, hold the WB button, then turn the dial until your White Balance is set to PRE, then release the WB button, and press it again until the letters "PRE" start blinking in your LCD panel on the top of your camera. That's your cue to take your shot (you have 10 seconds to take it), so aim your camera at your softbox and fire off a shot. You should now see GOOD appear in the LCD panel. That's it—your custom white balance is set (don't forget to turn your lens back to Auto focus, though). On Canon DSLRs, put the ExpoDisc over the front of your lens, aim at your softbox, and take a shot. Now, press the Menu button on the back of your camera, scroll down to Custom WB, and press the Set button to bring up the next screen, then press Set again to choose that shot you just took as the white balance reference photo. Lastly, press the White Balance Selection button on top of your camera, then rotate the Main dial until you see Custom WB appear in the LCD panel (don't forget to turn your lens back to Auto focus).

Rim-Light Profile Silhouettes Made Easy

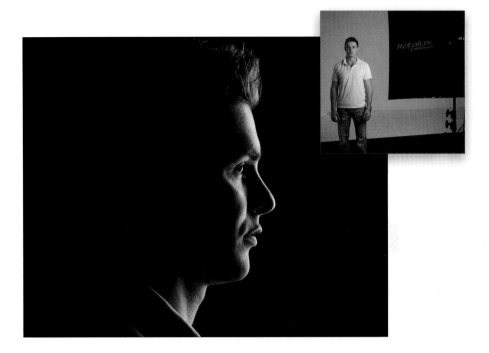

This is one of those super-quick, 30-second tricks that have a big impact. First, aim your softbox sideways and have your subject stand directly in front of the center of it (facing your camera). Now, have them turn sideways toward the softbox, so they're facing it directly. Next, have your subject take a step or two sideways, closer to you (while you're at your camera position). Have them step sideways toward you until they have actually moved past the edge of the softbox (so there's no softbox in front of them at all. It's actually a foot or so behind them, from your vantage point at the camera). Now take your shot. What you'll get is a strong rim light all the way around the profile of your subject, and the rest will appear as a black silhouette. If you want a little light to appear on the cheek facing the camera, have them move just a few inches back toward the light until you see that cheek lit just a tiny bit (this is where the modeling light comes in handy, because you can see a preview of how the light will fall).

FRANK DOORHOF'S WORDS OF WISDOM ABOUT USING ONE LIGHT

My friend, and studio lighting wizard, Frank Doorhof has a great saying he shares with his students. He tells them: "When you think you need two lights, use one light. If you think you need three lights, use one light. If you think you need four lights, maybe then you might consider a second light." He makes a really great point—if you can use just one light, chances are it's really all you need. The more lights you add, the more complicated things get, the longer it takes, and the more problems and challenges arise.

Using a Fan for Windblown Effects

Shooting portraits of women? Buy a fan. Not just a fan, a powerful, hurricane-force commercial fan that would put most of your lighting equipment in jeopardy if you were to ever turn it on to its highest possible setting. Anyway, a fan with a nice kick to it (like the Lasko 3520 20" Cyclone Pivoting Floor Fan, for around $35) creates a windblown hair effect that can add energy and excitement to your portraits (besides making the subject's hair look full and glamorous). The fan should be positioned on the ground, aiming upward at your subject, and once the fan is in place and turned on, there's not much else to do but shoot. If you get a huge, paying, fashion cover shot gig and you want to really impress your new clients, buy the only fan I've found that is made for shooting fashion—the Bowens Jet Stream 350 Wind Machine. With its 2500-rpm blast and a wireless remote, it'll be knocking your clients off their feet (and it should—it sells for around $1,465). B&H Photo has 'em in stock. What the heck—buy two!.

REDUCING GLARE IN GLASSES

If your subject wears glasses, seeing a reflection of the softboxes in their glasses is not uncommon, but you don't want such a strong reflection that it interferes with or covers their eyes. If that's the case, just move the main light to the side until the reflection goes away (it's easier than you'd think, because you'll see the modeling light reflecting in their glasses). However, what's important is that the glare is gone from the angle where your camera is set up, not from where you're moving the light. So this will go quicker if you have a friend or assistant move the light while you stand at the camera and tell them, "keep going…keep going…" until you see that the reflection is gone.

The Advantage of Shooting Tethered

You know that tiny LCD screen on the back of your camera? Yeah, that one. That little screen is what we use to make critical decisions about our photography (like "is this photo really tack sharp" or "are my subject's eyes both open"), but that screen (usually either 2.5" or 3" in size) is actually smaller than the screen on our smart phones. I know—crazy, right? No wonder we misjudge sharpness and quality so often—that screen is absolutely tiny. That's why, if I'm shooting in a studio, I shoot tethered directly into my computer, so that way I see each image really large (at least at 8x10" size on my laptop, or larger on my desktop monitor) right as I take it. At this larger size, you can really see what's going on in your photo (and how your lighting looks), and you can make adjustments based on a much larger-sized image, which makes it hard to look at that tiny 2.5" or 3" LCD display anymore. Tethering itself is actually very simple, just two steps: (1) Connect a USB cable from your camera's mini-USB port to your computer's USB port. (2) Now, you just need some tethering software. Luckily, Adobe's Photoshop Lightroom already has tethering built right in. If you don't have Lightroom and you're a Canon shooter, you already have the software you'll need—it's that EOS Utility software you got when you bought your camera (if you can't find it, you can download it for free from Canon's website). If you're a Nikon shooter on a Mac, go to www.sofortbildapp.com and download their excellent free tethering software. If you're a Nikon shooter on Windows, go to ControlMyNikon.com. If you're a Sony Alpha-series DLSR Shooter, you can use Sony's free Sony Camera Remote Control software.

Using a Gray Card to Nail Your Color

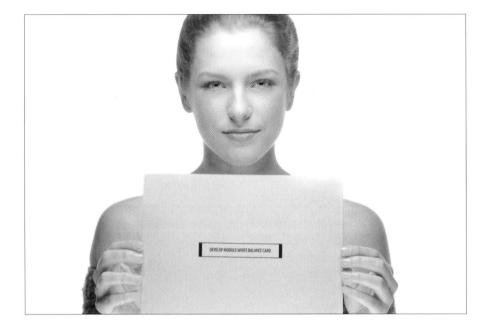

If you're going to be post-processing your images using a program like Photoshop's Camera Raw or Photoshop Lightroom, here's a trick that will make the color correction process absolutely painless, and nearly automatic. Once you get your lighting in place, have your subject hold up a gray card target that has light gray on it (the one shown here is a target that comes free with my book, *The Adobe Photoshop Lightroom Book for Digital Photographers*), then take a shot with it clearly in the frame. That's it—you need just one shot with the subject holding the card. Now, when you open your photos in Photoshop's Camera Raw or Lightroom's Develop module, and get the White Balance tool from the Toolbox (or the Basic panel), then click it once on the light gray card, your white balance is set. You can now apply that same white balance to all your RAW photos by copying-and-pasting just that white balance setting to as many photos as you want at once. A huge time saver.

THE MOST USEFUL INEXPENSIVE ACCESSORIES

Gaffer's tape and about six or so A-clamps. They should be in every studio. You can find them at your local hardware store (or go online), and you'll find a hundred uses for them.

Don't Light Your Whole Subject Evenly

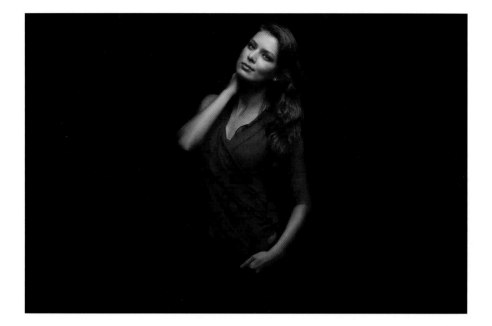

The first two things the human eye naturally focuses on in a photo are the brightest part and the sharpest part of the photo. Keep this in mind when you're shooting in the studio or on location (even with small off-camera flash), because if you light your entire subject evenly, you won't be directing your viewers to look where you want them to, which in most portraits is the subject's face. For a more professional look, you want their face to be perfectly lit, and then the light should fade away as it moves down their body. How much it fades away is up to you (it can fade to black if you want—your call), but when looking at your photo, it should be clear by the lighting where you want people viewing your image to look. One way you can control the light is to position it so it doesn't light all of your subject evenly, or to use a fabric grid, so the light doesn't spill everywhere, or even to use something to block the light from lighting the person's whole body evenly. I use a black flag (a 24x36" cloth flag) and position it under the light (usually on a boom stand), so the light is mostly concentrated on my subject's face. It doesn't have to block all of it—unless I want the person's body to fade to black—it just has to cut down the amount of light that falls on the rest of them.

💡 USING A MODELING LIGHT

Studios are generally pretty dark during shooting, but you can use your strobe's built-in modeling light, which is a fairly dim, continuous light that stays on between flashes, to let your camera's autofocus do its thing. Another advantage of using a modeling light is that it gives you an idea where your shadows are going to fall on your subject (it's not exact, but it does give you an idea).

How to Light a Couple or Small Group

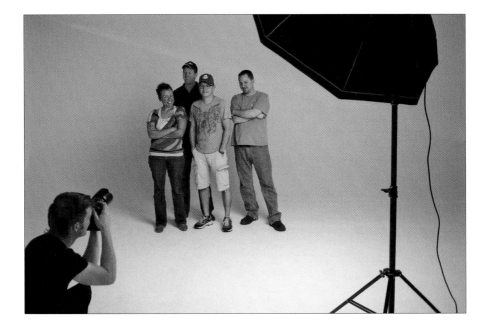

Lighting a couple or a small group is surprisingly easy, and you can do it with just one light and a large softbox, as long as you follow one simple rule: pull the light back fairly far from your subjects. If the light is too close, the person closest to the light will be brighter than the person standing next to them, and so on. Your goal is to have consistent, balanced light throughout the group, and the trick to that is to move your light way back. That way, the light pretty much hits the group at the same intensity, and the light looks balanced (just remember that moving the light farther away from your subjects makes the light darker, so crank up the power on your strobe to make up for that). Another helpful tip is to position the light fairly near the camera position (not way off to the side) or you'll have shadows casting across people in the group. You will want the light off to the side a bit, just not way off to the side. You can even position the softbox directly behind you as you shoot (if your head sticks up a little in front of it, don't sweat it), and that will do the trick, too. (*Note:* If you're thinking, "Hey, won't moving the softbox back farther make the subjects smaller in relation to the size of the softbox, so the light won't be as soft?" you're right, which is why you want to use a very large softbox for shooting groups. That way, when you move it far away, it's still big, so the light is still soft.)

💡 **LET YOUR MAIN LIGHT DO DOUBLE DUTY**

If you only have one light, you can have it pull double duty by having it light your background, as well. The trick is to move your main light close enough to the background so that it actually lights it for you.

Big, Beautiful, Wrapping Light

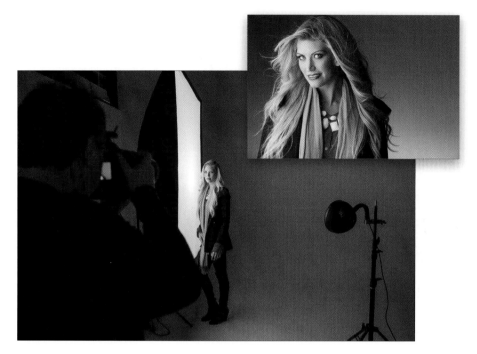

Here's a simple one-light setup using a 54x72" shallow softbox made by F.J. Westcott. As big as it is, it's only $350 and it creates some gorgeous light. Have your subject face forward, then put the light directly beside them and the light will literally wrap around them. Here, I had her face the light to really light up her hair, but they can face mostly toward the camera. In the studio, I usually choose f/11 because, for portraits, it's an f-stop that keeps everything perfectly in focus from front to back. But, I actually shot this at f/10 and that one f-stop doesn't make that big a difference. At f/11, I thought the lighting looked a little too dark. I could have cranked up the power on the light, but it was just easier (lazier) to lower the f-stop one stop and then the light looked much brighter. I was using my go-to lens: the 70–200mm f/2.8, and I was zoomed in to 100mm. My shutter speed was 1/100 of a second (I probably accidentally moved the dial during the shoot—it would normally be at 1/125 of a second). My ISO was 100. If I could tell you one hands-down, killer secret to getting really beautiful light, it would be to buy a really, really big softbox. The bigger the softbox, the more beautiful and wrapping the light, One posing tip: to help the light wrap around your subject, have them "play" a little toward the light (in other words, don't have them position their body so they are facing away from it—face them either straight ahead or aimed a little bit in the direction of the light). Also remember, whatever is closest to the softbox will be brightest (notice her arm on the left here). Just your standard portrait retouching stuff: removing minor blemishes, spots, or specks on her clothes, and brightening the existing highlights in her hair using the Adjustment Brush in Lightroom's Develop module (or Camera Raw). If you want really soft, creamy, luxurious, beautiful, wrapping light, get your hands on a really huge softbox, and the rest will take care of itself. Couple the size (bigger means softer) with getting your subject very close to the softbox (which makes it even softer), and you've got a tough combination to beat.

Edgy Lighting for Athletes

There are three lights here, in this easy setup. The two lights behind him have 1x3' strip bank softboxes (pretty inexpensive at around $150 each), with an egg crate fabric grid Velcroed over the front to focus the beam of light, so it's more direct and doesn't spill over much. Turn off all your lights and then turn on one of the strip banks and aim it at an angle toward your subject. Since there are no lights on in front, it should look like a bright rim light outlining his body. Turn on the second strip bank, and it should look the same, but lighting the other side. Try getting both sides looking even in height and power output. Lastly, turn on the front light. Here, it's a beauty dish with a metal grid, but a small softbox will do, too. Put it right in front of your subject, up high and aiming back at him at a 45° angle. Want the background solid white? Aim another light at the background with a metal reflector on it (here, there's one on each side, behind the backlights) and turn the power up until the background looks solid white. I'm using flash, so I'm in manual mode on my camera. I'm using the 70–200mm f/2.8 at 70mm, I'm at f/11, 100 ISO, and 1/125 of a second. I'm not really big on black-and-white images, but I knew I was going to create one when I made this image, because I love how things like muscles and tattoos look in black and white, especially when it's really contrasty. **TIP:** If you have a very muscular subject, have them apply some body oil to help add a shine to their skin that really looks great (have some on hand before they arrive). Applying body oil is pretty common for body builders, especially in competition, so they won't be shocked if you ask. Even if I plan to create a B&W, I always shoot in color and then use a plug-in to convert to B&W. I use Silver Efex Pro from Google's Nik Collection. Just open your image into it (it works with Lightroom, Photoshop, and Elements), and click on the preset you like. I also add a lot of sharpening in Photoshop to give the image a really sharp, crisp look (Unsharp Mask setting: Amount 90, Radius 1.5, Threshold 0. If it's too much, try: Amount 120, Radius 1.0, Threshold 3).

Hurley-Look Headshot Lighting

This is a three-light shoot, but it's a really easy one. There are two lights on the subject: two 1x3' strip banks, one on either side of him. The third light is on a short light stand directly behind him, aiming up at the background. I'm using flash, so I'm in manual mode on my camera. I'm using my go-to lens (the 70–200mm f/2.8) at 130mm, at my ideal studio f-stop (f/11), my lowest, cleanest ISO (100 ISO), and my standard shutter speed of 1/125 of a second. Headshot photographer Peter Hurley—who inspired this lighting look—uses continuous lights for his front lights, rather than strobes (he uses strobes on his background), but those are very expensive (strobes are a cheaper alternative). He places four lights to create a window, but here, I'm only using two lights. His trademark square-of-light look produces a nice, flat, flattering light, but at the same time it's bright and punchy—a wonderful combination for headshots. But, what Peter is famous for isn't just his simple lighting look, it's how he works with his subjects to get natural expressions and flattering poses. Our lighting setup here is designed to get close to his look without spending a lot. If you want to learn more about Peter's lighting setup and his tricks for getting the most out of his subjects, check out his book, *The Headshot* (published by Peachpit Press, and edited and produced by yours truly). Even though I was involved in producing the book, I can tell you without reservation, it rocks (and I learned a lot during the process. The guy's a genius). For post-processing here, it's just your standard portrait retouching stuff.

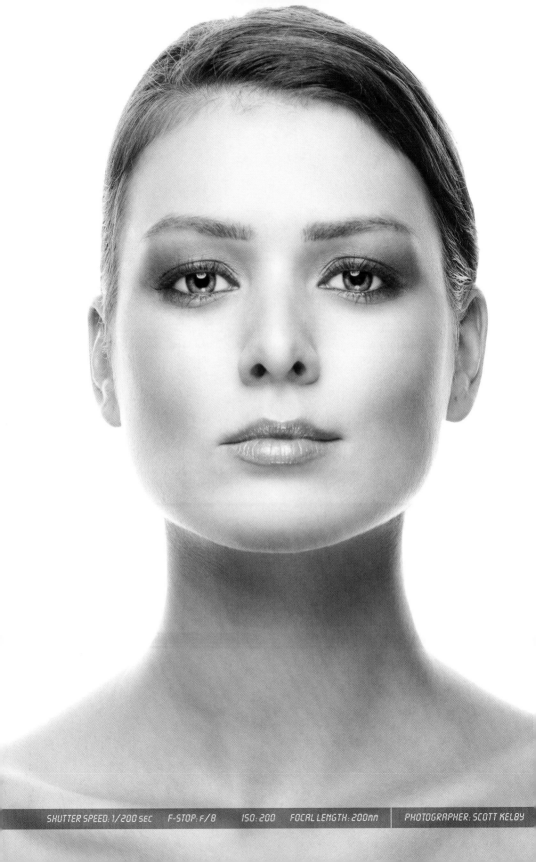

Chapter Five

Shooting Portraits Like a Pro

Tips to Make People Look Their Very Best

Getting professional-looking shots of people is harder than you might think, for one simple reason: the pros hire really good-looking models, and as you know, models are models for one simple reason—they forget to eat. I'm joking, of course. They're models because they photograph really, really well. So, what makes our job so hard is that we're not surrounded by fabulous-looking models who just happen to be standing around not eating. Nope, we usually wind up shooting portraits of our friends, many of whom (on a looks scale) fall somewhere between Mr. Bean and Jabba the Hut. This is why our job, as portrait photographers, is actually substantially more challenging than that of a seasoned professional—we've got to make magic from some seriously un-model-like people. This is precisely why we're often so disappointed with our portraits (when it's really not our fault). So, in this chapter, we'll look at two proven strategies to get better, more professional-looking portraits every time, including: (1) how to make friends with better-looking people (it helps if you're rich), and (2) learning to control your light and pose your subjects so that no one gets a really good look at them. The key to this is to use dramatic light, and by "dramatic light" I mean—virtually none at all. The less you light these "un-model-like" subjects, the better your final images will be. In fact, think silhouette or long distance night photography, where your subjects are 100 to 200 yards away—anybody looks good from that distance (that's why long distance relationships work so well). Anyway, what this chapter will give you is a strategy for photographing people, and a list of places where good-looking people hang out and wear jeans that cost more than the gross national product of Luxembourg.

What Not to Shoot with Your 50mm Lens

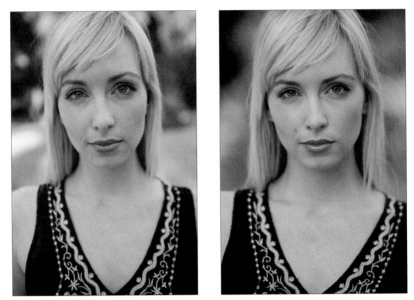

50mm *200mm*

Don't shoot portraits of women. Well, certainly not close-up portraits anyway, and for one simple reason—it's just not flattering. When you shoot people with a 50mm lens up close, they generally look a bit distorted and that's the last thing you want in a portrait. That's why you see the pros shooting with longer lenses so often (I usually shoot with a 70–200mm lens out around the 150mm to 200mm end of the lens most of the time). These longer lengths create a compression that's very flattering in portraits, so people just plain look better (and why wouldn't you want your subjects to look better?). Now, can you shoot a full-length bridal portrait from the back of the room with a 50mm lens? Sure. Can you shoot group shots with a 50mm? Absolutely. Should you shoot a close-up head shot? Only if you don't care about working for that client again, because they're not going to be happy with the results. The 50mm is great for some instances, but when it comes to shooting portraits of women, almost any longer lens would probably be a better choice. By the way, I didn't need to mention the whole "don't shoot portraits of women with a fisheye lens," did I? (Kidding. I hope.)

💡 THE BEST LENS FOR PORTRAIT PHOTOGRAPHY

With portrait photography, there's kind of a focal length "sweet spot" that pros generally choose, and that's anywhere between 85mm and 105mm. At lengths 85mm and over, these lenses provide a really flattering perspective and compression that makes people look great (by the way, you can go farther than 105mm).

Which Aperture to Use

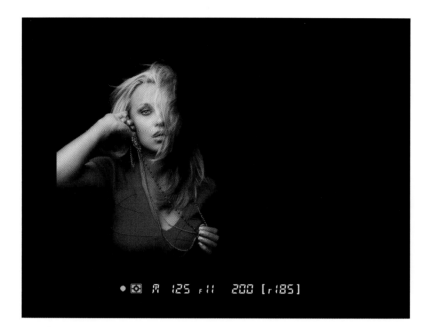

One thing I love about portrait photography is that a lot of the decisions are made for you (like which lens/focal length to use), so you can focus on the harder parts of portrait photography—ensuring that you have great light and capturing the personality of your subject. So, now that you know which lens to use, believe it or not (and this is very rare), there is a special aperture (f-stop) that seems to work best for most portrait photography. When it comes to portraits, f/11 is the ticket because it provides great sharpness and depth on the face (and isn't that what portraits are all about?), which gives you a great overall look for most portrait photography (now, I say "most" because there are some artistic reasons why you might want to try a different aperture if you're trying to get a special effect, but for the most part you can choose aperture priority mode, set your aperture at f/11, and then worry about the really important stuff—the lighting, capturing your subject's personality, how much to bill your client, etc.). Okay, as always, there's an exception to every rule, so see the tip below and the next page for when f/11 wouldn't be your first choice.

THE RIGHT BACKGROUND OUTDOORS

The background rule for shooting portraits outdoors is to keep the background as simple as possible, so position your subject where the least possible amount of activity is going on behind them. Here's where you might want to break the f/11 rule, so you can throw the background out of focus by using an aperture like f/2.8 or f/4 with the portrait focal length you like best.

Getting Shallow Depth of Field with Studio Strobes

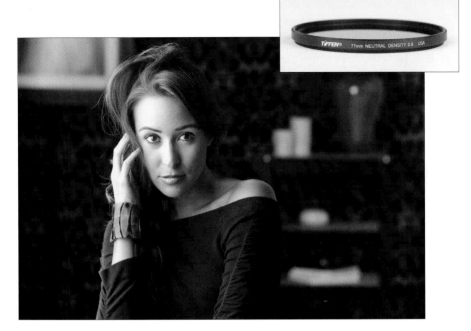

Generally, in the studio, everything's in focus (our subject, the background, you name it), because even at your strobe's lowest power setting, you still probably have to shoot at around f/8 to f/11, and that's great for most of the portraits you'll be shooting. But, what if you've built a set in the background, or you're using a scenic backdrop, or textured background, and you want it to be blurry and out-of-focus? You can't switch your f-stop to f/2.8 or f/4, because your shot would be way overexposed. So, what's the trick to getting soft, blurry backgrounds in the studio? It's using a filter that we would normally use outdoors to shoot waterfalls and streams—a neutral density filter (called an "ND filter"). This filter is totally see-through, but really dark, and basically it makes what your lens sees much darker. So dark that, to get a proper exposure, you actually have to lower the f-stop to around f/4 or f/2.8 (pretty tricky, eh?). You'll want to use either a 3- or 4-stop filter (these are made by B+W, Hoya, and Tiffen [shown above], among others) and they screw right onto the end of your lens (make sure you order one that fits your particular lens). That's it—pop the ND filter on your lens, and you're set to shoot at wide-open f-stops like f/2.8 or f/4.

🔅 USING CANVAS OR MUSLIN BACKGROUNDS

Canvas or muslin backgrounds are inexpensive enough that you should consider using one as a formal background. They're seamless and add texture to your photo without distracting from the subject. I'd recommend buying one (at least to start) that's kind of neutral—just make sure your background is no brighter than your subject.

What Height to Position Your Camera and Subject

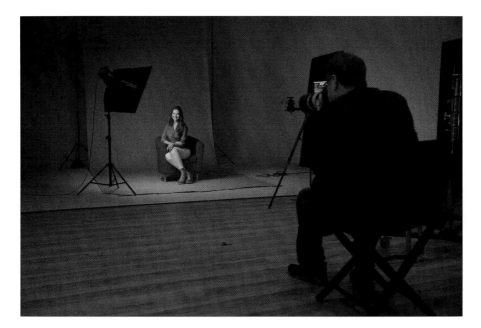

Portraits generally look best when you position your camera at the subject's eye level, so set your tripod up so you're shooting level with their eyes. Now, how far back should you position your tripod from your subject? Your focal length will dictate that for you, but if you're about 6 to10 feet from your subject, depending on your lens, you're in good shape. To get the right look and perspective in full-length shots, the trick is to shoot them from a really low perspective—either lying down or sitting on the ground in a cross-legged position. This makes your subject's legs look longer, makes them look taller and thinner, and even changes how the lighting looks on the background. If you're shooting portraits, especially candid portraits or editorial style shots, there's a rule that many pros use about where to position the subject's eyes in the frame—position them 1/3 of the way down from the top of the frame. This trick gives your portraits more visual interest, and it's easy to do when composing the shot. Another tip for great portrait shots is: try zooming in close so your subject's face nearly fills the entire frame. Also, try zooming in close enough so that either the top of their hair, or even the top of their head, gets cut off and extends outside of the frame. This is a very popular look in professional headshots, and you see it all the time in magazines, in ads, and on the web, so don't be afraid to cut off their hair or the top of their head—it can make for a more dynamic portrait.

> 💡 **THE ADVANTAGE OF HAVING YOUR SUBJECT SIT**
>
> If your subject feels awkward or uncomfortable when standing, have them sit (try a posing stool). Although you'll have to shoot from a lower position, most people are more comfortable sitting vs. standing.

A Better Way to Direct Your Subject's Posing

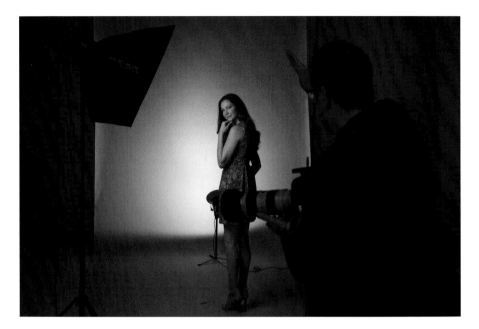

I've spent so many years shooting portraits and telling my subjects things like, "Move to your left a bit. No, my left. The other left. Uggh!" This stinks because your subject feels dumb for moving the wrong direction, you get frustrated because you just moved them the wrong direction, and the whole thing just doesn't have to happen if you use this great trick I learned from my buddy Jack Reznicki: stop giving them left/right directions. That's right, instead, just hold your hand up in front of you (as shown above) and then move your hand in the direction you want them to go, and by golly, they'll follow right along like a trained seal (so to speak). You can use this hand technique to move them forward, backward, to tilt their head one way or the other (no more "Tilt your head to the left. No, my left"), and so on. Another tip from Jack that I use is to write your subject's name on a piece of white gaffer's tape and put it on the back of your camera. That way, it's always right there in front of you, and you can always refer to your subject by name

> ### 💡 GET EVERYTHING SET BEFORE THEY ARRIVE
>
> If you're doing a studio shoot, keep your subject as comfortable and relaxed as possible by not keeping them waiting around—have everything set up, tested, and ready when they get there. Otherwise, you'll not only look unprofessional to your subject, they'll be uncomfortable sitting there and not posing while you're testing everything.

Avoid Seeing Too Much "Whites of the Eyes"

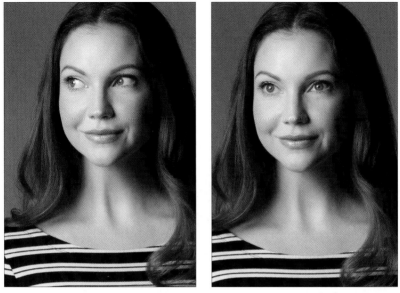

Bad Good

One thing that ruins a lot of portraits where the subject isn't looking straight at the camera is when you see too much of the whites of the eyes. Luckily, once you're aware of the problem, there's a pretty easy fix: have them look just to the left (or right) of your camera position. I usually hold my hand all the way out to the side and tell my subject to look right where my hand is. If they stay looking right there, you'll see plenty of their iris and you won't have that creepy looking "white eye" effect. Now, for larger, more flattering eyes: have your subject keep her chin down just a little bit. This puts a little extra "white" under the irises, and makes her eyes look bigger and better.

 ONLY PHOTOGRAPHERS CARE ABOUT THE CHARACTERISTICS OF CATCH LIGHTS

Catch lights are white reflections of the light source that appear in your subject's eyes. They're important because they add life and sparkle to the eyes—without them the eyes kind of look dead. However, the only people that ever notice or care about the shape, size, or position of catch lights (or reflections in your subject's sunglasses) are other photographers.

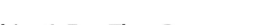
Focus on the Subject's Eye, Then Recompose

If you want to absolutely nail the focus when you're shooting portraits, then your subject's eye needs to be in super-sharp focus. If the eye isn't in focus, the rest doesn't matter. By the way, when I say "eye," I mean the eye closest to the camera (of course, if they're standing there with their shoulders and head facing directly toward the camera, both of their eyes should be the same distance from the camera. If not, they have an entirely different problem that's not going to be fixed with a camera). Anyway, here's the technique I use: (1) Aim the focus point on your LCD (usually a red dot or a red rectangle) directly at the eye closest to the camera (again, if their shoulders are square, straight toward the camera, just pick an eye), then (2) press the shutter button halfway down to "lock the focus" on their eye. Lastly, (3) with that shutter button still held halfway down, recompose the shot any way you'd like. Now, when you actually press the shutter button all the way to take the shot, your focus will be right on the money.

💡 THAT WORKS UNLESS YOU'RE SHOOTING AT F/1.4

The "lock focus and recompose" tip works for almost every situation, with one exception: when you're shooting a portrait with your f-stop set to f/1.4, or maybe even f/1.8, because the depth of field is so incredibly shallow that the recomposing part can actually put the eye a little bit out of focus. Instead, compose the shot the way you want it first, then manually move the focus point over the person's eye using the multi-selector (or multi-controller) on the back of your camera. A big thanks to Cliff Mautner for this tip.

Don't Shoot Down on Kids

©DOLLARPHOTOCLUB/JOLOPES

If you're unhappy with your shots of kids, it may be because you're shooting them like most people do—from a standing position, so basically you're shooting down at them. The problem with this is that, on an average day, that's how we see most children, with us in a standing position looking down at them, and if we photograph them from the same viewpoint, that's how the photos are going to look—average. The trick is to shoot from their level—get down on one knee, or sit (or even lay) on the floor, to capture them from a viewpoint we normally don't see, which honestly changes everything. It's one of the easiest things you can do that will have the greatest impact on your images. And don't forget the props. If they seem intimidated and shy in front of the camera, make it fun by using the same trick you can use with adults, give them a prop—an interesting or unusual toy or stuffed animal—to get their mind off the camera and on the fun.

GET OUT FROM BEHIND THE CAMERA FOR KIDS

I learned a great trick from Jack Reznicki: when shooting children, put the camera in position on a tripod, then use a wireless shutter release so you can interact with the child, and focus on getting reactions and emotions that are usually so hard to create when your head is buried in the back of a camera. If family members are on the set, choose one person to be the "attention getter," and have them stand behind and to one side of the camera.

Taking Great Photos of Newborn Babies

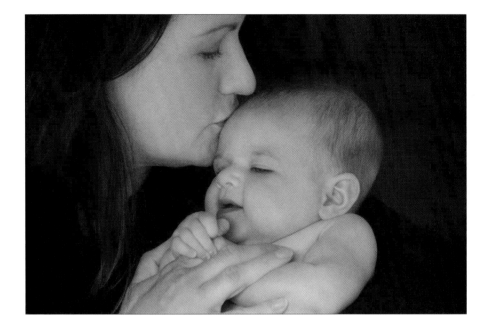

You've probably heard how hard it is to photograph babies. That may be true, but newborn babies usually have a distinct advantage—they're asleep. That's right, newborns spend most of their days sleeping, so getting great shots of them is easier than you'd think, but you have to put them in the right setting or everyone who looks at the photos will say something like, "Aw, too bad she was asleep." Generally, people like babies to be wide awake and smiling in photos, but there's a popular brand of newborn photography where the baby and mom (or dad) are sharing a quiet moment, and it really sets the stage for a touching portrait. I saw this first-hand when David Ziser (the world-class wedding and portrait photographer) spent one evening photographing my newborn daughter, Kira. Now, David had a huge advantage because my daughter just happened to be the cutest little baby in the whole wide world, but he did stack the deck in his favor with a simple, but extremely effective, technique—he had my wife and I both wear long-sleeved black turtleneck shirts. Then, he photographed Kira as my wife held her in her arms (I took a turn, as well). He shot very tight (zoomed in), so what you basically got was a sweet little baby resting peacefully in her mother's (and father's) arms. You can use a diffused flash , or you can use soft natural light from a side window.

💡 BETTER THAN A SELF-TIMER FOR GROUP SHOTS

If you're taking a group shot and you need to be in the shot, use an interval timer (also called an intervalometer), which makes your camera automatically take a series of shots at the time interval you choose. Some Nikons have this feature built in, but you can buy an accessory that plugs into your camera's remote shutter release port that will do it for you.

For Better Light Outdoors, Shoot in Shade

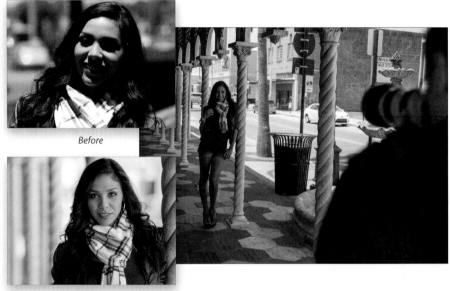

Before

After

The small photo in the top left is how the light looks on our subject when she's standing a few feet to the right, in direct sunlight. Note the harsh shadows, shiny skin and hot spots, and shadows filling her eye sockets—it's not flattering light. In the larger shot, she moved a few feet to her left so she's standing under a roof awning that blocks the harsh sun. For natural light shots, I generally want the background out of focus (to help separate the subject from the background), so I try to shoot at the lowest-numbered f-stop my lens will allow (f/2.8 , in this case). But, you'll also need to zoom in tight. So, I moved back from my subject (with a 70–200mm f/2.8 lens on my camera) and zoomed in to 130mm. These two things together (f-stop and zooming in) give us that separation and nice soft background you see in the final image (at the bottom left). Since f/2.8 lets in the most light, I was able to use my cleanest, lowest ISO (100 ISO) and still get a shutter speed of 1/320 of a second. So, I could handhold the shot and still have it nice and sharp. I think a lot of photographers confuse "natural light" with beautiful light, but they are two different things. Natural light usually refers to light coming from the sun, which is the harshest light source in the universe most times of the day. What makes it beautiful is when something is spreading and diffusing (softening) that natural light. Our job is to find that diffused, non-direct sunlight. Having the subject stand in the shade is a quick and easy way to use natural light, and since they're in the shade, the light's not harsh—it's soft and flattering. Ideally, you'll put your subject near the edge of the shade. That's where the light will generally be its softest and prettiest (under the shaded area, get as close as you can to the direct sun without any of it actually hitting your subject). So, why didn't I position her to the right more to get her closer to the edge of the shade? Because I wanted that row of columns to appear behind her. For post-processing, there's not much beyond the standard portrait retouching stuff (removing minor blemishes, softening her skin a tiny bit, brightening her eyes a tiny bit, etc.).

Diffusing a Larger Area

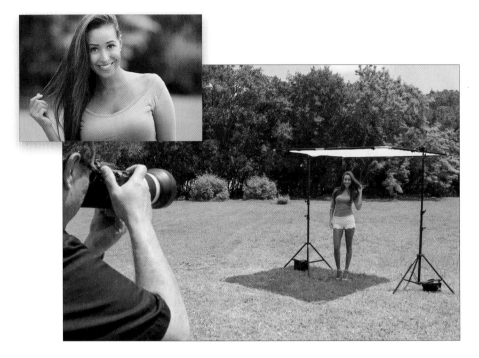

Here, we're in a big empty lot, and we've put up a large diffuser to soften and spread the harsh "high noon" sunlight overhead. This is a 6.6x6.6' Lastolite Large Standard Skylite Rapid Kit, which comes with a 1.25-stop diffusion panel (it's around $370). Plus, you'll need two light stands to support it, and two Lastolite swivel grip heads to angle the diffuser toward the sun. Those swivels run around $48 each. Also note the two sandbags—one on each light stand. Those are very important. Without them, the whole thing can crash over with a small gust of wind. Now, if you're thinking this is getting kinda expensive (you're into about $500 or so at this point), just remember that this rig is less expensive than nearly any lens you might want to buy, and will probably have a bigger impact on how your outdoor portraits look than any $500 lens, so it's worth considering. A handheld diffuser is great for headshots, but if you need to cover more of your subject (or if you have a couple or a small group), then you'd go to a bigger diffusion panel (a.k.a. scrim) like this. With something this big, you could easily do a 2/3-length shot or even full-length. Notice the quality of the light here—we're in the middle of a vacant lot, at literally high noon, and the quality of light underneath this diffuser is just beautiful. The diffuser and frame are very lightweight. It all fits in a small travel case (it's made for location shoots) and takes a few minutes to put together. This was taken with a 70–200mm f/2.8 lens zoomed in to 135mm. My f-stop is f/2.8 and my shutter speed is 1/1250 of a second at 160 ISO. Once again, the post-processing was the standard portrait retouching stuff and darkening the edges using the Lightroom Develop module's (or Camera Raw's) Post Crop Vignetting Amount slider in the Effects panel. Just drag it to –11 and you're done.

Shooting in Direct Sun

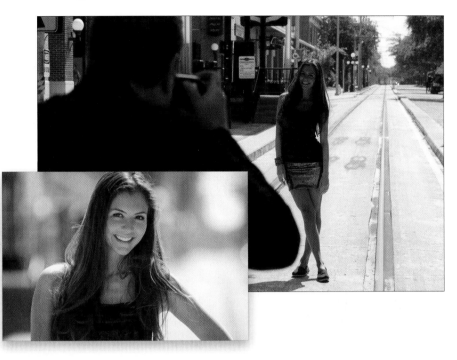

We're shooting in pretty much the harshest sunlight you can imagine and we're standing in the middle of a street along some trolley tracks (I'm trying to avoid seeing parked cars). I positioned my subject with her back to the sun, which almost creates a silhouette, but we'll address that with our camera settings. This is a really handy technique (learned from renowned wedding photographer Cliff Mautner) because there's not always shade around, and you don't always have a way to soften and diffuse the light. With it, you can shoot in direct sunlight and still have soft, beautiful light on your subject. Start by putting your subject's back to the sun, which creates a nice rim light coming through their hair and along the edges of their shoulders, arms, etc. With the sun behind them, the side of their face facing the camera is dark because it's essentially in the shade. So, the trick is to overexpose the image by around one full f-stop, so they're not in the shadows anymore. If you shoot natural light portraits in aperture priority mode, then you can use exposure compensation to overexpose the image. If you shoot in manual mode, you'd just set your proper exposure, then choose the next brightest full f-stop. My f-stop here is my standard natural light f-stop of f/2.8 and I zoomed in all the way to 200mm with my 70–200mm f/2.8 lens, creating the out-of-focus background behind her. My shutter speed is 1/1000 of a second, and I'm at 400 ISO. My post-processing was just standard portrait retouching stuff.

💡 GET A MODEL RELEASE

If you're shooting a subject for any commercial use make sure you get a signed model release from them. This gives you the right to use their likeness in commercial projects or to resell their images for use in stock photography.

Beautiful Backlit Shots

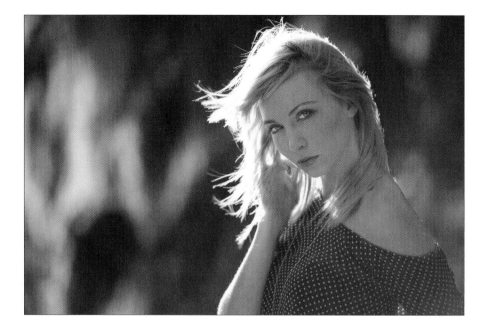

If you want to add visual interest to your outdoor shots, look for backlight opportunities, especially when shooting people. Backlit images bring a drama and dimension you don't often see. First, position your subject so the sun is directly behind them, with no light falling on their face, so they look like a silhouette. Then, switch your camera's metering mode to Spot Metering, and aim your focus point on your subject's face. This tells the camera, "This is the most important thing in the photo—make sure it's properly exposed." Now, when you take the photo, it will make your subject's face much brighter. The rest of the photo will get brighter, too, but in most cases that's okay, because what's behind your subject is the sun (which is usually pretty bright anyway). If you're shooting in aperture priority mode (which is what I shoot in outdoors in natural light) and you think the entire photo is too bright, back it off by using exposure compensation. On a Nikon, hold down the exposure compensation (+/–) button on the top, and move the command dial on the back to the right to either –0.3 or –0.7 (in the top control panel), and then take another shot. On a Canon, turn the power switch to the top position (above On), look at the LCD panel on top, then use the quick control dial on the back to override the exposure either –0.3 or –0.7, and take the shot.

💡 **IF THEY LOOK UNCOMFORTABLE, HAND THEM A PROP**

One thing that makes people uncomfortable in front of the camera is that they don't know what to do with their hands. If that's the case with your subject, give them something to hold (like a prop), and their comfort level will instantly go up, which translates to more natural-looking photos. If you can give them a prop that they can relate to, all the better.

Better Natural-Light Portraits with a Reflector

Sunlight isn't always where you'd like it when you're shooting a portrait, so you use a reflector to bounce some of that sunlight over onto your subject, right where you need it. Reflectors are great because: (1) They're cheap. I use a Westcott 30" 5-in-1 circular collapsible reflector (it has gold, silver, white, black, and a translucent light diffuser [for shooting in harsh direct light—you put it between the sun and your subject to soften and diffuse the light]) and they sell for around $30. (2) They're collapsible and fold into a small, flat circle. (3) They're very lightweight, so they're easy to take with you just about anywhere. (4) They can provide fill light (like when your subjects are backlit [their backs are to the sun], so they're virtually a silhouette—you can bounce some of that sunlight back onto them almost like you're using a light), or when you just want to fill in some dark shadows on one side of your subject's face. The white side of the reflector is the most subtle (and doesn't wind up blinding your subject or, at the very least, making them squint). The silver side is usually used inside a studio or when you need really "punchy" reflected light outdoors (it reflects a lot more light than the white side). The gold side is only for outdoor portraits and works best later in the day because the light it reflects is a very warm sunset-like gold If you're just trying to fill in some shadows, hold it down low and bounce the sunlight from above back onto their subject. But, if your reflector is providing most of the light (your subject is in the shade), the person holding your reflector will need to hold it up high and bounce the light back onto your subject from up there, which is definitely more flattering. Have them slowly tip it down until you see it starting to light your subject's face (ideally, you'd like it aiming down at your subject at a 45° angle). When it looks good, have them hold it there while you make the shot.

Direct, Contrasty Window Light

Our subject is standing directly in front of a large glass window, so there's nothing there to soften or diffuse the light. The sun is pretty high in the sky (it's around 4:00 p.m.) and the bright sunlight is coming through the window at an angle. I had my subject stand very close to the window because, for this look (which I would generally use with men), I want very sharp, contrasty light (putting him right near the window is the opposite of what I would do if I was shooting a woman and wanted soft, diffused light). So, that's it: direct light streaming in from a tall window. No diffusion—no nuthin'—just direct light. If you look directly behind our subject, you'll see my black laptop bag taped to the wall with gaffer's tape to cover the lighter beige wall in the gap between the two black tubes on the wall. It's not pretty, but it worked. Also, having your subject wear a dark-colored shirt makes this look easier. I used a 70–200mm f/2.8 lens, zoomed in to 95mm, with my f-stop at f/4.5. There is plenty of light in the room, so to create this dark, dramatic look, I shot in aperture priority mode, using exposure compensation to darken the scene by 1.7 stops. Even though you're darkening the room around him, his face will still be brightly lit by the direct sunlight. I don't shoot a lot of black and white, but I knew that I was going to convert this to black and white for the added drama. You might be wondering how I got away with using harsh, direct sunlight. It's because I was intentionally going for a really contrasty look. This contrasty light (and the post-processing) accentuates his skin texture and facial hair, and brings out detail. For men, that usually looks terrific. In Lightroom's Develop module (or Camera Raw), I dragged the Contrast slider to the right quite a ways, then used a plug-in called Silver Efex Pro, which is part of the Google Nik Collection. Just click on the preset thumbnail that looks best, and then click OK. (By the way, the preset that usually looks the best is High Structure [Harsh].) The final step was to add a lot of sharpening, using Photoshop's Unsharp Mask filter.

Softening Window Light

Here, our subject is standing directly in front of a large window, which should make a beautiful shot, except for one thing: window light, by nature, is not soft and beautiful. Sometimes it is, but it depends on the window's location, the time of day, and the angle and position of the sun, because it can be some of the harshest, nastiest light you've ever seen. That's why we keep a frosted vinyl shower curtain liner with us (literally, just $1.99 at Walmart) to tape up over a window (using gaffer's tape we bought from B&H Photo—it comes off surfaces without leaving any sticky residue, or peeling off paint or finishes, or doing any harm whatsoever. It's amazing stuff. Around $6 a roll). My shooting position is directly to her left along the wall. If you want just really soft, wonderful, wrapping light from a window, this trick turns that window into a giant softbox, and the diffused light that comes through is just absolutely gorgeous. You could get a little softer light by having her take a few steps back from the window. Just know that will lower the amount of light, so you'd probably have to bump up the ISO a bit more, because we're already at our lowest possible f-stop. I used my 70–200mm f/2.8 lens, at f/2.8 to put the background out of focus, but as you can see, it's only a little bit out of focus. Why only a little bit? Wouldn't f/2.8 make it really out of focus? Well, it would if I could zoom in tighter, but to get more of her in the frame than just her head and shoulders, I had to zoom out to 70mm. I couldn't move farther back because the room wasn't that deep. By the way, when you add this frosty diffuser in front of the window, it softens the light big time, but it also cuts the amount of light. So, I had to increase my ISO to 800 to get my shutter speed above my 1/60-of-a-second-minimum handholding rule. Post-processing was the standard retouching stuff. Also, I used Photoshop's Content-Aware Fill feature to get rid of the edges of two framed pictures you could see on the wall behind her to the far right. I made a short video for you on how Content-Aware Fill works. You can find it on the book's companion webpage (mentioned in the book's introduction).

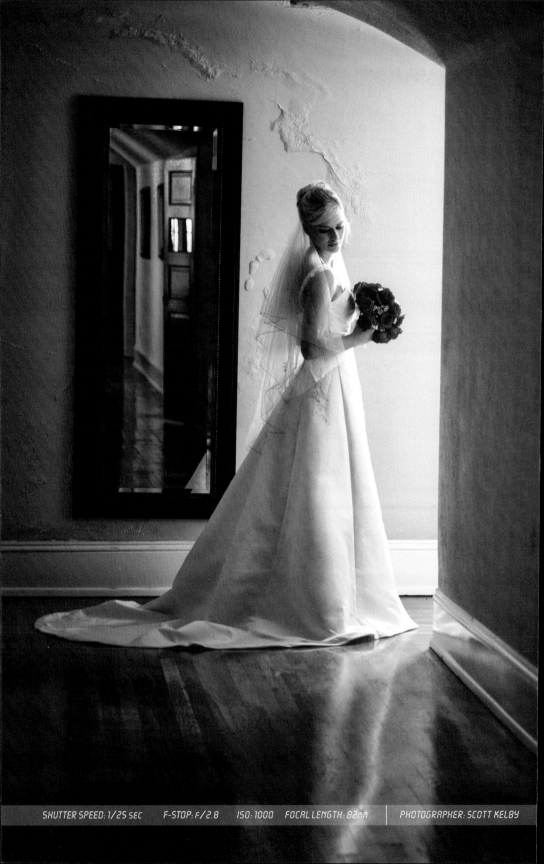

SHUTTER SPEED: 1/25 SEC F-STOP: F/2.8 ISO: 1000 FOCAL LENGTH: 82mm | PHOTOGRAPHER: SCOTT KELBY

Chapter Six

Shooting Weddings Like a Pro

How to Get Professional Results from Your Next Shoot

Shooting a wedding is tricky business, and if you have friends (and they know you have a nice camera), it's only a matter of time before you're standing in a church yelling things like, "Okay, next I need the groom's grandmother and grandfather." Once you've said that line aloud in a church, you are officially ordained as a temporary wedding photographer. Now, just because you took the gig for free, as a favor to that guy you know over in accounting, don't think for a minute that the bride is expecting anything less than absolute pro-quality images. Worse yet, the nicer gear you have, the better they expect those images to be, and if, up until this day, you've been a sports shooter or a landscape photographer, all that goes out the window, because today you are a wedding photographer, which is arguably the single hardest photography job in the known world. The reason is simple: there is no reshoot. This particular wedding, the one you are responsible for shooting, only happens once. There is no, "Oh, my camera broke" or "I didn't bring enough memory cards" or "I forgot my charger for my flash," because if the bride hears anything even approaching one of those excuses, she will take her bare hands and squeeze your neck until either your lifeless body falls to the floor like a wet bag of cement, or a pack of AAA alkaline batteries pops out of you like a Pez dispenser. That's because regardless of whether you're getting paid or not, she has waited, dreamed about, meticulously planned, agonized over, and micro-managed this special day to death, and if you miss any one of those critical moments (the ring, kissing the bride, walking down the aisle as man and wife for the first time, cutting the cake, the first dance, etc.), then it's time for you to die. That's why this chapter is all about one thing: increasing your life expectancy.

Create a Shot List

Wedding Photography Shots Before the Ce...

____ Wedding dress lying over a chair
____ Zipping up or buttoning the wedding dress
____ Mother of the bride fastening the bride's necklace
____ The bride's garter
____ The bride's veil
____ A close up of the bride's shoes peeking out from under the dress
____ Bride looking into a mirror
____ Bride looking out window
____ Bride and bridesmaids putting on makeup
____ Bride pinning corsage/boutonniere on mother/father
____ Bride hugging parents
____ Bride touching up
____ Bride and parents leaving for ceremony
____ Groom tying tie
____ Groom looking into mirror
____ Groom looking out window
____ Groom pinning corsage/boutonniere on mother/father
____ Groom hugging parents
____ Bride and parents leaving for ceremony

Wedding Photography Shots At the Ceremony

____ Outside of ceremony site
____ Guests walking into ceremony site
____ ...nd father entering ceremony site

Before you even leave to head to the wedding, you should put together a shot list of photos you'll need to take for the wedding album, prints, etc. There are no redos at weddings, so you'd better be sure you leave with a list in hand of which shots you need, from bride and groom formals, to detail shots (the invitations, the rings, the bouquet, the bride's shoes, etc.), to reception shots like cutting the cake, receiving lines, place cards, and more. Without a written shot list, you're winging it, and it's almost an absolute lock that you'll miss one or more critical shots that your clients (the bride and groom) are going to expect to be in their album, so don't take a chance—this little bit of preparation can make a world of difference. Luckily, you can find wedding photography shot lists online for free at places like http://bit.ly/aboutshotlist (actually, there are literally hundreds of different shot lists available for downloading—just Google "wedding shot list" and you'll have a wide range of choices). Find a shot list that makes sense to you, and although you can get creative and do far beyond what it suggests, at least you'll have the most critical shots covered. Also, make sure you talk to the bride and groom before you finalize your shot list to ensure the specific shots they want are included (they may want shots with old friends from high school or college, or a special relative, and the only way to find out about these is to talk with the bride and groom in advance).

💡 **HAVE BACKUPS FOR EVERYTHING!**

Always take backups for everything. At the very minimum you need to have two camera bodies, backup batteries for your flash, a backup flash unit, extra memory cards, a backup lens, and backup batteries for both cameras.

Tricks for Low-Light Shooting in a Church, Part 1

While you should use a tripod when shooting the formals, when shooting the ceremony in a low-light situation, you'll probably need to handhold. This is a problem because handholding in low-light situations is almost a guarantee of having blurry photos—when there's low lighting, your camera compensates for it by slowing down the shutter speed to take in more light so it can make a proper exposure. So, your exposure will still be right, but chances are your photos will wind up being blurry because the shutter speed isn't fast enough. Any tiny little movement on your part equals blurry photos. So, how do the pros get crisp low-light shots in a setting like a church? One thing they do is increase their ISO setting, which raises the shutter speed (you generally need a shutter speed of at least 1/60 of a second for non-blurry photos). Luckily, today's DSLRs let you shoot at high ISOs with little visible noise. So, how high can you go? At least ISO 800, but you can usually get away with as high as ISO 1600 in most situations (or more, depending on your camera model). So, now that you know what to do, here's how to do it: Aim at the low-light scene you want shoot, press your shutter button halfway down, and look in your viewfinder to see what your shutter speed will be. If it's slower than 1/60 of a second, you're going to need to crank up the ISO until you see your shutter speed hit at least 1/60 of a second or faster (then hold your camera very steady).

💡 SILENCING YOUR CAMERA'S BEEP

The last thing the wedding couple (or the clergy, or the guests) wants to hear during the ceremony is the distracting sound of your camera beeping as it locks focus. So, before the wedding begins, go to your camera's menu and disable the audible beep sound.

Tricks for Low-Light Shooting in a Church, Part 2

The second trick wedding pros use to shoot in low-light situations is to shoot with a fast lens to let in more light (by that, I mean a lens where the largest available f-stop is something like f/1.4 or f/1.8, or maybe f/2.8—lower numbers are better). Once you have one of these lenses, shooting at these fast f-stops (let's use f/1.8, for example) lets a lot more light in, which gives you faster shutter speeds so you don't have to raise your ISO nearly as much (or at all). Since we know that raising our ISO adds at least some noise to our photos, if we have a choice, we'd rather use a fast lens than crank up our ISO. Now, depending on how dark it is where you're shooting, you might still have to increase the ISO amount, even when using one of these fast lenses at it's wide-open (lowest number) setting, but you'll have to raise it less, which means less noise. Now, when you're shooting the formals in the church (before or after the ceremony), here is a recipe you can use to get a natural-looking light balance between your flash and the available light in the church: set your ISO to 800, set your shutter speed to 1/60 of a second, and set your f-stop to f/5.6, or a lower number if possible (like f/4, f/3.5, or even f/2.8). By using a relatively low shutter speed like 1/60 of a second, it's a slow enough speed that your camera can properly expose the background (you see it lit with the available light in the room), and then your flash comes in to freeze the action. Once you've got those two settings in place, all you have to do is take a test shot with your flash, and if it overpowers the room light (the background looks black), then lower the brightness (power) of your flash unit, so although your subject will be mostly lit with flash, you'll still see some of the natural light in the church. This gives a nice balance between the natural light (which should be around 30% to 35% of the light in the photo) and your flash (which should be 65% to 70% of the light).

Do You Really Need the f/1.4 Lens?

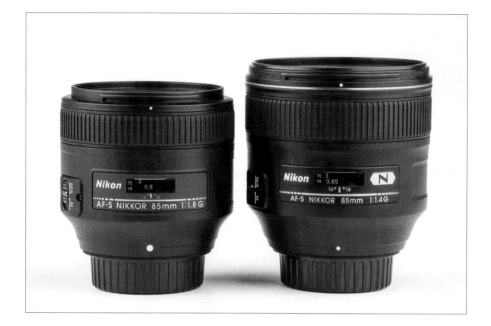

You need fast lenses to shoot in lower light with less noise. But, how fast of a lens do you really need? The two most popular fast lens sizes for wedding photographers are probably the 50mm prime and the 85mm prime (prime means it's stuck at that one focal length). Okay, so now do you need the f/1.4 or the f/1.8? This I can help with: At the time this book was published, a Nikon 50mm f/1.8 lens sold for around $217 (over at B&H). However, to get just 2/3 of a stop more light, the Nikon 50mm f/1.4 sold for around $482 (more than double the price). Besides the obvious price difference, you need to be more accurate with your focus shooting at f/1.4 than you do shooting at f/1.8 (shooting a close object with either is going to create a very shallow depth of field. For example, if you shoot a close-up portrait at f/1.4, the tip of your subject's nose could be in focus, but then their eyes would be a bit out of focus, and their hair would be way out of focus). For that reason, I'm personally more likely to shoot at f/1.8 (it gives me a little more latitude, and a little more area in focus). As for quality, there's a lot of debate as to whether anyone can really see the quality difference between the f/1.4 or the f/1.8, so for most folks, I recommend going with the less expensive f/1.8 lens.

💡 DON'T CHANGE LENSES, CHANGE CAMERAS

Things happen very quickly at weddings. So, if you're shooting with a zoom lens, and you suddenly need to switch to a wide angle, don't switch lenses—switch camera bodies. Keep two camera bodies around your neck (or one in your hand), and put a wide-angle lens on one body, and a zoom lens on the other. That way, switching lenses takes two seconds, not two minutes, and because of that, now you "get the shot."

Backlighting Your Bride

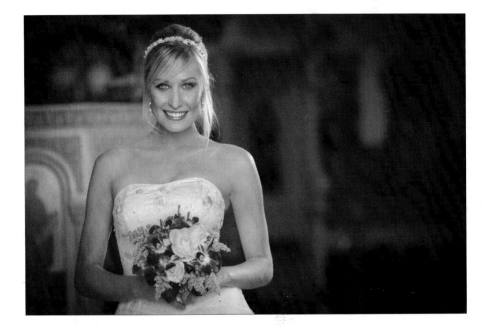

A popular effect with wedding photographers is to backlight the bride—where a bright light rims the outline of the bride—and then add in just a little bit of flash to light the front of the bride, so she's not a silhouette (as shown above). This takes two flash units: one in front of the bride (in this case, I used an off-camera flash on a light stand, positioned to the left of the camera at a 45° angle), and a second flash on a light stand behind the bride (here, it was behind and to the right, just out of the frame). The flash of light from the front flash triggers the second flash behind the bride. The key is to make sure the flash behind the bride is much brighter than the flash in front of the bride (in the shot above, I lowered the power of the front flash as low as I could, but kept it bright enough so it would still trigger the flash behind her. It took a couple of test flashes to find out just how low that front flash could go). Another nice look (which is very dramatic) is to go ahead and let her just be lit with a flash behind her, then turn the flash in front off, so she actually is mostly a silhouette. If you do this, you'll have to set your front flash so it doesn't fire the full flash, but only a very low light pulse—just enough to trigger the wireless flash behind her, but so it doesn't throw any measurable light on the bride (Nikon's DSLRs with pop-up flash have this feature built in).

💡 COMPOSE TO INCLUDE THE CHURCH

A trick I learned from master wedding photographer David Ziser: compose a decent number of the formal bride and groom portraits to include the interior of the church. It's important to brides to see the church where the ceremony took place, and by composing it into the formals, it really gives the shots a sense of place.

Finding That Perfect Bridal Light

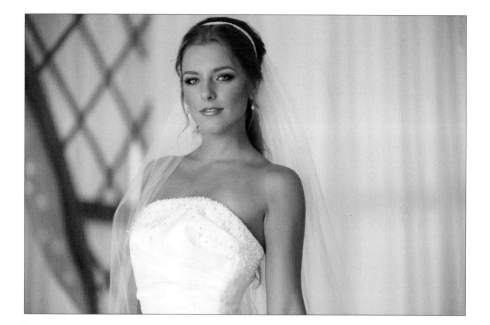

At most weddings there is a spot with really spectacular light just waiting for you to walk over and find it, but once you find it, you have to know how to use it. That light, of course, is natural light coming in through a window (it's hard to make a photo look bad in that light). Look for a window that doesn't have direct sunlight (a window facing north usually works well to provide some soft, diffused light). So, once you find this wonderful natural side light coming in from a window, where do you place the bride? Ideally, about 6 to 8 feet from the window, so the light falls evenly and softly upon her (almost sounds like a song, doesn't it?). This is a great spot for shooting some pre-wedding shots of the bride alone, the bride with her mother, and the bride with her father.

💡 TIPS FOR POSING THE BRIDE

More tips from David Ziser: Have the bride stand with her feet in a staggered V-shape, then shift her weight to her back foot, and lower her shoulder farthest from your light source. This creates a flattering diagonal line between her shoulders and creates a much more dynamic look for your pose. To keep detail in the bridal gown, you want your flash to cross the dress, not hit it straight on. Simply position the bride so her shoulder that is closest to the light source is angled toward the light source.

Formals: Where to Aim

©ISTOCKPHOTO/KEVIN RUSS

When shooting large groups for the formal portraits, you'll want to make sure that you use an aperture setting that keeps everyone in focus. Try f/11 for a reasonable depth of field for groups. Now, where do you focus? If you have more than one row of people deep, the old rule (which still stands true today) is to focus on the eyes of the people in the front row. You have more depth behind than in front, so make sure you focus on them, and the rest should be okay, but if that front row is out of focus, the whole shot is a bust.

DON'T SPEND TOO MUCH TIME ON THE FORMALS

A very famous wedding photographer gave me some great advice one day about shooting the formals (the posed group portraits). He said, "Get the formals over fast. You have to do them, but nobody cares about them." They don't usually include a special or touching moment and they're rarely photos anybody talks about after the wedding (unless, of course, you forget to do them). So, get everybody together, knock those shots out, and move on to the important job of capturing the moments that do matter.

Formals: Don't Cut Off Joints

When you're framing your formals in your viewfinder, for a more professional look, be careful not to cut off anyone at the joints (in other words, don't let the bottom of the frame cut anyone off at the elbow or knee. On the side of the frame, don't cut anyone off at the wrist or elbow either). Basically, stay away from the joints. If you have to crop an arm or leg off, try to do it as close to the middle of the arm or leg as possible, staying clear of the joints. 'Nuf said.

💡 SOME TIPS FOR FORMALS

Build off the bride and groom: A popular format for creating all your formals—have the bride and groom in the center, and have them stay put. They don't move—instead you have groups of other people (bridesmaids, groomsmen, the best man, etc.) move in and out around them. Use them as building blocks to make group shots easier. Another tip: Your main job is to follow the bride. Make darn sure your main focus at the pre-wedding, the ceremony, the formals, and the reception is the bride. Follow her just like you would follow the quarterback if you were shooting a football game. Especially if you're going to be selling these photos, as it will be the bride (either directly or indirectly) who will be buying the prints. So, make darn sure that she's the clear star of the show.

Formals: How High to Position Your Camera

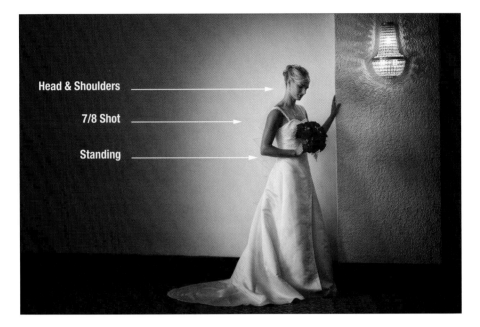

When you're shooting your formal shots, the height that you position the camera is actually very important, because if it's not positioned correctly, your subject's body can look distorted or some parts can look larger than normal (in general, this is just not good stuff). So, finding the right height for professional portraits is critical. Here are a few guidelines to help you get the pro look:

Standing, Full-Length Portrait: Position your camera (on your tripod) at the bride's waist height (yes, you'll have to squat down/bend over, etc., but the final result will be worth it). Keep your lens straight (don't aim up toward the bride's face).

7/8 Shots (from the Calf Up): Position your camera (on your tripod) at the bride's chest level and shoot with your lens straight from there.

Head and Shoulders Shots: Position your camera (on your tripod) either at the bride's eye level or slightly above.

💡 BACKGROUND TIP

Vary your background for your formals. It may not seem like a big deal at the time, but when you see the same background over and over and over again in the final wedding album, it can become really tedious. Once you've shot a few sets on one background, if there's another simple background nearby, try it in order to keep the album from looking like a cookie cutter.

Change Your Vantage Point to Add Interest

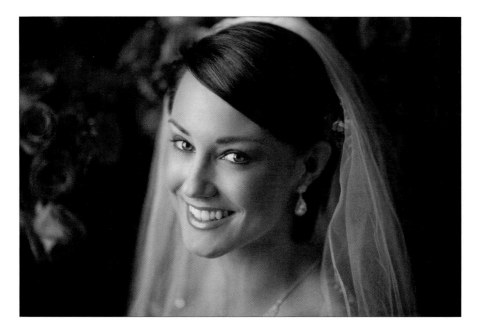

Want to create a shot everyone will remember? Shoot it from a high vantage point (look for a second story window you can shoot down from, or a balcony on the second floor, a bridge, etc.). If you can't find an existing high vantage point, then you can always create your own by bringing (or borrowing) a ladder to shoot from (like the Conair Travel Smart LadderKart, which doubles as a hand truck to help you move your gear, when you're not standing on it. It holds up to 300 lbs., and sells for around $80, but I've found other similar ladders online, as well). Of course, be careful, because being on a ladder with expensive camera equipment is the stuff Hollywood comedies are made of. This high vantage point trick is ideal for shooting bridesmaids, groomsmen, the bride and groom, and even the bride alone (as shown here, where I shot the bride while standing on a ladder).

💡 WHY YOU WANT A SECOND SHOOTER

Bring a second shooter (sometimes even a third) as an insurance policy to make sure all the most important shots are covered—the bigger the wedding, the more you need one. You can't be everywhere, and if anything goes wrong, there's someone else to keep shooting, or deal with the problem. They'll also bring a different style, dimension, and camera angle, and can shoot from a different location, plus there's a good chance that if you missed "the shot," your second shooter will have gotten it (or vice versa).

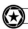

Shooting the Details: Which Ones to Shoot

The photojournalism style of wedding photography is very big right now (where you tell the story of the wedding in photos as if you were covering it for a newspaper or magazine). One of the cornerstone elements of this technique is to make sure to photographically capture the tiny details of the wedding, especially behind the scenes before the wedding. Here's a list of things you might want to capture (shoot), which can either stand alone in the wedding album or be used as backgrounds for other photos:

- The bride's shoes

- The bride's dress hanging on a hanger

- The bride's tiara, necklace, etc.

- The wedding invitation

- The sheet music played at the wedding

- The guestbook (once a few people have signed it)

- Their champagne glasses

- Name cards at the reception

- Their wedding rings (perhaps posed on the invitation with some rose petals casually placed nearby)

- The airline tickets for their honeymoon

- The sheet music, or CD jewel case, to the music for their first dance

- The groom's boutonniere

- The bride's bouquet

- Any fine detail in her dress

Close-Up Detail Shots

PETE COLLINS

When the bouquet was delivered, I went out to the balcony so I could use natural light, and I was careful to place the bouquet in the shade so the natural light would be soft. I also went and borrowed the bride's engagement ring for the shot and placed it inside the petals of one of the roses. I'm using a macro lens here (and also for stuff like close-ups of the groom's cuff links, the invitation with both rings sitting on it, etc.). They have a ridiculously shallow depth of field, so any camera movement at all and the whole shot will be out of focus—you need to be on a tripod. I'm shooting in aperture priority mode and, since the depth of field is so shallow, I try to shoot at f/16 or f/22 to squeeze another 1/16" that's in focus. On a tripod, I use my lowest ISO (as always) and it doesn't matter what my shutter speed is because I'm on a tripod. The 70–200mm lens is a staple of many wedding photographers, but you're not going to be able to get in as tight as you'd like because they usually have a minimum focusing distance. So, if you start to get too close to the ring, everything goes out of focus and you can't get in really close (and if you try to get as close as you can and then crop it tight, you won't get that super-crisp detail and mega-shallow depth of field that is the trademark of a macro shot. The shot on the left in the inset is as close as I can get with a 70–200mm before it goes out of focus). That's where a macro lens comes in (or better yet, use my handy tip below). A macro lens lets you zoom in and get crazy close (like you see on the right in the inset), and create a level of detail that has real impact. Plus, look at how amazingly shallow the depth of field is for the image on the right. The diamond and mount are in focus, and just 1/16" behind that, it all goes blurry and out of focus, which really makes the diamond stand out! **TIP:** Don't buy a macro lens, get a close-up lens instead. Whether you shoot Nikon or Canon, you can use Canon's brilliant screw-on close-up lens, which is only about 3/4" thick, super-lightweight, and pretty inexpensive. You just throw it in your camera bag and screw it on to your zoom lens when you need it. Super handy!

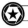

Reception Photos: Making Them Dance

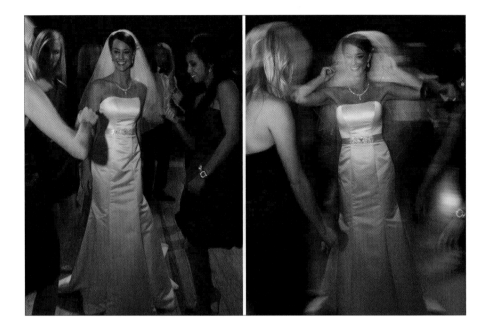

There's a problem with taking photos of people dancing. If you shoot them with a flash (and most likely you will), it will freeze their movement, so they'll look like they're just standing still, but in somewhat awkward poses. It still amazes me how people doing a line dance can be pictured as people in a police lineup—the camera just doesn't capture motion, unless you tell it to. There are really two techniques: The first is in the camera. Use a slow shutter speed so the people have a motion blur, which makes them look like (you guessed it) they're dancing. (If you want the main person in your shot, like the bride, to be in focus, you can use panning, where you take the camera and follow their move-ment.) If you didn't remember to employ this technique during your reception shoot, then you can add this motion blur in Photoshop. The first step is to duplicate the Background layer. Then go under the Filter menu, under Blur, and choose Motion Blur. Set the Angle to 0°, then increase the Distance until things look like they're really moving. If you want to keep one person in focus, get the Eraser tool, choose a really big, soft-edged brush (like the soft round 200-pixel brush) and erase over the person you're focusing on (like the bride, etc.) so that person appears in focus, while everyone else is dancing and moving around having a good time.

💡 BACK UP YOUR PHOTOS ONSITE

A wedding happens once. You don't get a redo. So, make sure that backing up your photos on location is a part of your workflow. If you fill a memory card, and pop in a new one, the next thing you should be doing is backing up that full card to a hard drive.

Reception Flash

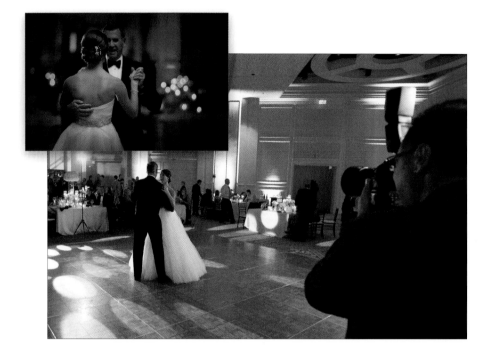

Here, the room's lit with colored lights and constantly changing colored LEDs on the walls. I'm using a single speedlight flash on my camera, aimed straight upward toward the ceiling (it's too high to bounce off—I'm only interested in the tiny bit of flash that comes out of the front of the flash). So, some of the light from the flash goes forward to light the bride and her father, but still blends in with the existing room light without overpowering it. The lighting was very colorful, so if I turned up the flash and aimed it directly at them (even if I added a diffuser or small softbox), you'd see mostly flash, and most of the color will have been overpowered. Notice how you can still see a magenta light on the bride's dress and along her arm, and on her dad's head. Since the flash is aiming straight up, it's set to full power. When using flash, my camera's always in manual mode. My shutter speed is set to 1/250 of a second (making the room appear darker). My f-stop is f/1.4, which let me handhold in this low-light situation, but I had to raise my ISO to 640 (having a fast lens, like an f/1.4, keeps your ISO from getting too high in low light). I used an 85mm lens so I could shoot at that fast aperture, and it's wide enough to let me include some of the reception hall. Using such a low f-stop also puts the background a bit out of focus, separating them from the background, even though we're not zoomed-in tight. By the way, to give you an example of how important having a fast lens is in a low-light situation like this, I was able to take the shot above at only 640 ISO to give me a shutter speed of 1/250 of a second, which was enough to freeze their motion while dancing, and eliminate any movement from me handholding the camera. The production shot of me shooting was taken at a slower f-stop of f/2.8. To get the shutter speed to 1/125 of a second (just fast enough for a non-blurry handheld photo), my assistant needed to use an ISO of 16,000! It looks really clean because he uses a camera that performs really great at high ISOs like this (a Canon 1DX), but what I wanted to demonstrate is that those really fast f-stops really do make a difference.

Go Super-Wide for an Epic Feel

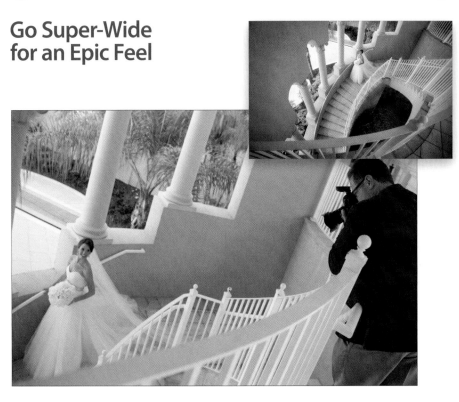

It was the middle of the day and we scouted for some locations for the bridal portrait that weren't in direct sunlight. We found this beautiful staircase. Since she was inside the stair area, she was shielded from the sun. I positioned myself up high, shooting down, so I could see the bride and the elegant-looking columns behind her, as well. We were using available light and, in that case, I shoot in aperture priority mode (where I choose the f-stop and the camera automatically chooses a shutter speed it thinks will make a decent exposure, and it's usually right). Normally, I would use a higher-numbered f-stop, like f/8 or f/11, but despite how it looks here, the lighting was actually fairly low in this shade, so I lowered my f-stop to f/2.8. The background didn't actually go out of focus here because I was shooting a wide-angle lens, so even though I'm at f/2.8, I'm not zoomed in tight (I'm way out wide) and everything will pretty much be in focus throughout. Perhaps not as sharp as at a higher f-stop, but I was able to keep my ISO at 100 (the cleanest setting) and still get 1/125 of a second shutter speed, so the shot wouldn't be blurry because of movement while handholding. Going for the "epic" wedding shot, which means the bride is swept away in the beautiful surroundings, I chose a super-wide-angle lens—a 16–35mm f/2.8 lens. The key when using a super-wide-angle lens like this is to keep your subject from getting too close to the sides of the image because it will normally distort them and stretch them so they look much wider. To make it look even bigger and more epic, I climbed up two steps on a LadderKart (see page 109). That way, I could include the railing right in front of me and create more depth. To focus the light more toward the center of the image, I darkened the edges all the way around the photo just a tiny bit using the Post Crop Vignetting feature found in the Effects panel in Lightroom's Develop module (or Camera Raw): just drag the Amount slider to the left a little bit and you'll see the edges darken all the way around. It usually just needs a touch, but it adds a lot.

The Lens Flare Look

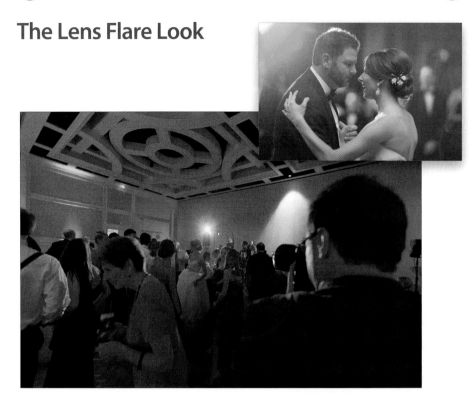

During the reception, I positioned myself so I'm shooting directly into the colored light that's aimed at the dance floor—a sure recipe for getting lens flare (while this lens flare look drives some traditional photographers crazy, brides love it). The light was constantly changing color, and even moving, so I would pick an area, camp out there, and try to catch the bride and groom in between the other guests out dancing alongside them. You can see the lens flare creating a ring over my shoulder (camera left) in the behind-the-scenes shot. This technique just takes a little patience because, even though you're aiming directly at a light shining right in your direction, it doesn't always flare—you'll get a bunch with the effect, and a bunch without it. I locked focus on the bride and groom by holding the shutter button halfway down, and then repositioned myself so the light was aiming straight at me. When I saw it start to flare, I pressed the shutter button the rest of the way down to take the shot, knowing that it would be in focus because I had already locked the focus on the bride/groom before aiming my lens at the light. I used an 85mm lens, and just the existing room light at f/1.2. Even at that wide-open of an f-stop, my ISO was still 2500. My shutter speed was probably a bit higher than I really needed at 1/250 of a second, but they were dancing and I wanted to make sure it would freeze their movement. I took this shot at f/1.2 because of the low light, but a happy by-product is that it puts the background way out of focus, which helps give the bride/groom visual separation from the background. Just one thing to keep in mind: when you shoot at f-stops like f/1.2 and f/1.4, your focus is really critical. Lock your focus (hold the shutter button down halfway) when you're directly over the subject's eye that's closest to you. In-camera lens flare effects tend to create a flat, hazy look, so you might want to add some contrast back into the image by dragging the Contrast slider to the right in the Basic panel in Lightroom's Develop module (or Camera Raw).

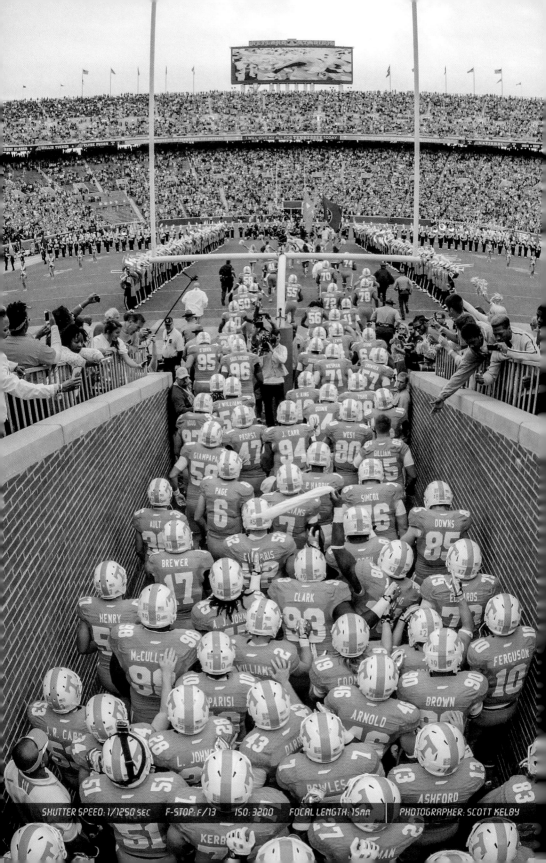

Chapter Seven

Shooting Sports Like a Pro

How to Get Professional Results from Your Next Sports Shoot

I know that these chapter intros are just here for a mental break, and they're not actually supposed to provide any useful information whatsoever, and I think I've done a fairly good job of living up to that lofty goal so far. However, I'm very passionate about shooting sports, and this is the only place I have to pass on a warning that is actually based in truth (or at least as based in truth as that movie *The Perfect Storm* was). Anyway, if you are a serious fan of college or pro sports, I want to tell you up front that you will rue the day you actually shoot on the field, because you will never, ever, ever, in a bazillion years even consider going back into the stands like a regular fan again. You will be literally ruined for life. Here's why: you get spoiled down on the field of play. It's a different game down there. It's not like what you see on television. You see, on TV, when you see a cornerback and a wide receiver jawboning back and forth before the snap, you figure they're trash talking. Talking smack. Occasionally, they are, but you know what they're mostly talking about? Nine times out of 10, they're talking about the gear the photographers on the sidelines are using. I was shooting an NFL game in Atlanta once, and I set up right near the line of scrimmage, and I heard the receiver say to the cornerback, "Dude, is he really trying to shoot this with a 200mm lens?" And the cornerback said, "I looked during the last time out—he's got a 1.4 tele-extender on there." Then, the WR said, "Did he have VR turned on?" The corner said, " Yup." Then, the WR said, "Dude, it's a day game. You know he's got to be at 1/1600 of a second or higher" and just then the quarterback called an audible and yelled "Get me close to that guy with the 400mm f/2.8—I want to see if it's the new model with the nano coating." This goes on all game long, game after game, city after city. The players call it "camera smack" and just because you don't hear about it on TV, doesn't mean it's not happening.

Which Lenses to Use

GEORGE WALKER IV

When you're shooting sports, carrying a load of lenses and a big camera bag will strain your back and just add to your frustration. Instead, go light with just two lenses:

(1) **A wide-angle zoom lens** (something that goes at least 24mm wide). You'll need these wide angles to capture full stadium shots, full court shots, close-up group shots, etc.

(2) **A 300mm or 400mm telephoto lens** (or a 200–400mm zoom). At the very least, you'll need a 200mm lens, but plan on doing a lot of running because if the players aren't right in front of you, they'll be too far away to make pro-quality shots.

You won't want to change lenses, so ideally you'll put one lens on one camera body, and one lens on the other. The only other thing you'll need to carry (besides extra memory cards and a backup battery) is a 1.4x teleconverter to get you even closer to the action (these magnify the amount of zoom, turning a 300mm telephoto into a 450mm). *Note:* Some pros advise against 2x teleconverters because they feel 2x photos are not as sharp and you lose up to two f-stops of light, making it harder to get the fast shutter speeds you need indoors. To move all this stuff around try a Manfrotto Pro Photo Vest or a Think Tank Photo belt system.

💡 **SHOOT FROM A LOW POSITION**

Pro sports photographers often shoot down on one knee to get a lower, and better, perspective for their shots. It gives you the feeling of being right there, and helps to make the athletes (or their cars) look "bigger than life." Try it next time, just make sure you buy some gel-filled knee pads from the local home improvement store first.

Adding a Teleconverter to Get Really Tight

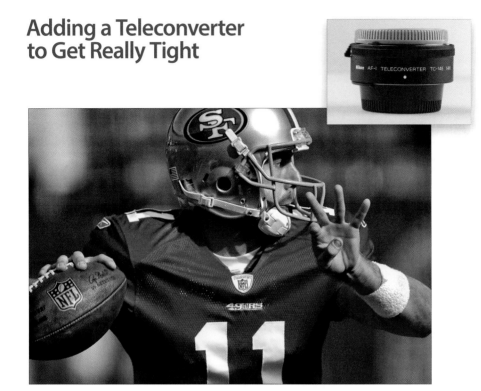

If you look at some of the really amazing sports shots out there today, many of them bring you really, really close to the action. They bring you emotion and action that you'd miss from wide-angle TV shots, or sitting up in the stands, or even watching on those giant stadium monitors. While I generally shoot a 400mm lens for most sports, I realized that I needed to get in even tighter—especially after having my portfolio reviewed by sports photography legend Dave Black, who encouraged me to put a 1.4x teleconverter in front of my 400mm lens (making it over 550mm in length) to get even closer, and it made a tremendous difference. Whatever focal length you're shooting, a teleconverter is a fairly inexpensive way for you to get even closer to the action and take your sports shots to the next level. (*Note:* This works best for shooting day games or in really well-lit situations, because putting on a 1.4x tele-extender makes you lose 1 full stop of light, so your f/2.8 lens becomes an f/4 lens, etc. If you use a 2x tele-extender, then you lose 2 stops. So, for daylight it's okay, but indoors, unless you have a camera body that shoots in low light with really low noise, it's kinda dicey.) By the way, Dave had a great quote about getting in close. He said, "Go big or go home!" He's right.

💡 **DON'T HAVE LONG GLASS? RENT IT FOR THE WEEK!**

If you have a special game or assignment coming up, and you don't have long enough glass to shoot the game the way you want to, then just rent it. I've used LensProToGo.com— they have all the long glass for both Canon and Nikon shooters (they rent camera bodies, as well), they ship directly to you overnight, and they are reasonably priced.

How the Pros Focus for Sports

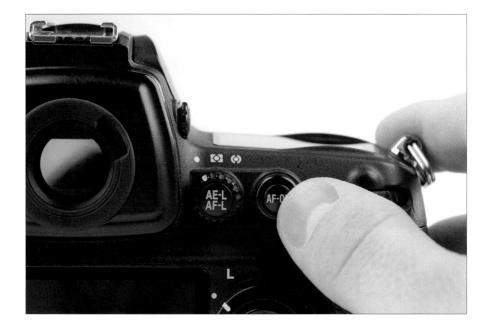

If you want to get more shots in focus, you've got to switch to back focusing (where you focus by pressing a button on the back of your camera body with your thumb, rather than focusing by pressing your shutter button). This makes a bigger difference than you'd think, because by separating the focus from the shutter button, your camera no longer focuses, then shoots—you've already focused on your subject with the button on the back, so now your shutter button just shoots. This back focusing helps to keep the autofocus from jumping off your subject when someone walks into your frame (which is a real struggle when shooting team sports), because if someone does walk into your frame (like a ref), you just take your thumb off the back focus button until they're gone (but keeping shooting) and when they're out of your frame, just hit the back focus button again. Generally, I keep my thumb on that back focus button, aim at my subject, and then I don't have to worry about my focus—I just concentrate on my timing. On Canon cameras, press the Menu button on the back of the camera, go to your Custom Function IV-1 menu, and choose Metering start/Metering + AF start. On most Nikon DSLRs, go to the Custom Setting menu and, under Autofocus, choose AF Activation, and set it to AF-ON Only.

> ### 💡 HAVING YOUR FOCUS AUTO-TRACK THE ACTION
>
> If you're going to be shooting sports, switch to a focus mode that tries to automatically track a moving object if it moves out of the focus area. On Canon cameras, it's called AI Servo AF, and on Nikon cameras, you'd switch to Continuous-Servo focus mode.

Shoot Wide Open at Fast Shutter Speeds

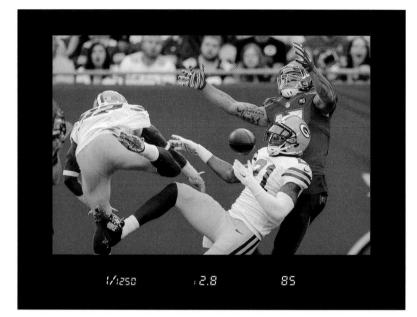

By shooting wide open, I mean shoot as close to your wide open aperture as possible (so if you have an f/2.8 lens, shoot at f/2.8 or one stop up). This will pay off in two ways:

(1) **This will blur the background,** creating a more dramatic, dynamic, and uncluttered photo of your subject. Busy backgrounds are a problem when shooting sports, and shooting with a telephoto lens at a wide open aperture gives you a very shallow depth of field (your subject in the foreground is in focus, while the background is out of focus).

(2) **You'll be able to shoot at faster shutter speeds,** which will freeze the action of the athletes, and greatly help when shooting indoors under artificial low-light situations. To freeze the action, ideally, you'll need a shutter speed of around 1/1000 of a second or faster (any slower than that and you'll probably have at least some blur. Although I've had some sharp sports shots as low as 1/640 of a second, they're not all sharp, so 1/1000 of a second is our goal). If you're shooting outside on a sunny day, this is no problem—set your camera to aperture priority mode, use the lowest f-stop your camera will allow, and you'll probably have shutter speeds of more than 1/4000 of a second. If it's a partly cloudy day, you may drop down to 1/2000, and that's okay.

STILL PLAYERS ARE BORING

Don't shoot football players in the huddle or standing around, or the runner standing with one foot on first base, or the outfielder waiting for a pop fly. Shoot the action, because when you look at your photos later, you'll hate the shots that don't have it.

Auto ISO Lets You Always Freeze the Action

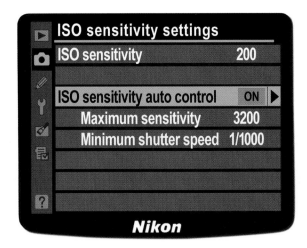

If you're shooting a sport where you need to freeze the action, then you need to make sure you're shooting at a shutter speed that freezes action—around 1/1000 of a second. That's easy to do in broad daylight shooting at a wide open aperture like f/2.8 or f/4 like we would normally do with sports, but if it gets cloudy, or the light changes, or it gets later in the day, you run the risk of your shutter speed falling below 1/1000 and coming home with a bunch of blurry sports shots. That's why you'll fall in love with the Auto ISO feature, which makes sure you never fall below a certain shutter speed, because it will automatically increase the ISO without any input from you. What's especially slick about this is it won't just jump from 200 ISO to 400 ISO, it'll only move exactly as much as it needs, so it might go from 200 ISO to 273 ISO (something you couldn't even choose on your camera if you wanted to, right?). On Canon cameras, you need to set the ISO speed to A by looking at the LCD panel and turning the main dial on top of your camera. On Nikon cameras, you turn this on by going to the Shooting menu and choosing ISO Sensitivity Settings. Then you enter the Minimum Shutter Speed you want to maintain (I use 1/1000 of a second), and turn the ISO Sensitivity Auto Control on.

💡 DON'T PLAN ON CHANGING LENSES

For sports photography, if you want to compete with the big boys, don't plan on changing lenses—plan on changing cameras. You'll miss "the shot" if you have to change lenses. That's why the pros have multiple camera bodies hanging around their necks—so they can change from a 400mm telephoto to a wide-angle lens in an instant.

Shooting at Night or Indoors? Raise Your ISO!

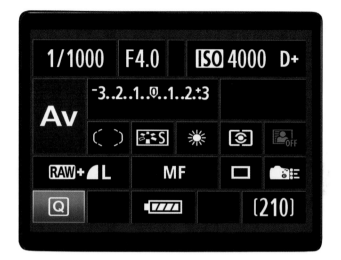

The biggest challenge of shooting sports happens when you shoot at night, or if you shoot indoors. That's because, without that bright sunlight, your shutter speed will drop like a rock. There's really only one way around this—you'll have to raise your ISO like crazy to get your shutter speed back up to 1/1000 of a second to freeze sports action. So, why do we worry so much about raising the ISO? Well, it's because the higher you raise your ISO, the more noise (grain) you'll see in your photos. Today's high-end sports cameras have very low noise, even at very high ISOs, but it's still sometimes visible. But, really, there's nothing we can do about it. This is why "fast lenses" (like an f/2.8 or f/4) are so helpful—the faster the lens you have, the less you'll have to raise your ISO (and the less noise you'll have). So, how much of a difference does a fast lens really make? Well, if I'm shooting in an NFL football stadium at night with really bright stadium lighting, and I set my f-stop to f/4, I have to set my ISO around 4,000 to get my shutter speed up to 1/1000 of a second. If I have an f/2.8 lens, I can usually set it at just 1,600 ISO (much less noise). That one stop makes that big a difference (but man do they charge you a bundle for that one extra stop of light). So, you will see some noise, but seeing some noise beats having a blurry photo every single time.

THE ADVANTAGE OF USING FAST MEMORY CARDS

Fast memory cards were made for sports shooters, because we usually shoot in continuous shooting (burst) mode. Faster cards write data faster, so the images in your camera's buffer leave the buffer quicker (leaving room for you to take more continuous shots).

Shooting in Burst Mode

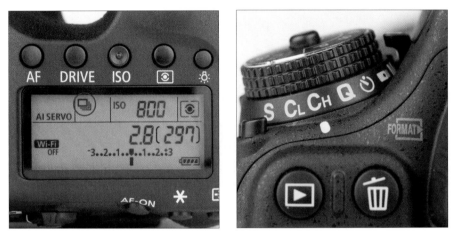

Canon Nikon

Much of the shooting you'll be doing in sports photography will require you to take bursts of shots (four or more shots per second) in order to make sure you get the shot while a play is in motion. So, you'll need to set your camera to shoot multiple shots while you hold down the shutter button (this is called burst mode on some digital cameras). By default, most cameras shoot one frame at a time, so you'll have to switch this burst mode on.

Canon: Press the Drive or AF•Drive button, then rotate the quick control dial until you see an icon that looks like a stack of photos on the top LCD panel.

Nikon: Switch the camera's mode to continuous by first pressing the Menu button, choosing the Custom Settings menu, and then choosing Continuous High-Speed (to choose either 10 fps or 11 fps). Then, press the release mode dial lock release button on the top left of the camera and turn the release mode dial to CH.

Now, you can simply hold down the shutter button to fire multiple shots.

💡 **THE ADVANTAGE OF SHOOTING FROM THE END ZONE**

If you shoot football, you'll see a lot of pros jockeying for space in the end zone and the corners of the end zone so they have a clear, unobstructed line of sight, and they're in position if someone breaks loose to "take it to the house." The only "gotcha" is that if possession changes, you have to decide if you want to go to the opposite end zone.

Using a Remote Camera

Having a second DSLR aimed at a different part of the field (or track, or arena, etc.) gives you a huge advantage, because you can cover twice the area. For example, if you're shooting baseball from a dugout, covering the batter with your main camera, you can have a second camera aimed at second base. When you see a play happen at second base, you press a remote to fire your second camera. If it's near you, you can use a cable release (or wireless shutter release). If it's far away, you'll need two wireless transmitters (I use PocketWizard Plus IIIs)—one connects to your remote camera, and you hold the other. When you see the action come into the view of your remote camera, you press-and-hold the remote button and it fires the shots (I always set my remote camera to shoot a burst of shots for as long as I hold the remote button down. I also pre-focus on the spot I want [like second base itself], then switch my focus to Manual, so it doesn't change when I press the remote button). You should also get: (1) a Manfrotto Super Clamp with a Manfrotto Variable Friction Magic Arm with Camera Bracket—this lets you mount the camera to all sorts of surfaces by just clamping it on, and then you can position it just how you like it. And, (2) a safety cable or two to double secure your rig, so if something comes loose, your gear doesn't hit the floor or fall and hit somebody.

> ### 💡 STABILITY FOR SHOOTING SPORTS
>
> Sports shooters generaly use monopods instead of tripods because they are easy to move, and many professional sports that ban tripods allow monopods. Carbon fiber ones are popular and can hold a lot of weight, but are surprisingly lightweight.

The Two Most Popular Sports Shots

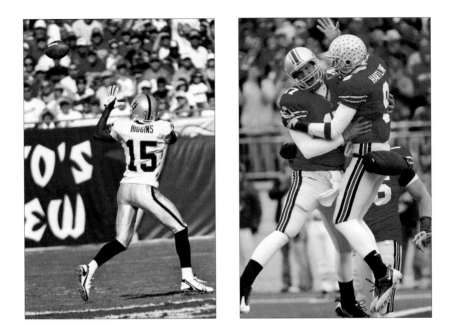

The "Holy Grail" for any serious sports photographer would be to have their work published in *Sports Illustrated* magazine. But what kind of images does *Sports Illustrated* run the most? Based on my research, they run two types of images: (1) Action images, where the ball (if there is one) is in the frame with the athlete. (2) Celebrations. Occasionally, it's an editorial shot of an athlete who just suffered a crushing defeat, but usually it's one or more players celebrating after a big win. Also, they're usually in tight on the players, so you can see their facial expressions and the emotions of the game. So, how does this help you? Well, after all these years, you can imagine that *Sports Illustrated* has figured out exactly which types of sports photos people want to see, right? Right! Now you know which two types of shots you want to be sure to capture the next time you're shooting a game. Remember, if the ball's not in the shot or the players aren't celebrating, it doesn't make it into the magazine.

💡 DON'T ALWAYS FOCUS ON THE WINNER

In sports photography, it's only natural to follow the winner. But if you only cover the winner, you might miss some of the most dramatic shots with the most powerful story-telling angle, which are the expressions and reactions of the loser or the losing team. This is especially important if you just missed the action play—quickly switch to the reaction of the guy who missed the ball, or didn't block the shot, or missed the goal, etc. Sometimes their reactions are more fascinating than those of the person who makes the shot.

Pros Know the Sport & Shoot the Details

If you know the sport you're shooting, you'll get better shots than the next guy because you'll know where the next play is likely to unfold. Being able to anticipate when and where the big moment will unfold can make all the difference in getting "the shot." The key is you have to watch the event while you're shooting. Part of that is knowing a sporting event is more than the players. Today it's about the arena itself; it's about the fans; it's about all the sights and sounds that surround the event (sports news services always ask for these types of storytelling shots). For example, when I'm shooting football, I always shoot a nice close-up of both teams' helmets (there's usually at least one sitting prominently on an equipment case in the bench area) or the football sitting there by itself just after the ref places it on the field for the next down. For baseball, I shoot a lone glove sitting on the bench, or some bats leaning against the wall in the dugout, or even a close-up of home plate. Make sure you keep these in mind to shoot between innings, quarters, periods, etc. So, if you're assigned to shoot a sport you don't know well, go watch some videos, go buy some magazines on the topic, and study how the pros that cover that sport are shooting it.

💡 COMPOSING FOR SPORTS

When you're shooting athletes, the most important thing to capture, generally, is their face. It's their facial expressions that tell the story, but if you really want to take it to the next level, try to include the ball in the shot, as well. Now, when composing your sports images, be sure to give your athlete somewhere to go. Don't compose the shot so your athlete is running out of the frame and looks boxed in.

Pan to Show Motion

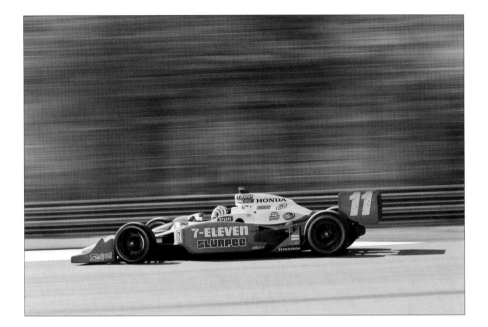

We've talked about using super-fast shutter speeds to freeze the motion of sporting events, but there are times when it's more dramatic to emphasize the motion and let parts of the photo become intentionally blurry from movement. There are three keys to this technique:

(1) **Use a slow shutter speed**—ideally, either 1/30 of a second or 1/60 of a second with a long lens and 1/4 of a second or less with a wide-angle lens. So, switch to shutter priority mode and set the shutter speed accordingly.

(2) **Pan right along with your subject**—following them with your camera. It's the camera's motion that creates the blurred background, because you're moving (panning) with the athlete so they remain sharp while everything around them appears blurred.

(3) **Use continuous shooting (burst) mode** for your best chance to capture a sharp shot—capturing multiple shots per second really pays off here.

One important thing to remember: Don't stop panning when the athlete leaves your frame—continue panning for a couple of seconds afterwards to get a smooth release.

💡 FREEZING MOTION TRICK FOR MOTORSPORTS

You can shoot car racing at really high shutter speeds when the cars are coming almost straight at you. If you can't really see the sides of the wheels, you can't tell they're not spinning. Switch your camera to aperture priority mode, then shoot wide open at the lowest numbered f-stop your lens will allow, and focus your camera on the driver's helmet.

Don't Be Afraid to Crop Your Photos

In general, I hate cropping, and if I have to crop a photo after I've taken it, it kind of makes me feel like I've failed at my most basic job as a photographer—deciding what to include in the photo (how the photo is composed). So, I do it very rarely, except for sports, where I crop all the time and feel no remorse whatsoever. I have to. All sports photographers (especially the pros) do. It's because, for most sports, the play often moves away from you in a split-second. Even with a 400mm lens, outfielders look tiny in your frame, so we have to crop in tight after the fact (in Photoshop, Elements, Lightroom, etc.) to create dynamic-looking images. It's a part of sports photography—the tight crop, and the tighter the better! If you're reading this and thinking, "Oh, so that's how those sports shooters get those super-up-close shots that look so great!" The answer is "Yes!" and now you can do it, too! Also, the shorter the lens you have, the more you'll be doing it. This is another reason why having a high-megapixel camera is a big benefit to a sports photographer—you can crop the image in tight and still have plenty of resolution for print or for the web. One more thing: when you're cropping your image and you think to yourself, "Man, that's really a tight crop!" that's your cue to crop it even tighter!

💡 **WHY YOU NEED TO SHOOT THE WARM-UPS**

You need to show up early for whatever sporting event you're shooting and experiment with your settings while the players are warming up. Also, you need to warm up, as well. If it's been a week or more since your last sports shoot, you need some time to shake the rust off and get back into the groove.

Chapter Eight

Shooting Landscapes & Nature Like a Pro

Tips for Creating Stunning Scenic Images

I think one of the most appealing things about being a landscape photographer is not only are you coming back with amazing photos, but you get to experience some of the best of what nature has to offer while you're doing it. I'll never forget this one time I was shooting in Montana's Glacier National Park. I got up around 4:15 a.m., so I could head out early and be in position for a dawn shoot. When I reached the lake overview, it was still pitch dark, and I remember setting up my tripod and watching it blow right over in the freezing wind that whipped off the lake. I just laughed and set it right back up, attached my camera gear to the ballhead, and realized that I'd better not let go of the rig or it, too, might blow over. I didn't want to give up my spot, because I had a pretty good vantage point (at least it looked like a good one in the dim moonlight). So, there I stood, out in the freezing, bitter cold, where each gust of wind was like a thousand knives jabbing right through me. I'm standing there shivering in the piercing cold, and then it started to rain. Not snow. Nope, that would have been pretty. It was rain. A driving rain that felt like a massive army of Lilliputians were firing their tiny arrows at me, but I just stood there in the bone-chilling cold like a wet, frozen statue, with my cracked, frostbitten fingers barely able to grip my tripod. I silently prayed for the sweet mercy of death to come upon me and relieve me of this frigid hostile misery. It was just then when I looked over and saw another photographer, who had just set up his tripod about 14 feet from me, slip on the ice that had formed on the overlook. I stood there and watched as he and his tripod, expensive camera and all, slid down the side of the embankment. I could hear him moaning for help, but I just couldn't stop smiling as I looked over and saw his Tamrac camera bag still up on the overlook beside me. I nearly pulled a muscle as I tossed his gear-laden bag into my rented SUV and quickly drove away, thinking to myself, "Man, this is what it's all about."

The Golden Rule of Landscape Photography

LOCATION: MONTEREY, CA

There's a golden rule of landscape photography, and you can follow every tip in this chapter, but without *strictly* following this rule, you'll never get the results the top pros do. As a landscape photographer, you can only shoot two times a day: (1) Dawn. You can shoot about 15 to 30 minutes before sunrise, and then from 30 minutes to an hour (depending on how harsh the light becomes) afterward. The only other time you can shoot is (2) dusk. You can shoot from 15 to 30 minutes before sunset, and up to 30 minutes afterward. Why only these two times? Because that's the rule. Okay, there's more to it than that. These are the only times of day when you get the soft, warm light and soft shadows that give professional quality lighting for landscapes. How stringent is this rule? I'll never forget the time I was doing a Q&A session for professional photographers. The other instructor was legendary *National Geographic* photographer Joe McNally. A man in the crowd asked Joe, "Can you really only shoot at dawn and dusk?" Joe quietly took his tripod and beat that man to death. Okay, that's an exaggeration, but what Joe said has always stuck with me. He said that today's photo editors (at the big magazines) feel so strongly about this that they won't even consider looking at any of his, or any other photographer's, landscape work if it's not shot at dawn or dusk. He also said that if he takes them a shot and says, "Look, it wasn't taken during those magic hours, but the shot is amazing," they'll still refuse to even look at it. The point is, professional landscape photographers shoot at those two times of day, and only those two times. If you want pro results, those are the only times you'll be shooting, too.

Composing Great Landscapes

LOCATION: LAKE LOUISE, BANFF NATIONAL PARK, CANADA

The next time you pick up a great travel magazine that features landscape photography or look at some of the work from the masters in digital landscape photography, like David Muench, Moose Peterson, Stephen Johnson, Bill Fortney, and John Shaw, take a moment to study some of their wonderful, sweeping images. One thing you'll find that most have in common is that these landscape shots have three distinct things: (1) A foreground. If shooting a sunset, the shot doesn't start in the water—it starts on the beach. The beach is the foreground. (2) They have a middle ground. In the case of a sunset shot, this would be either the ocean reflecting the sun, or in some cases it can be the sun itself. And lastly, (3) they have a background. In the sunset case, the clouds and the sky. All three elements are there, and you need all three to make a really compelling landscape shot. The next time you're out shooting, ask yourself, "Where's my foreground?" (because that's the one most amateurs seem to forget—their shots are all middle and background). Keeping all three in mind when shooting will help you tell your story, lead the eye, and give your landscape shots more depth.

> ### 💡 ANOTHER ADVANTAGE OF SHOOTING AT DAWN
>
> Another advantage of shooting at dawn (rather than at sunset) is that water (in ponds, lakes, bays, etc.) is more still at dawn because there's usually less wind in the morning than in the late afternoon. So, if you're looking for that glassy mirror-like reflection in a body of water, you've got a much better shot at getting that effect at dawn than you do at dusk.

Where to Put the Horizon Line

LOCATION: MONUMENT VALLEY NAVAJO TRIBAL PARK, MONUMENT VALLEY, UT

When it comes to the question of "Where do I place the horizon?" the answer is pretty easy. Don't take the amateur route and always place the horizon in the dead center of the photo, or your landscape shots will always look like snapshots. Instead, decide which thing you want to emphasize—the sky or the ground. If you have a great-looking sky, then put your horizon one-third of the way from the bottom of your photo (which will give you much more emphasis on the sky). If the ground looks interesting, then make that the star of your photo and place the horizon one-third of the way from the top of your photo. This puts the emphasis on the ground, and most importantly, either one of these methods will keep your horizon out of the center, which will give your shots more depth and interest. To help keep your horizon straight, use the Virtual Horizon feature on your camera (if your camera has this feature) or use a double level—a simple little gizmo that slides into your flash hot shoe (that little bracket on the top of your camera where you'd attach an external flash). This double level gizmo has a mini-version of the bubble level you'd find at Home Depot and it lets you clearly see, in an instant, if your camera is level (and thus, your horizon line).

💡 **REALLY BORING SKY? BREAK THE RULE**

If you're shooting a landscape shot with a sky where nothing's really happening, you can break the 1/3 from the top horizon line rule and eliminate as much of the sky from view as possible. Make it 7/8 ground and 1/8 sky, so the attention is totally off the sky, and onto the more interesting foreground.

Use the Blinkies to Keep More Detail

What if you look on your camera's LCD monitor and you see the blinkies appearing in an area that's important to you (like in the clouds, or in someone's white shirt, or in the snow, etc.)? (Technically, they're not called "the blinkies," that's our nickname for them. They're actually called highlight warnings or highlight alerts, and having this turned on, and adjusting for it, is a critical part of getting properly exposed landscape shots.) Well, this warning shows exactly which parts of your photo have been overexposed to the point that there's no detail in those areas at all. You'll be amazed at how often this happens. For example, even on an overcast day, clouds can blow out (turn solid white with no detail) easily, so we keep our camera's highlight warning turned on. Then, if you look at the shot in your LCD monitor, those blown out areas will start to blink like a slow strobe light and you can use your digital camera's exposure compensation control to fix it. Basically, you're going to lower the exposure until the blinkies go away. It usually takes a few test shots (trial and error) to find out how much you have to back down, but normally this only takes a few seconds. Now, these blinkies aren't always bad—if you shoot a shot where the sun is clearly visible, it's going to have the blinkies (I don't mean sunlight, I mean the red ball of the sun). There's not much detail on the suface of the sun, so I'd let that go. However, if your clouds have the blinkies, that's a different story. Again, just use your camera's exposure compensation control and lower the exposure until the blinkies go away.

The Secret to Shooting Sunsets

LOCATION: KAUAI, HAWAII

Because you're shooting into the sun, it can really throw your camera's built-in light meter way off, and what looked so beautiful when you were standing there comes out…well…pretty lame. Luckily, there's a simple trick to getting perfect sunset shots every time. The trick is to aim just above the setting sun itself (but make sure you can't see the sun itself through your viewfinder), then hold your shutter button halfway down, which tells the camera to set the exposure for just what it sees in the viewfinder right now. This gives you a perfect sunset exposure, but don't let go of that shutter button quite yet (keep it held down), then you can move your camera and recompose the shot as you'd like it to look. By keeping that button held down, you've locked in that perfect exposure, and once everything looks good to you, just press the shutter button down the rest of the way and take the shot. You will have nailed the exposure and captured the scene perfectly. Also, don't pack up your gear right after the sun goes down, because you'll miss what is often the most magical light of all. Around 20 to 30 minutes after sunset, sometimes the clouds turn bright orange, or deep red, or purple, or if you're lucky, a combination of all three, and some of my all-time best shots have been taken after everyone else has gone to dinner. Wait even longer (30 to 45 minutes or more after sunset), and the sky will often turn a vibrant, deep blue (not black, like the night—I'm talking blue—and it happens right before night). It only lasts for a few minutes (10 or 12 minutes usually), but what wonderful twilight photos you can get then. Try this blue twilight-hour shooting when you have a cityscape, or bridge, or other lit object in the background—it makes for a wonderful scene.

For Landscapes, You Need a Clear Subject

LOCATION: YAQUINA HEAD LIGHTHOUSE, OREGON

One of the things that kills a lot of landscape shots is that there's no clear subject, and for a landscape shot to really work, you have to be able to look at it and explain what you shot in one simple sentence. It's a lighthouse. It's that seagull on the rocks. It's that old barn. It's the palm trees on the beach. If you can't explain your landscape shot in a short sentence like that, you don't know what the subject is, and if you don't know, people viewing your image won't know either, and if that happens, the photo just isn't working. Keep this in mind when you're composing your landscape shots, and ask yourself the question, "What's my subject?" If you can't come up with a solid answer immediately, it's time to recompose your shot and find a clear subject. It makes all the difference in the world.

GETTING MORE INTERESTING SHOTS

You always want to shoot from angles we don't see every day. Like, if your subject is mountains, don't shoot them from the road at the bottom of the mountain. This is exactly how we see mountains every day when we drive by them on the interstate. Create mountain shots that have real interest, give people a view they don't normally see—shoot from up high. Either drive up as high as you can on the mountain, or hike up as high as is safe, then set up your camera and shoot down on or across the mountains.

A Timesaving Pano Trick

When you come back in from a shoot, if you shot some panos, you're going to find out one of the challenges of shooting panos: finding them. For example, when you open your images in Adobe Photoshop Lightroom, or Adobe Bridge, or in Photos, etc., you're looking at thumbnails of perhaps hundreds of images from your shoot, and it's a bit of a challenge to figure out where your panos start and end. I have completely forgotten that I have a pano included in a particular shoot, because they just don't jump out at me. Luckily, there's a simple trick that makes finding your panos a two-second job: Before you shoot the first frame of your pano, hold your finger up in front of your lens and take a shot (as you see in the first frame above). Now start shooting your pano. Once you finish shooting the last shot of your pano, hold two fingers in front of the camera and take another shot (as seen in the last frame). Now, when you're looking at your photos in a photo browser and you see one finger in your shot, you know there's a pano starting there. So, select all the photos that appear between your one-finger shot and your two-finger shot—that's your pano. Open those in Photoshop or Lightroom and let it stitch them together for you.

💡 FAKING PANOS

A great way to create a fake pano in Photoshop or Elements: crop the photo so it becomes a pano. Just get the Crop tool (C) and click-and-drag so it selects only the center of your photo, cropping off the top and bottom, leaving you with a wide panoramic crop of your original photo. Hey, don't knock it until you've tried it.

Where to Focus for Landscape Shots

LOCATION: ARIZONA

When you're taking a landscape shot, where do you focus your camera's focal point (that red dot in the center of your viewfinder. Well, its default spot is in the center, but you can move that spot, so if you moved yours, get it back to the middle for this)? With landscape shots, the rule is: you want to focus about one-third of the way into the image. This gives you the widest possible range of focus throughout the image. Also, another trick you can use is to shoot big, sweeping landscape shots at f/22, which gives you the most focus from front to back in your shot.

GETTING THE CLEAREST LANDSCAPES POSSIBLE

Have you ever seen a landscape photo that just has incredible clarity throughout the image? I'm not talking about sharpness—I'm talking clarity (like a total lack of haze, or fog, or any other atmospheric effect). Well, there's a technique for getting that amazing clarity, and it's simple: shoot in winter. The air is the clearest during wintertime, and it's the perfect time of year to get those amazingly clear shots that you just can't get any other time of year.

The Seven Deadly Sins of Landscape Photography

LOCATION: GLACIER NATIONAL PARK, MONTANA

I talk a lot about the things you need to do to make great landscape photos, but here's what to avoid when taking landscape shots. If you can live your life avoiding these seven perilous pitfalls, your landscape shots will be blessed with the magical kiss of first morning light (not really, but they will certainly look a whole lot better).

(1) Choppy Water: When we're shooting a lake or a cozy harbor, what we're looking for is that still, glassy water that creates a beautiful reflection.

(2) Frozen Water in Waterfalls: You're looking for that smooth, silky water—the silkier, the better—and that means you have to keep your shutter open for a long time (the longer it's open, the smoother your water will be).

(3) Bald, Cloudless Skies: Most people find clouds beautiful (I sure do), but when it comes to landscape photography, they're not just there to be pretty.

(4) Harsh, Midday Sun: This light was designed to punish nature and the efforts of anyone who holds up a camera and aims it at any landscape.

(5) A Crooked Horizon Line: If there is one thing that drives people crazy when they look at a photo, it's a crooked horizon line.

(6) Distracting Junk Near the Edges: This one is particularly deadly because it's so easy to miss.

(7) No Foreground Object: If your shot doesn't have a strong foreground element, it's pretty much sunk.

And...Dead Trees and Tree Stumps...And...Okay, I said there were just seven, but I thought I'd add a couple more in, like a flat gray sky, out-of-focus foreground objects, or anything boring.

Getting the Star Filter Effect

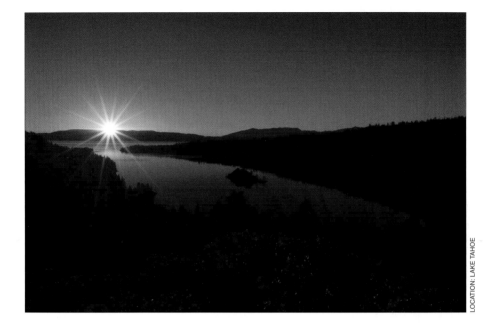

LOCATION: LAKE TAHOE

There are special lens filters you can buy that can turn bright lights captured in your dusk and nighttime images into starbrights. However, if you don't want to spring for a filter, you can get a similar effect right in-camera by doing just two things: (1) Choose an f-stop with the highest number you can, like f/22. And then, ideally, (2) position yourself so the sun is touching something (like a rooftop, or a mountain, or the horizon, or anything where part of the sun is visible and part is touching that certain "something"). That's it.

WHY YOU NEED A WIDE-ANGLE LENS

If you're shooting landscapes, you've probably come back from a shoot more than once and been disappointed that the incredible vista you saw in person didn't transfer to your photos. It's really tough to create a 2D photo that has the depth and feeling of being there. That's why I recommend one of two things: (1) Don't try to capture it all. That's right, use a zoom lens and deliberately capture just a portion of the scene that suggests the whole. (2) Buy a super-wide-angle lens. Not a fish-eye lens—a super-wide-angle lens (like a 12mm). If you're trying to capture it all, a super-wide-angle (sometimes called ultra-wide-angle) lens is often just the trick you need to take in the big picture.

Look for Clouds to Hold the Color

LOCATION: GLACIER NATIONAL PARK, MONTANA

When it comes to shooting landscapes at sunrise or sunset, clouds are usually your friends. Not a blanket of clouds, mind you, but scattered clouds. The reason is you need something to hold the color in the sky. You need something for nature's gradients of color, that happen right around sunset, to play off of, and that something is clouds. If you've ever witnessed an empty, cloudless sky at sunset or sunrise, you know how lifeless they can be, so don't let a weather report that's calling for clouds the next day scare you off from your shoot. Sometimes, it's those clouds that turn the ordinary into the extraordinary.

💡 THE TRICK TO GETTING RICHER COLORS

To get richer, more vivid colors use a polarizing filter. It screws onto the end of your lens and it basically does two things: (1) it cuts the reflections in your photo, and (2) it can often add more rich blues into your skies by darkening them and generally giving you more saturated colors throughout. Two tips: (1) polarizers have the most effect when you're shooting at a 90° angle from the sun, and (2) you'll use the rotating ring on the filter to vary the amount (and angle) of polarization.

Using a Graduated Neutral Density Filter

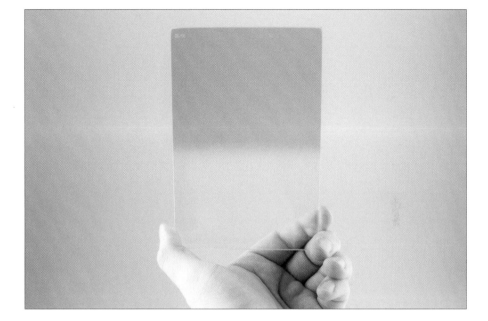

If the polarizing filter is the most important filter for landscape photographers, then a graduated neutral density filter has to be the second most important. This filter is designed to help you do something your camera can't usually do on its own, and that is expose for the foreground without overexposing the sky. That's why this filter has become so popular—it darkens the sky, but it's how it does it that really creates a pleasing effect. This filter is graduated, so it's darkest at the top of the sky, and then it graduates down to full transparency (like a gradient), so the ground doesn't get darkened at all. The one I use is actually rectangular plastic, and I simply hold it up in front of my lens then take the shot. I don't use a lot of filters, in fact just a few, but this is one that makes a really big difference, and that's why it's with me on every landscape shoot.

💡 **GET DOWN LOW**

We shoot pretty much everything from a standing position. So, everything looks just like it would to anyone walking by that same spot. Try something from a different perspective—a view people wouldn't normally see. Get down low—really, really low. If you go down on one knee, you see things from a young child's perspective. Sit on the ground, and you've got a toddler's point of view. But if you really want to take it to the next level, lie on the ground and shoot, showing a perspective normally seen by squirrels (it gives you some idea why they're so nervous all the time).

Keeping Your Gear Dry Outdoors

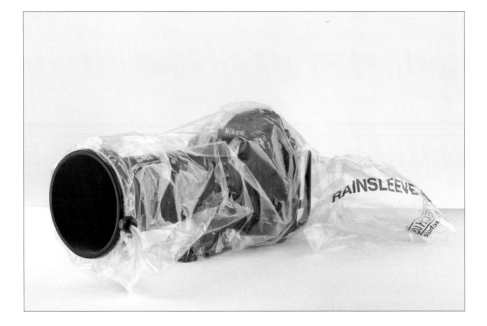

You can buy all sorts of sophisticated rain covers if you wind up shooting in rainy weather quite a bit (take a look at Think Tank Photo's Hydrophobia® covers, which are awesome, but expensive), but the problem is that if the weather unexpectedly turns bad, chances are you might not have a rain cover with you (if you have a small camera bag, it probably won't fit). That's why I keep a package of OP/TECH Rainsleeves in my camera bag at all times. They're not fancy, but they're small enough to always have with you in your camera bag (and they work with lenses up to 18" long). Plus, they're cheap as anything—you can get a pack of two for around $6. I've had to use them before, and they do a pretty decent job for those times you get caught by surprise.

💡 WHAT TO SHOOT IN BAD WEATHER

If it's an overcast or drizzly day, don't spend it inside because you'll miss some great shooting opportunities, like: (1) Right after the rain, while it's still cloudy and dark, is the perfect time to shoot foliage, forests, mossy rivers, and waterfalls. (2) If it's storming, there's a good chance that right after the rain stops, and the clouds break and the sun peeks through, there will be a very dramatic shot. (3) Before the storm "lets loose," you can get some really amazing skies. And, (4) atmosphere (low-hanging clouds or fog) can make for some really interesting landscape photos (we're talking soft, diffused light heaven).

Instant Duotones for Landscape Images

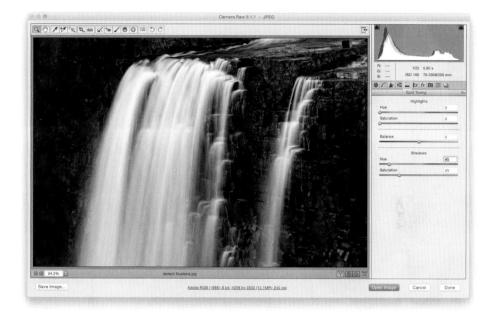

If there's one place where duotone effects look great, it's on landscape images (they can work great for some portraits, too, but I always felt they were born for landscapes). They've always been kind of a pain to create, which is why I've felt photographers don't use them more often. But, I've got a technique for people who use Photoshop's Camera Raw or Lightroom that is so simple, you'll be creating great looking duotones in literally seconds. The first step is to convert the image to black and white. In Camera Raw, go to the HSL/Grayscale panel and turn on the Convert to Grayscale checkbox. In Lightroom, in the Develop module, just press the letter V on your keyboard. Now, go to the Split Toning panel, but don't touch the Highlights sliders at all. Instead, go to the Shadows section and increase the Saturation amount to 25. Next, drag the Hue slider over to somewhere between 25 and 45 (that's usually where I stay for my own work, but you can choose any Hue setting you'd like—just drag the slider to choose a different hue) and you're done. That's it. Done. Finis. Really.

Shooting Waterfalls

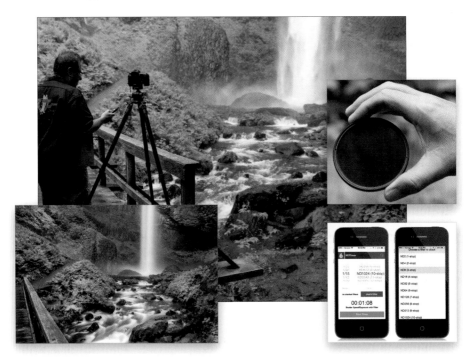

I'm making a long exposure here (to create that silky water), so even though it's daytime, I'm on a tripod, using a cable release. The red light on the back of the camera is on because this behind-the-scenes shot was taken while the shutter was open. The final image was taken with a 16–35mm f/2.8 lens zoomed all the way out at 16mm. My f-stop was f/22 so I could keep the shutter open as long as possible, but I added a 3-stop neutral density filter to my lens (seen above) to keep my shutter open even longer. The sun was behind the waterfall, so I was able to get a pretty decent, silky water effect just setting my f-stop to f/22 without any filter at all because it made my shutter speed 2.5 seconds long, which isn't bad. But, once I added the 3-stop ND filter to my lens, it increased my shutter speed to 15 seconds, which made the water much silkier and smoother. My ISO was 100 (I used the lowest possible ISO not only because I was on a tripod, but because it was my least-sensitive-to-light ISO, so it also forced the shutter to stay open longer). Now, if you need the scene even darker, you can "stack" a second filter on top of the first one (maybe use a 10-stop filter, and then a 2-stop on top). Need to know how long to keep your shutter open? Use an app. I use ND Timer (by Three60, available for IOS; shown above right). It tells you exactly how long to leave it open (even if you stack filters), plus it has a built-in timer. It's just 99¢. Although my camera was able to autofocus with the 3-stop ND filter on, if you use an 8-stop or 10-stop (or stack), it's so dark, your camera won't be able to autofocus. So, focus first with autofocus turned on (before you put the filter on), then switch your focus to manual (on the lens), and put the filter(s) on. I did four things in Lightroom (or Camera Raw; I created a video, which you'll find on the book's webpage, mentioned in the book's intro): (1) increased the Contrast amount, (2) added Post Crop Vignetting, (3) increased the Clarity amount to bring out the detail, and (4) used the Adjustment Brush to brighten some of the highlight areas in the grass and bushes.

Photographing Animals

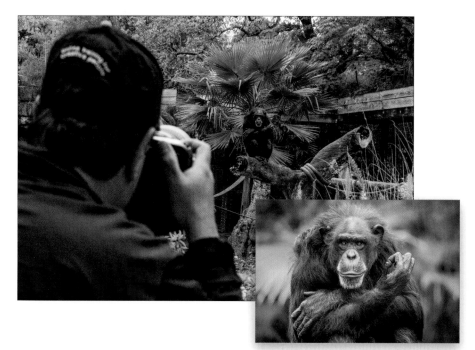

I'm shooting outdoors here in a zoo using a long lens (most zoos allow you to bring in a long lens and, in many cases, even tripods). The final image was taken with a 200–400mm f/4 lens with a 1.4 tele-extender to get in even closer. With that, I'm zoomed in to 506mm on a full-frame camera body. I'm using a monopod to help steady my lens. My f-stop is f/5.6 (the lowest f-stop I can choose with a tele-extender added to my f/4 lens—with the tele-extender, you lose 1 stop of light). My shutter speed is 1/400 of a second at 1250 ISO (I could have lowered my ISO down to 200 or even lower and still probably had enough shutter speed to have the shot be really sharp, especially since my lens was held up with a monopod). When shooting in a zoo, frame the image so you can't actually tell it was shot in a zoo. This is often challenging because, while you may have an unobstructed view of the animal, the background behind them is usually either an ugly fence or an obviously man-made enclosure, or it just looks very different from their actual natural habitat. So, be aware of the background as you're composing your shot. This can get really frustrating because, of course, the animal won't always be in a location that lets you get the shot with a decent background. It requires a lot of patience, and you might have to walk away without getting a good shot, because the animal just stays in one location, or is too far away, or stays in an area with an ugly background. Try shooting from a different angle, which might improve the background. The patience part of this is really key. Another way around this is to zoom in tight and shoot wide open (using the lowest f-stop your lens will allow), which puts the background out of focus, like you see above. In post, I increased the contrast a bit in Lightroom's Develop module (or Camera Raw). Then, in the Effects panel, under Post Crop Vignetting, I dragged the Amount slider to –11 to darken the edges of the image just a tiny bit. Lastly, like every image, I sharpened it using Photoshop's Unsharp Mask filter.

Zoo Photography

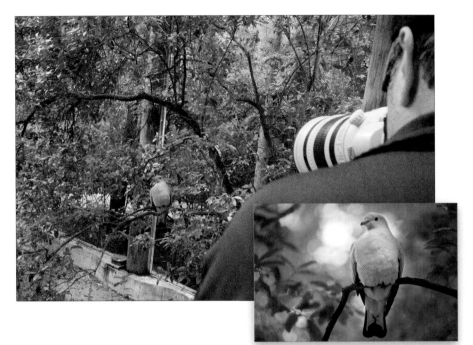

Our subject is perched on a branch inside an enclosed aviary at a zoo. I'm up high in a stand giving me a "bird's-eye view" of the area. The final image was taken with a 200–400mm f/4 lens at f/5.6 on a full-frame camera, but I'm zoomed in to just 280mm (the bird isn't that far away). If you use a cropped-sensor camera, you wouldn't need nearly as long a lens since that crop factor works in your favor, bringing you at least 40% to 60% closer (depending on your make and model, a 70–200mm lens would get you just as close if not closer). My shutter speed is 1/640 of a second at 1250 ISO (I could have lowered my ISO down to 400 and still probably had enough shutter speed to have the shot be really sharp). With any wildlife photo, it's essential to get the eye sharp and in focus, and that was fairly darn easy with the bird just perched there not far from me. I prefer not to shoot up or down at a bird, if possible, so I got down as low as I could to get the final shot above. I was only shooting up a tiny bit (I'm standing in the shot you see above, but to get this image I did wind up kneeling and resting my lens on the railing in front of me). The challenge, once again, was hiding the fence that surrounded the aviary so you couldn't tell it was taken inside one, and by zooming in tight and using a wide-open f-stop (like f/5.6, in this case), I was able to blur the background enough so you can't see the fence or the unappealing area surrounding the bird. Also, make sure you take a look at everything in the frame before you take the shot—there were lots of little distracting branches and twigs that were sticking into the shot when I first framed it up, so I tried moving a foot or so in either direction until I could find an angle where I could get this fairly clean view. For post, in Lightroom's Develop module (or Camera Raw), I dragged the Contrast slider to the right. Then, I went to the Effects panel, under Post Crop Vignetting, and dragged the Amount slider to –11 to darken the edges of the image just a tiny bit. Lastly, like every image, I sharpened it using Photoshop's Unsharp Mask filter (I used quite a heavy amount of sharpening here: Amount 90, Radius 1.5, Threshold 0).

Shooting Cityscapes at Dusk

I'm on a floating dock across the river from downtown Portland, Oregon, on a sturdy tripod, and I have a cable release to minimize any camera movement when I press the shutter button. Since I'm shooting at dusk (and after dusk—more on that in a moment), we need to be on a tripod because our exposure will be fairly long (well, certainly longer than we could handhold). I'm using a 16–35mm f/2.8 super-wide-angle zoom lens, zoomed all the way out at 16mm. I chose an f-stop of f/8 to put everything pretty much in focus, and my shutter speed was 1/10 of a second (much slower than I could handhold). To even get to 1/10 of a second, I had to raise my ISO to 1600, so there wasn't much light out there at all. What you're seeing above is part camera technique, part patience, and part Photoshop. It's actually two photographs: The first is taken right after the sun goes down, so you get that nice sunset sky. The problem is that right after sunset, it's still not really dark outside, so the lights of the city aren't on yet. You're going to need to take a second photo about 20 to 30 minutes later—way after sunset. It's pretty dark in the sky, but by that time, the lights are mostly on and that's what you need for the second image—the city lights (it doesn't matter what the sky looks like for this second shot, it's literally only to capture the lights). Don't move your tripod or the camera at all—not even a inch—between the "just after sunset" shot and the "city lights" shot. Once you have both, then you're going to take the "just after sunset" photo and add the city lights from the second photo to it in Photoshop (this is a common technique, and the only way you get that beautiful sky mixed with beautiful city lights before they would actually be turned on). Open both images in Photoshop, copy-and-paste the "city lights" shot onto the "just after sunset" shot, add a black layer mask, and paint in white over the buildings and bridge, and the city lights appear. If that sounds confusing, just watch the video I created on how to do that (then it'll make sense. You can find it on the book's companion webpage, mentioned in the book's introduction).

Chapter Nine

Shooting Travel & City Life Shots Like a Pro

How to Come Back with Images You're Really Proud Of

When you come home from a really amazing trip, it's not enough to chronicle your trip through photos and show factual images that detail where you were. You want to move people. You want to create images that are so powerful that they make the person viewing them want to go there so badly that they're willing to risk a series of white collar crimes (mostly embezzling) to pay for their trip to that very same place. Now, if you took good enough shots, it won't be long before your friends are overcome with emotion (jealousy) and will have to go to the exact same location to experience that same amazing feeling once again. Now, if either of your two friends have DSLR cameras, it's helpful to understand right up front that they're not going to that spot because they trust your judgment on travel. They're going there because they think they can get better photos from that spot than you did. Then, once they come back and show off their images, all your mutual friends will say something like, "Did you see Rick's photos from Machu Picchu? Wow, his were much better than Sandy's" and at that moment—you've been blinged. Actually, this is what is known as an IB, or an "Intentional Bling," and it gives you some insight into just how shallow your friends really are. But as shallow as they are, you can drain a little more water out of the pond by pulling this quick and easy stunt: when they see a really cool travel shot of yours, and they ask you where you took it (which means they don't already recognize the landmark)—lie. They'll never know. For example, if you shot the Portland Head lighthouse in Cape Elizabeth, Maine, tell 'em it's the Nauset lighthouse in North Eastham, Massachusetts. By the time they catch on, they'll already be back home, and you can feign a mysterious illness.

In This Case, Less Gear Is More

I'm a total gear freak, but the one time I definitely don't want to lug around a lot of gear is when I'm doing travel photography. You're going to be lugging your gear all day long hopping on and off of all sorts of transportation, and as the day goes on, it seems to get heavier and bulkier, and by the end of the day, you've all but stopped digging around in your camera bag. Instead, take as little with you as possible—one or two lenses, tops (see the next page for more info). Also, there are some incredibly lightweight travel tripods available today. When it comes to lugging around lots of gear in an unfamiliar city, travel photography is definitely a case of "less is more." Do yourself a favor and travel light—you'll take more shots, because you'll change lenses and mess with your equipment less.

💡 HOW TO KNOW WHAT TO SHOOT

Before you travel to a new city, do some research to see what other photographers have shot there and where they shot it. A great place to do this type of research is the websites of the big stock agencies (like Corbis or Getty Images). If you're looking to find the shots everybody else misses, visit 500px.com. Just search for the country or city you're going to.

My Favorite Travel Lenses

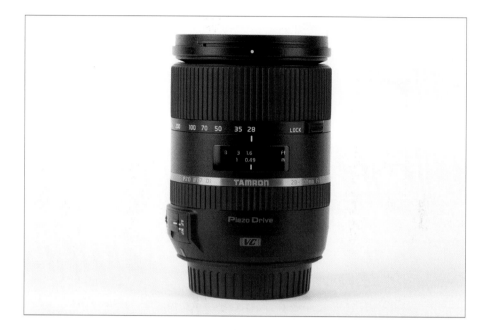

I like to keep my camera rig really light and simple when I'm on vacation, because after all, I'm on vacation (not on assignment). So, I usually go with just one lens that "does it all." With a cropped sensor camera, I recommend an 18–200mm lens (both Nikon and Canon make an 18–200mm f/3.5–f/5.6 lens), so you can cover everything from wide-angle to tight zoom without ever changing lenses. For a full-frame camera, I'd check out a 28–300mm f/3.5–5.6 (which is pretty close to the equivalent of the 18–200mm on a cropped sensor). This has become my "go-to" lens for travel, because once again, it covers it all (from wide-angle to tight zoom). An affordable option in the 28–300mm range for full-frame cameras is Tamron's lens. However, if it's one of those "once-in-a-lifetime" trips to somewhere really exotic, then you might want to consider taking a super-wide-angle lens, too (like a 12–24mm for cropped sensor bodies or a 14–24mm for full-frame bodies) for wide cityscapes or big sweeping scenes at a temple. Now, some of these "super wides" can be pretty pricey, but that's what lens rental houses like LensProToGo.com and BorrowLenses.com are all about.

 DON'T CARRY A CAMERA BAG—CARRY A LENS BAG!

If you're only taking one extra lens (like I mentioned above), you might want to consider taking along a lens bag. They're smaller, they strap across your chest (much harder for anyone to swipe in big cities), and they're just big enough to hold a lens, a cleaning cloth, and a filter or two. Check out the ones from GoBoda. Really well-designed.

What to Do When It Has Been "Shot to Death"

If you travel to a famous city, your friends and family at home will expect shots of that city's most famous landmarks. So, get those out of the way first—shoot those for the folks back home now and get them "in the bag." Then, you can spend the rest of your time showing the city your way—shooting the people, the local flavor, the customs, and taking shots that speak to you. But, what do you do when you know it has been shot to death? The obvious thing is to shoot it from a different angle. Since, in many cases, that angle just doesn't exist, try this: shoot the landmark in weather it's not normally seen in. Since the landmark doesn't change, shoot it when its surroundings are changing to get that shot that you just don't see every day. Here's another idea: try shooting it from a difficult place to shoot from (in other words, shoot it from some view or vantage point that would be too much bother for most folks to consider. Find that "pain in the butt" viewpoint, and chances are you'll pretty much be shooting it there alone). Now, when you're out shooting a cathedral, or a stadium, or a building, etc., take one extra shot—shoot the sign so you won't be scrambling to find the name later. If you ever wind up selling the photos, you will absolutely need this info.

💡 **THE BEST SHOT MAY BE JUST THREE FEET AWAY**

My good friend Bill Fortney said it best, "The biggest impediment to photographers getting great shots is the fact that they don't move. The best shot, the best view, and the best angle is sometimes just three feet from where they're standing, but they just don't move—they walk up, set up, and start shooting." Besides just moving left and right, you can present a different view by simply changing your shooting height.

Shoot the Details Instead

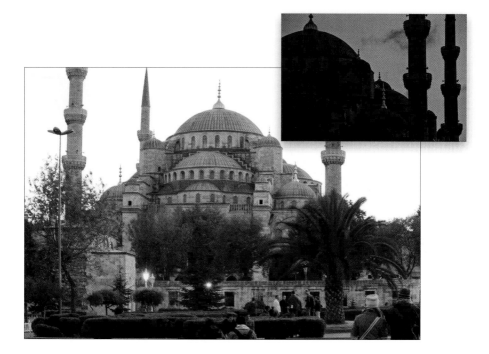

Here's a shot from Istanbul, Turkey, of the famous Sultan Ahmed Cami Mosque, also known as the "Blue Mosque," taken just before sunset. The problem with capturing something so large is that you're surrounded by distracting stuff—everything from tourists to street lamps—which makes it really hard to capture unless you're up very high shooting down on it. In my *Shoot Like a Pro* seminar tour (which is based on this series of books), I talk about how challenging it is shooting things like the exteriors of cathedrals, theaters, opera houses, and the like, because they're not usually all by themselves on a flat, unobstructed piece of land. They're usually downtown, and they're usually surrounded by either construction/restoration equipment (think construction cranes, barriers, and fences) or local businesses with signs, power lines, and such. It makes capturing a clean, unobstructed shot really tough. That's why I recommend zooming in and focusing on just one important part of the structure, like I did in the smaller shot above. I also waited until the sun had gone down. That shot was taken 1 hour and 11 minutes after the larger shot, which also means I had to shoot on a tripod because the light was so low (there was no way I could get to the 1/60 of a second or faster shutter speed I would need to handhold this shot). By only showing part of the structure, you're bringing the viewer something they wouldn't see if they were just standing there. Plus, zooming in tight on an important detail area is a very powerful and dynamic way to present a large structure like this. I shot with a 70–200mm f/2.8 lens zoomed in to 135mm. My f-stop was f/5.6 and my shutter speed was 1/15 of a second. My ISO was 200 ISO (the lowest, cleanest ISO for the camera body I was using). Just three main things for post-processing: (1) The mosque is backlit, so I opened up the Shadows in Lightroom's Develop module (or Camera Raw) to bring out detail. (2) To enhance the texture, I increased the Clarity, and then (3) I dragged the Tint slider to the right toward magenta to make the sky color more interesting.

Hiding Tourists, Cars, Buses, etc.

This shot was taken in the heart of Rome, Italy. I was standing in a small park across the street from Altare della Patria (Altar of the Fatherland). No matter what time of day you're standing in front of it, the view will pretty much always have cars, buses, scooters, and tourists right in front of it. Using Photoshop to clone all those cars and buses out of the way would be a nightmare, because you'd have to rebuild a lot of the front of the building. So, instead, try this: get down really low. This totally changes your perspective and field of view, and uses the foreground grass to hide distracting stuff like cars and buses. It took me a few shots, and using Live View to check my positioning, to get it right, but that's okay—the film is free, right? By the way, you can use this same trick shooting your kid's sporting events to hide the outfield fence on a baseball field, or the empty stands on a soccer field, or to hide anything in your line of sight when standing. For travel photography, I'm generally a "one body, one lens" guy. My go-to full-frame lens for travel now is a 28–300mm f/3.5–6.3 (see page 153 for more on this). In the final image, I'm zoomed out wide at 35mm, and I'm at f/6.3 at a shutter speed of 1/100 of a second (it was kind of overcast). My ISO was at 100. For post-processing, I added some contrast and sharpening, and used the Shadows slider to open up the shadows in the building a bit (just drag it to the right in either Lightroom's Develop module or in Camera Raw). While this makes for a good example, it doesn't make a really great shot, especially with that scaffolding on the left side of the building. Want to see how to get rid of stuff like that? Watch the video I made to show you how on the book's companion webpage (mentioned in the book's introduction).

Another Trick for Hiding Tourists

This is Sainte-Chapelle in Paris, France. It's one of the most amazing churches I've ever seen. It has these tall, amazing, stained glass windows on all sides, all the way around the entire church. Everything below the stained glass is gold leaf—the whole place is just stunning. It's also very small and always very crowded, and it was also under restoration—you can see scaffolding along the entire left wall in the large shot above. I can deal with that, but the tourists are a different problem. I've shown this shot many times to people who have been to Sainte-Chapelle and heard, "How in the world did you get this shot without the place being packed with people?" Now, you can try to get there before all the tourists do, but that doesn't always work—the earlier it opens, the better chance you'll have that there won't be as many tourists in line. However, this shot was taken just moments after the shot with all the people. The trick here is simply to raise the camera high enough that you're looking just over the tops of their heads. They're all still there, but I composed the shot aiming upward. If I lowered my lens barrel even a half-inch, you'd see the tops of their heads. You'd think viewers would say, "Where's the bottom of the church?" but not a single one has (only when I tell them the trick do they realize the floor is missing). For the final shot, I used a 14–24mm f/2.8 lens and took the shot at 14mm. Even at f/2.8, and at 800 ISO, I could only get my shutter speed to 1/20 of a second. That is very risky for handholding a shot (no tripods allowed here) and I should have increased my ISO to get my shutter speed above 1/60 of a second. I can only imagine I wasn't paying enough attention (I was seriously blown away at seeing this church). So, I attribute the fact that I got a sharp shot at 1/20 of a second to a steady hand and a lot of luck. This shot has a lot of post-production because (1) it's an HDR shot, and, (2) I had to select the right half of the photo in Photoshop, copy it onto its own layer, flip it horizontally, and then drag it over the scaffolding to hide it. I did a video tutorial to show you how it's done (it's on the book's companion webpage mentioned in the book's introduction).

Zooming to Hide Distractions

Here, we have two guards, manning their post in Beijing's Tiananmen Square, with a backdrop of the main entrance of the Forbidden City (they do a flag-raising ceremony here each day). There are a lot of problems with this larger photo, including the fact that the guard on the left looks somewhat distracted and the fire extinguisher isn't adding a lot to the shot. There are also a lot of cars and buses between the guards and the Forbidden City entrance. All of these things are competing for your attention when this shot is really just about the guard on the podium. By zooming in tight, you can eliminate a lot of distractions in your image and simplify it, which generally makes it stronger. In this case, one of the benefits of zooming in was that I was able to frame the subject so it looks like he's under the ever-watchful eye of Chairman Mao Zedong across the street. The fact that the guard appears to be casting a suspicious glance helps sell the story even more (though capturing his suspicious look was just plain luck). By putting the background out of focus, it visually separates the guard from the busy background, and by composing the image with all that negative space to the right of him, it draws your eye directly to him, making a more dynamic image. For the final image, I was using a 70–200mm f/2.8 lens zoomed all the way in to 200mm to put the background as out of focus as I could. (*Note:* I had to walk a few feet backward to be able to frame the shot with lots of negative space on the right side of him.) For the same reason, my f-stop was f/2.8. My shutter speed, even this late in the day, was 1/1600 of a second (thanks to using such a wide-open f-stop like f/2.8). My ISO was set at the cleanest native ISO for that full-frame camera body, which was 200 ISO. I did use Photoshop's Clone Stamp tool to remove some distracting things from the background, including red cones and part of a truck on the edge of the frame, and sharpened the image in Photoshop, as well.

There's a Picture in There Somewhere

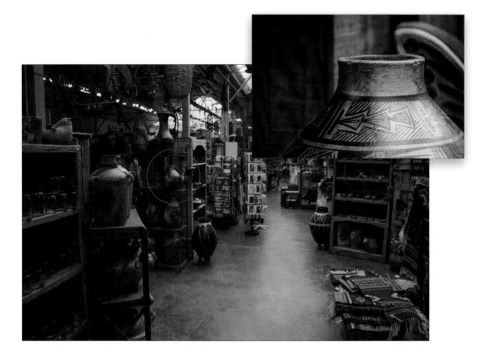

This was taken inside Jackalope, one of the awesome gift shops in Santa Fe, New Mexico. Lots to shoot indoors and out, and the place is very camera friendly. We've all been in situations where you see all this cool stuff in one place, but it's so busy or crowded that it's hard to think there's even a shot there. In situations like this, it helps to remember that we don't have to show every-thing we see in front of us—we can pick and choose what winds up in the frame. By zooming in tight, we only reveal what's in our frame—which, in this case, was just this one vase—as if it were all alone. If I had moved even an inch to the right, you would have seen the price tag of the butterfly carving behind it. So, while I'm composing the shot, I'm moving a few inches in either direction to see which one gives the least distracting image, and this was my favorite of the ones I took. I used my same go-to travel setup here (one camera body and my go-to travel lens, the 28–300mm f/3.5–6.3). For the final image, I'm zoomed in reasonably tight at 200mm and, at that zoom amount, my f-stop could only go as low as f/5.6. Because we were indoors, I had to bump up the ISO to 400 to get my shutter speed to 1/60 of a second (that's about the minimum most folks can handhold a shot and still have it nice and sharp. Any slower and your image would be a little blurry). So, to sum up, I'm at f/5.6, at 1/60 of a second shutter speed, at 400 ISO. The behind-the-scenes shot above was shot at 28mm (wide angle), so I could get my f-stop down to f/3.5, and that increased my shutter speed to 1/640 of a second—plenty of speed to get a sharp shot. So, while it's nice and sharp, it's just a "meh" shot, which is why I needed to zoom in to make something out of it. For post-processing, I increased the Contrast amount in Lightroom's Develop module (or Camera Raw), and then darkened the outside edges by drag-ging the Post Crop Vignetting Amount slider to the left in the Effects panel.

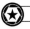

Working People into Your Travel Shots, Especially Kids & Old People

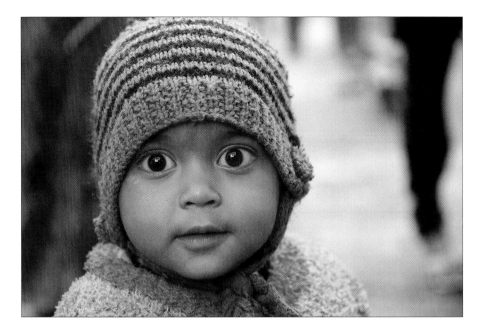

If you want to improve your travel photos, here's a simple trick: add more people to your shots. When you really want to capture the flavor of an area, don't just shoot buildings, cathedrals, and monuments—show the people of that area. Nothing conveys the character and soul of a city more than its people, and that's why many of the top travel photo pros work people into their shots. If you're feeling disappointed with your travel shots, it's probably because you're looking at cold buildings and empty streets. Add people and everything changes (for the better). Travel magazine photos have two main people themes: old people and children. Now, when I say old people, I don't mean people in their late 50s. I mean really old people, and by that I specifically mean old, wrinkly, craggy-looking women whose skin looks like shoe leather, and old, hobbly, crusty men with canes, wearing hats that haven't been washed since the Korean War. As for kids, the younger the better (but skip the babies). As long as you shoot them on uncomplicated, simple backgrounds, kids make incredibly compelling additions to your urban and travel pics. Also, if you get either age group to pose for you, make sure you spend some time talking with them before you start shooting—it can go a long way toward loosening them up, which will give you more natural looking poses and expressions (plus, they'll probably let you shoot longer after you've built up a little rapport).

💡 WHAT NOT TO SHOOT

Okay, so kids and old people are "in." What's out? Crowd shots. They're just about useless (you won't even put 'em in your own travel album). Shoot an empty street first thing in the morning, or shoot two people together, but skip the crowds.

Getting People to Pose

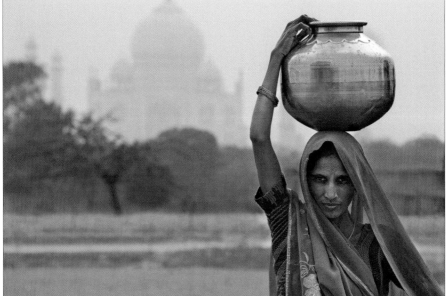

LOCATION: AGRA, UTTAR PRADESH, INDIA

Candid shots of some of the locals make a nice addition to your travel shots, but if you have too many of them, they start to look less like travel photos and more like surveillance photos. To get those close-up, fascinating personal shots, you'll need to get some of the locals to pose for you. One of the best tricks for getting people to stop what they're doing and pose for you is to get them to let you take the first shot. When they see that I have a camera, I smile at them, hold up the camera with my finger on the shutter, and nod my head as if to say, "Is it okay if I take your picture?" Most of the time, they smile and nod back, and pause just long enough to let me snap one photo. Then I immediately turn the camera around and show them the photo on the camera's LCD monitor. Once they see that photo on your LCD, it kind of breaks down a barrier, because everybody loves a photo (especially if they're the subject), and they're usually more than happy to pose for a few more.

> ### 💡 A SUREFIRE WAY TO GET THEM TO POSE (BUY STUFF)
>
> If you're uncomfortable with the "lift-and-nod" technique I outlined above, here's one that can't miss—find somebody selling something and buy one. If you're in a market, and you buy something from a vendor, you can bet that they'll pose for a quick picture or two, because now you're not just some tourist with a camera, you're one of their customers. This one works like a charm.

Hire a Model (It's Cheaper Than You'd Think)

LOCATION: EIFFEL TOWER, PARIS, FRANCE

How do the pros get those amazing shots of people in exotic locales? One of their tricks is to hire a local model (especially if they're shooting to sell the photos to a stock photo agency). Now, if you think hiring a model is out of your budget, it's usually cheaper than you'd think (well, unless you were thinking it's really, really cheap). Here's a real world example: I hired a professional model for a shoot in New Mexico, and the going rate was $15 per hour, plus I had to provide her prints from the shoot for her portfolio. Some models new to the business will work for free in exchange for you making prints for their portfolio (the term for this in the business is TFP, which stands for "Time For Prints," [they are trading their time for your prints]), so ask your prospective model if they do TFP. If they look at you and ask, "Does that mean Tampa Free Press?" you should probably find another model. Two worldwide resources for finding working models online: www.modelmayhem.com and www.onemodelplace.com.

💡 GET THAT MODEL RELEASE!

If you've hired a model, make absolutely certain that you get your model to sign a model release, which enables you to use those shots for commercial work. You can find some sample model releases online (I believe the PPA [Professional Photographers of America] has downloadable release forms available for its members), and having one could make all the difference in the world.

Look for Bold, Vivid Colors

LOCATION: HAVANA, CUBA

One of the things to keep an eye out for when you're shooting urban and travel shots is the bold, vivid colors of the city. You'll often find brilliantly colored walls, doors (a bold-color wall with a contrasting colored door), shops, signs, cars, and bikes. One of my favorite urban shots was of a bright red Vespa scooter parked directly behind a bright yellow Lotus sports car. It almost looked set up, and I took dozens of shots of it because the colors were so vivid and perfectly matched. Keep your eyes peeled for brightly painted walls (especially if you find someone working in front of the wall, or waiting patiently for a bus with the wall in the background, or a bright car parked in front of a bright wall). If you're looking for these colorful combinations while you're out exploring, you'll be surprised at how often they'll reveal themselves to you. By the way, I know I'm beating a dead horse here, but these colors will look richer and have more depth in (you guessed it) great light, which generally occurs (you know it) around dawn and dusk. Just remember, the next best thing to those two is open shade.

GIVE YOURSELF A THEME

To spark your creativity and show the city in a different light for a day, give yourself a mini-assignment. Pick a topic and spend part of the day focusing on that subject. Some ideas are: charming street numbers; interesting doors and/or doorways; things that are one vivid color; weather vanes; flowers; charming local barns; close-ups of local architecture; coffee cups; those little food signs in local markets; interesting columns, traffic signs or street signs; mailboxes; or things that are a particular shape.

For Maximum Impact, Look for Simplicity

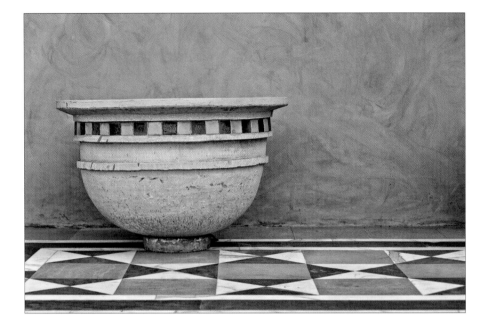

The single thing that probably kills more properly exposed city life photographs than any-thing else is clutter—all the distracting background items, foreground items, and just general stuff that gets in the way. So, one of the big secrets to creating powerful and dramatic urban and travel shots is to strive for simplicity. Look for simplicity in your backgrounds, in your people shots, in your architectural elements, in every aspect—the simpler the surroundings, the more powerful the impact. Go out shooting with that very goal in mind. Look for the ab-sence of distraction. Look for the absence of clutter and noise, watch for distracting elements that sneak into the top and sides of your frame, and create some photos that have great impact, not because of what they have, but because of what they don't have—lots of junk.

💡 HOW TO AVOID BLURRY TRAVEL SHOTS

I picked up this tip from my buddy, Scott Diussa: To keep you from "missing the shot" due to slow shutter speed, turn on your camera's Auto ISO feature. This tells your camera to automatically raise your ISO if it sees your shutter speed get below a minimum shutter speed that you choose (I choose 1/125 of a second, because almost anybody can handhold a shot at that speed and it'll be in focus). Set your maximum at 1,600 ISO, because a photo with a little noise beats the heck out of one that's even a little bit blurry.

Shoot the Food

In every travel magazine feature about a charming city, you'll find a photo of its food. Trying new dishes is one of the fun things about traveling, so why wouldn't you include them in your photographs? Watch the expressions of people who look at your album when they come across a photo of a great-looking dish, and you'll always "shoot the food." Your best opportunities are during the day—ask to sit near a window (to catch some of that gorgeous natural window light) or outside (preferably under an umbrella or awning, so you can shoot in shade). If you've got a white tablecloth, you've got a great background to shoot on—just remove distracting items from around the dish as much as possible. Also, the classic food shots you see in travel magazines generally have two things in common: (1) They use a very shallow depth of field (where the front of the plate is in focus and the back is somewhat out of focus). To do this, use the lowest f-stop possible (f/4, f/2.8, or lower if you can). And, (2) shoot plates that have great presentation (food that's beautifully arranged on the plate, which usually comes from higher-end restaurants).

💡 WHAT TIME TO SHOOT

The best time to shoot urban and travel shots is probably dawn, when the light is golden and the streets are empty. Second best is dusk (still golden light, but no empty streets), but you can shoot in open shade during the day. If you want that killer shot of the city skyline, wait until about 30 minutes after sunset and shoot at twilight. You absolutely, positively must take this type of low-light shot with a tripod, though, because your shutter is going to have to stay open for a full second or more.

The Trick for Shooting at Night

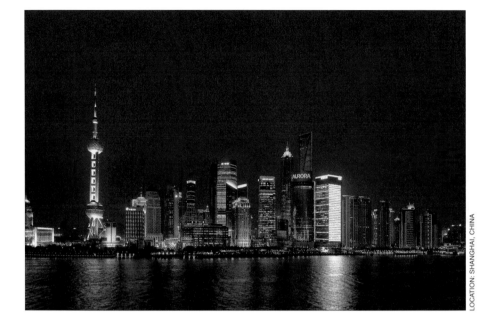

LOCATION: SHANGHAI, CHINA

If you're shooting outdoors at night, don't shoot with one of your camera's standard modes, like aperture priority, or any of the preset modes, like landscape or portrait. They work pretty well during the day, but shooting at night, and getting the night sky to be that really dark blue or black that you're seeing with your eyes, often isn't going to happen with one of those modes, because they'll make the whole image too bright (your camera doesn't know it's night, so it's just doing its job of trying to make a proper exposure). The real secret to shooting at night is to shoot in manual mode. To do that, you'll need to use the meter inside your camera's viewfinder (this is so easy to do, you'll be amazed, so don't let this freak you out one little bit). Switch to manual mode and dial in a starting shutter speed (at night, you'll be on a tripod, so try something like 1/30 of a second to start). Then, to start, choose an f-stop of f/8. Now, look in your camera's viewfinder for the meter. There's a big line in the center of your meter, and then little lines that go above it and below it (or to the left and right). If you see lines above the big line, it means that if you shot right now, your shot would be too bright (overexposed), so try moving your sub-command dial (or quick control dial) until you see those lines go away (which means perfect exposure). Now, that may be technically correct, but if that night sky isn't nice and black (or dark blue), keep turning that dial until it underexposes.

💡 **THE MONOPOD SCAM**

While many places have a strict policy banning tripods indoors, they don't have a policy on monopods. So, if they say anything to you about shooting on a monopod, you can always say, "Hey, this isn't a tripod." It often stops them dead in their tracks.

Shooting Light Trails

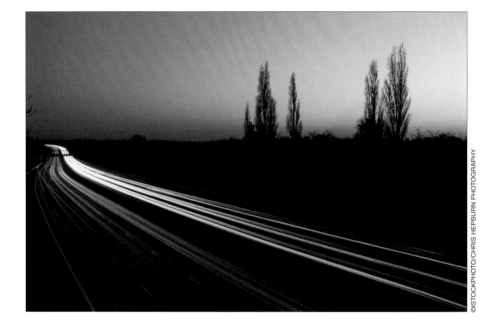

©ISTOCKPHOTO/CHRIS HEPBURN PHOTOGRAPHY

When I think of light trail shots, I always think of the light trails from cars driving at night, and they're easier to shoot than you might think. You just need a tripod and shutter release (to keep everything from moving while your shutter is open, and it's going to be open for a few seconds—long enough for the lights to move. By the way, the longer your exposure, the longer those light trails will be). Once your camera is on the tripod, and your shutter release is ready, change your shooting mode to manual, dial in an f-stop that makes everything in focus (like f/11), and start with a shutter speed of 15 seconds (you may have to increase it to 20 seconds or more, but start here). Make sure your ISO is at its cleanest setting (for most DSLRs, 100 or 200 ISO). When you see a car coming into your view, just press your shutter release, wait 15 seconds, then take a look at the image on your LCD to decide if you need to increase your shutter speed (remember, longer shutter speeds mean longer light trails, so it's worth a try). One of the most popular, and interesting, locations for shooting light trails is a high vantage point—either on an overpass, or a bridge, or someplace where the cars are below you.

💡 LOOK FOR HIGH VANTAGE POINTS

The average person's view of a city is from the city streets (or a tour bus), so if you want more compelling photos, look for a different vantage point—one above the city. You can also ask for a hotel room on the highest available floor. If you don't have a balcony or window you can open, you can shoot through the window if you: (1) turn off any lights in your room—they'll cause reflections—and (2) put your lens or lens hood as close to the glass as possible. A polarizing filter can cut reflections, but you may need to shoot on a tripod.

Including the Moon and Keeping Detail

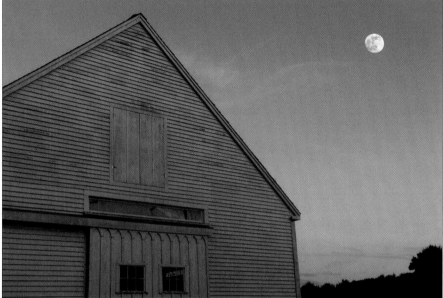

SCOTT KELBY AND ©ISTOCKPHOTO/DAVID LENTZ

This sounds like it would be easy—a nighttime scene with a crisp detailed moon in the sky in the background, but most people wind up with a totally overexposed bright white circle, rather than the detailed moon shot they were hoping for. That's because it's just about impossible to get both the nighttime scene (which takes a long exposure) and a detailed shot of the moon (which takes a very short exposure because it's actually quite bright) in the same shot. So, what photographers have been doing for years is creating multiple exposures (two images captured in the same frame). Now, there are some digital cameras today that let you create double exposures, but it's just as easy to take two separate photos—one of the nighttime scene (a barn, in this case), one of the moon—and combine them later in Photoshop. First, start with your nighttime scene. Use a wide-angle lens (maybe an 18mm or 24mm), put your camera on a tripod (an absolute must), set your camera to aperture priority mode, choose f/11 as your f-stop, and your camera will choose the shutter speed for you (which may be as little as 20 or 30 seconds or as long as several minutes, depending on how dark the scene is), then take the nighttime scene shot. Now switch to your longest telephoto (or zoom) lens (ideally 200mm or more). Switch to full manual mode, and set your aperture to f/11 and your shutter speed to 1/250 of a second. Zoom in as tight as you can get on the moon, so there's nothing but black sky and moon in your shot (this is critical—no clouds, buildings, etc.), then take the shot. Now add the moon to your nighttime scene in Photoshop (visit **kelbytraining.com/books/moon** to see my step-by-step Photoshop tutorial on how to do this).

Shooting Fireworks

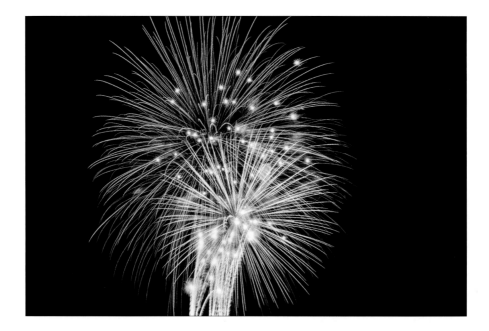

This is another one that throws a lot of people (one of my best friends, who didn't get a single crisp fireworks shot on the Fourth of July, made me include this tip just for him and the thousands of other digital shooters that share his pain). For starters, you'll need to shoot fireworks with your camera on a tripod, because you're going to need a slow enough shutter speed to capture the falling light trails, which is what you're really after. Also, this is where using a remote shutter release really pays off, because you'll need to see the rocket's trajectory to know when to push the shutter button—if you're looking in the viewfinder instead, it will be more of a hit or miss proposition. Next, use a zoom lens (ideally a 200mm or more) so you can get in tight and capture just the fireworks themselves. If you want fireworks and the background (like fireworks over Cinderella's Castle at Disney World), then use a wider lens. Now, I recommend shooting in full manual mode, because you just set two settings and you're good to go: (1) set the shutter speed to 4 seconds, and (2) set the aperture to f/11. Fire a test shot and look in the LCD monitor to see if you like the results. If it overexposes, lower the shutter speed to 3 seconds, then check the results again. **TIP:** If your camera has bulb mode (where the shutter stays open as long as you hold the shutter release button down), this works great—hold the shutter button down when the rocket bursts, then release when the light trails start to fade. (By the way, most Canon and Nikon digital SLRs have bulb mode.) The rest is timing—because now you've got the exposure and sharpness covered.

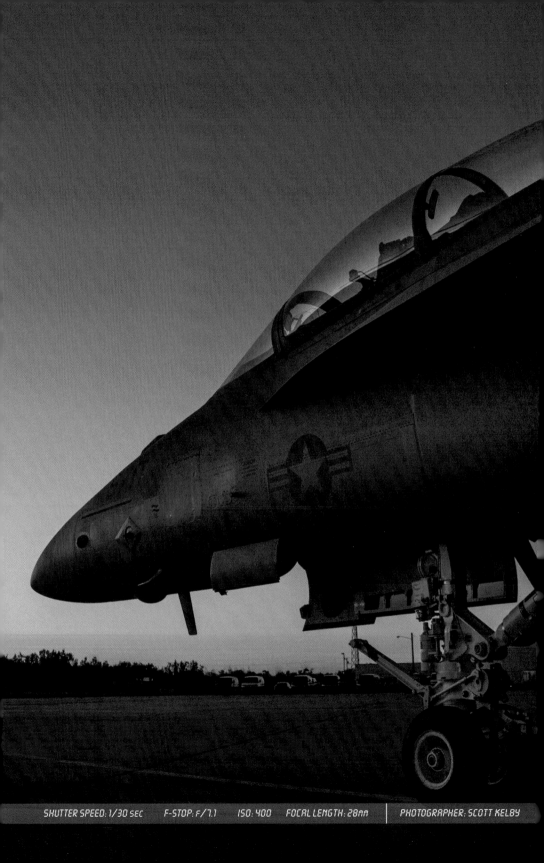

Chapter Ten

Shooting Other Stuff Like a Pro

Tips for All That Other Stuff We Shoot

What do you call things that you don't have an exact name for? Oh, that's easy. That's "stuff." For example, if you're out with a friend shooting, and your friend says, "Hey, take a shot of that stuff over there," you know exactly what they mean and you turn and nail the shot. Now, imagine that same scenario, but you can't use that amazing catch-all term and, instead, you have to try to describe it. Your friend turns to you and says, "Hey, take a shot of that over there?" You say, "Where?" They say, "Over there! That area over to your right." You say, "I don't see it." Your friend says, "Oh my gosh, it's right over there." You have no idea what they're talking about so, of course, you miss the once-in-a-lifetime shot of a killer whale jumping fully and completely up out of the water, chasing a fully grown male seal who somehow manages to avoid the razor-sharp teeth of the graceful mammal, and you're just standing there as the whale watches hopelessly as his catch of the day escapes into the icy waters below your inflatable Zodiac chase boat. If your friend had just said, "Take a shot of that stuff," you'd be walking up to the podium right about now to accept your World Press Photo award (Best of Show) for the image you titled, "The One That Got Away," and just as the flashes of the press on hand are firing, and you're lifting the heavy crystal award over your head and waving to your breathtakingly handsome husband and two perfect kids (one boy, one girl), and you're daydreaming about the new full-frame body you're going to buy with your $10,000 Best of Show check, your cell phone rings. It's *National Geographic*, and you're about to explode with excitement until you hear that it's actually one of their lawyers, and they want to talk to you about some screen captures you have on your tablet. See, that's the kind of "stuff" I'm talking 'bout!

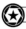
Don't Shoot Down on Flowers

On an average day, if you were to walk by some wildflowers in a field, or along a path in a garden, you'd be looking down at these flowers growing out of the ground, right? That's why, if you shoot flowers from a standing position, looking down at them like we always do, your flower shots will look very, well…average. If you want to create flower shots with some serious visual interest, you have to shoot them from an angle we don't see every day. That usually means not shooting down on them, and instead getting down low and shooting them from their level. This is another one of those things the pros routinely do and most amateurs miss. The shots above show the difference: on the left, the typical "shooting down on flowers" shot; on the right, the same flower in the same light using the same focal length lens shot 30 seconds later, but I shot it from the side (down on one knee) instead of shooting down on it. You can see the difference shooting a non-typical angle makes. By the way, while you're down there, try getting really low (down below the flowers) and shoot up at them for a fascinating angle you rarely see!

💡 TIPS FOR SHOOTING FLOWERS

Where do you get great flowers? Just go to a florist and buy them. You can pick exactly which flowers you want, and chances are the flowers you're getting are in great shape and fresh. Best backgrounds? The most dramatic is a black background. Buy a yard of either black velvet or velour for behind your flowers. White is also popular. Buy a few sheets of white mounting board, then position one behind the flowers and use another to reflect natural light (from a window with indirect sunlight) back onto the white background, so it doesn't look gray.

Don't Wait for Rain—Fake it!

This one may sound cheesy at first, but you'll be shocked at how well this works. Instead of waiting for a rainy day to shoot, take a little spray bottle with you, fill it with water, and spray the flowers with water yourself. I found a nice little spray bottle in Walgreens' beauty section (I know what you're thinking, "Walgreens has a beauty section?" Believe it or not, they do) for a couple of bucks, and it works wonders. Just a couple of quick spritzes with the spray bottle and you've got some lovely drops of water on your petals, and no one will ever know you didn't wait patiently for Mother Nature to intervene. Get a small enough bottle and you can carry it in your camera bag (empty, of course). By the way, I've used this spray bottle technique to shoot some yellow roses I bought for my wife, and by using a macro lens, you'd swear I was shooting on the White House lawn after a spring shower. Try this once—you'll become a believer.

💡 WHICH LENSES TO USE FOR SHOOTING FLOWERS

A macro lens lets you get a 1:1 view of your subject and reveal flowers in a way that only macros can. A macro lens has a very shallow depth of field—so much so that when photographing a rose, the petals in the front can be in focus and the petals at the back of the rose can be out of focus. A close-up lens will turn your telephoto zoom lens into a macro lens for 1/4 of the price, and 1/10 the weight and size. And, finally, zoom lenses work great for shooting flowers for two reasons: (1) you can often zoom in tight enough to have the flower nearly fill the frame, and (2) it's easy to put the background out of focus, so the focus is just on the flower.

Shooting HDR: The Gear

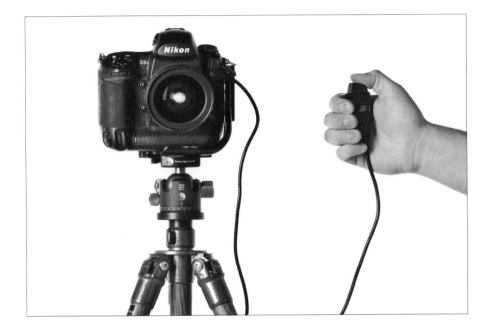

I was going to call this "The Essential Gear," but thanks to some pretty significant improvements in the software we use to create our HDR images, they're only essential if you're going to become a serious HDR shooter. You no longer absolutely need this gear to successfully shoot an HDR image, especially if you're just giving it a drive around the block to see if you like it. Now, if you try a few HDR shots, and you fall hopelessly and deeply in love with HDR (hey, this has happened to some of my friends—people who otherwise led normal, everyday lives until that point), then you should definitely invest in at least two pieces of gear that will give you better-quality HDR images. They are: (1) a decent tripod, unless you only plan on shooting HDR shots in really bright sunlight (which won't actually be the case, because some of the coolest HDR stuff is shot indoors), and (2) a cable release, so you don't wind up adding any extra vibration that might mess up your image. Now, there's a reasonable chance you already have both of these (especially if you've read any of the previous books in this series), and if you do, you should definitely be using both of these when you shoot your first HDR shot, because they will give you sharper images, and with HDR that sharpness is key. Also, since you might be considering just dipping your toe into the HDR pool of love, I want to let you know what the basic workflow will be, because it's a two-part process: the first part is shooting a particular way (hopefully using the gear just mentioned), because you know, up front, you want to create an HDR image, and the other part is combining these images into a single image and then adjusting that image so it looks good to you (more on all this on the following pages).

Shooting HDR: The Basic Idea

First, a couple things: (1) shooting and toning HDR is actually fairly easy and probably way easier than you'd think, and (2) within the HDR community of photographers, no two seem to ever agree on anything, during any phase of this process, when it comes to making an HDR image. That being said, the first part of this process is shooting. You're going to set your camera up to shoot a series of shots of the same thing—without moving at all—and what you basically need is one regular shot, one shot that is underexposed (darker) by 2 stops of light, and one that is overexposed (brighter) by 2 stops of light—three images total of the exact same scene (some photographers shoot seven bracketed photos, or even 11, but for our purposes here, we're just going to use those three, which are enough to create a good-looking HDR image). If you use a Canon camera, and switch your camera to Av mode, set your f-stop to something like f/8, turn on Exposure Bracketing, and take three shots in a row, you'll have exactly what you need (one regular shot, one 2 stops darker, and one 2 stops brighter). That's the way Canon cameras and some Nikons bracket—2 stops at a time. Some Nikons, however, only do 1 stop at a time, so you'll have to take five bracketed shots, even though you'll only use the first shot (normal), the second shot (2 stops darker), and the fifth shot (2 stops brighter). One other thing photographers don't agree on is exactly which f-stop to use, but everybody pretty much agrees you need to use an f-stop that keeps a lot of your image in focus. Personally, I generally shoot my HDR shots at f/11 and most of the pros I know use f/8, but if you go on the web and search for this, you'll find people touting everything from f/1.8 to f/32. So, who is right? That's easy. Me! (Kidding. Totally a joke.) People make great cases for all different f-stops for the particular subject they're shooting, but if you're new to this, why not try f/11 for starters? If you're shooting indoors, though, try f/8 as f/11 may overexpose your images. On the next page, we'll look at how to turn this bracketing on.

Setting Up Your Camera to Shoot Bracketing

First, I recommend setting your camera to aperture priority mode. Okay, onto the bracketing: Exposure bracketing was actually designed to help us out in sticky lighting situations by taking more than one exposure of the same image. So, if you were off with your exposure by a stop or two (either you were too dark or too light), you could use one of those other images with the darker or lighter exposure—pretty clever when you think about it. Anyway, we use this feature to automatically take the exposures we need for HDR photos, because we actually need to combine a really dark photo, a regular photo, and a really bright photo into just one photo that will capture a larger range of light than our camera can capture in one single frame. Today, most DSLR cameras have built-in exposure bracketing, so just check your camera's manual for how to do this. Once you've turned on exposure bracketing, don't shoot them one at a time. Instead, switch your camera to automatically shoot a burst of all three (or all five) when you press-and-hold the shutter button down just once, by setting your camera to burst mode (again, check your manual). Now, once you've turned bracketing on, you just press-and-hold the shutter button until you hear that all three (or five, or more) bracketed shots have been taken. Besides just being plain easier to do it this way, you'll get less camera vibration and the shots will fire faster in burst mode than they would having to manually press the shutter button three or five times in a row. Plus, using this method, you won't forget how many frames you've taken and won't have to ask yourself, "Did I just shoot four or five?" (Hey, it happens.) Now, if you're shooting HDR at twilight/night, oftentimes the exposures are going to get longer. By using a cable release (with your camera on a tripod), you can take advantage of its lock switch (just press the cable release button and lock it into place). While it's easy to press-and-hold the shutter button for three or five shots during the day, you may introduce shake for the night shots.

What They're Not Telling You About HDR

If you've done any research on shooting and processing HDR images, you probably know that you have to shoot bracketed photos, and then you need some program to combine those bracketed photos into one single image (like Photomatix Pro, or Photoshop's built-in HDR Pro, or whatever). But, a lot of folks are disappointed once they've combined their bracketed frames into one HDR image, because they say, "My shots really don't look like the ones I see on the web and in books. What am I doing wrong?" It's not that they're doing something wrong, it's just that there's something the pros do that few are willing to talk about. They take their compiled HDR images into Photoshop and do quite a lot of post-processing there, tweaking everything from the color to the sharpness, adding Clarity, and even running plug-ins like the Google Nik Collection's Color Efex Pro (in particular their Tonal Contrast and Glamour Glow presets, which are very popular for finishing off HDR images). They probably spend more time in Photoshop than they do in the HDR software itself. So, if you're wondering why your images don't look like theirs, it's because they're doing one more big step to finish off their photos. Just so you know.

💡 PHOTOSHOP FOR HDR

We produced a book written by my buddy (and co-worker) RC Concepcion called (wait for it…wait for it…) *The HDR Book: Unlocking the Pros' Hottest Post-Processing Techniques*, and it focuses on exactly how to post-process your HDR images in Photoshop. The book is a huge hit, and you can pick it up wherever really cool books are sold. You'll love it.

Making Your Own Product Table

If you're looking for a great surface to shoot your product shots on, look no further than your local hardware store for a large panel of white formica. This stuff works great for a number of reasons: (1) When you put a product on white formica, its surface is already a little reflective, so it automatically gives your product a little bit of a natural reflection (not a sharp mirror reflection like acrylic, but kind of a subtle satin-like reflection). (2) It's very easy to keep clean—you can just wipe it lightly with a damp cloth—so you don't have to replace it often, like you do with white seamless paper, and (3) because it bends pretty easily, you can lie one end flat on a table, and then attach the other end to a couple of inexpensive light stands with some A-clamps, and this gives you a smooth, seamless curve behind your product, which makes it perfect for product photography. A full 8x4' sheet costs about $45–50 at my local hardware store, and believe it, it's worth every penny.

💡 USING CONTINUOUS LIGHT

For product photography, I usually use continuous lights. These aren't flashes, these are lights that stay on all the time, and they give bright daylight-balanced light, but because they use fluorescent bulbs, they don't get hot, so you can even use them to light food. These work incredibly well because you can see exactly what you're going to get—there's no shooting a few shots, then tweaking the lights, and shooting again. Outside of the fact that they stay on all the time, they're just like strobes, and have all the similar accessories, like softboxes (including strip banks), and fabric grids, etc., but since they're always on, you don't have to worry about a wireless trigger or flash cables.

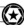

The Advantage of Using Strip Banks

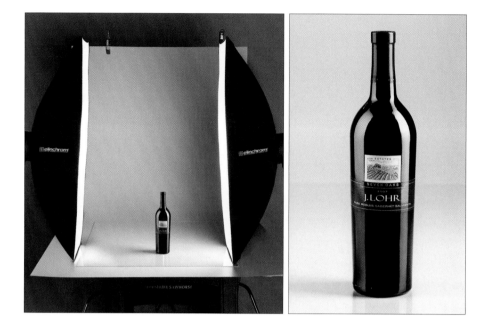

Ever see a product shot of a wine bottle, or a piece of electronics, and reflected in the product you see a tall, thin, soft, rectangular reflection? Maybe even two of them? These wonderful highlight reflections are most likely from one of the mainstays of a lot of pro product shooters—a strip bank (also sometimes called a strip light). These are actually just tall, thin, rectangular softboxes (picture a softbox that's just 18" wide, but around 36" long), and they are very popular in product photography because of those wonderful tall reflections they create in products that reflect. (It's tough shooting products that are reflective, because you can see a reflection of everything in the product itself—even sometimes the photographer—so be careful when you're shooting reflective products.) You can buy strip banks for strobes, or even for the Westcott Spiderlite TD6 that I use for product photography, and the nice thing about them is that you can use them tall (vertically), or turn them on their side and use them horizontally for a really wide, wrapping light.

💡 SOME PRODUCT PHOTOGRAPHY TIPS

Use a tripod. Product shots are one of those things that if they're not absolutely tack sharp, they just don't work, and that's why the pros use a tripod every time. Hide distracting stuff. Look at most professional product shots, and you'll find that they go to great lengths to hide anything that would distract you from the presentation of the product, even if it's a part of the product itself. Perfect example? Headphones. You know there's a cord on them, but in ads you rarely, if ever, see the cord—you just see the headphones. And, before you shoot anything, clean it first. This is one of those things that, if you don't do it, it will take you ten times longer to fix it in Photoshop than the 15 seconds it would have taken you to do it right in the studio.

Using Foam Core

While you'll find portrait photographers using white reflectors a lot in the studio (usually to reflect or bounce light from the main light into the side of the face that's in the shadows), when it comes to product photography, more often than not, you'll find the pros using a large sheet of foam core instead. Foam core tends to have a little more sheen to it than most reflectors and reflects more light. Plus, because you can cut a sheet of foam core (found at most craft stores or office supply stores) down to pretty much any size you need, you can make these small enough to sit right on your product table and get right up close to your product (but just out of your viewfinder's frame).

CREATE REAL REFLECTIONS AND DRAMATIC BACKGROUNDS

You'll often see a reflection appear below a product, and while you can add these reflections after the fact in Photoshop, it's easier to just have real reflections. The easy way to get those reflections is to shoot your product on some plexiglass (either clear or white frosted). Just put a rectangular sheet of plexi right over your background (you can pick up these small sheets of plexiglass at your local Home Depot or Lowe's for around $15) and it does the rest. If you want to go for a dramatic look for your product shots, try this: go to your local home supply mega hardware store and buy a single tile of black granite. This stuff is incredibly reflective and just sitting your product on it makes it scream, "Shoot me!"

Compare Your LCD to Your Computer Monitor

Once you've downloaded the images from your memory card onto your computer and opened them in the software you use to view and organize your photos (I use Lightroom, a software application from Adobe designed just for photographers. You can download a free 30-day trial at adobe.com/lightroom), grab your camera and start comparing how the photos look on your camera's LCD monitor compared to seeing them on your computer screen. Is it a pretty close match? Is your camera's LCD darker or lighter than what you see onscreen? This will give you a quick idea of how close your digital camera's LCD is to your computer screen, where you'll ultimately be editing your photos. This can be a big help when you're out shooting. If you learn that your LCD makes everything look cooler (bluer) than it is on your computer screen, then you know you don't have to add a warming filter to your lens to warm up your photos—they're already warm enough. If the LCD is brighter than your computer screen, most cameras let you lower the brightness of the LCD, so it more closely matches your computer. You'll be amazed at how knowing how "true" your LCD actually is can help you and your photography.

> ### 💡 ORGANIZE YOUR PHOTOS WITH LIGHTROOM
>
> Although I use Photoshop for all the serious retouching and high-end tweaking of my photos, I use Lightroom for managing and organizing my thousands of digital photos, processing my RAW photos, creating onscreen slide shows, printing out multi-photo layouts, and even creating custom photo books. If you get serious about this whole digital photography thing (and if you bought this book, you're getting serious), I recommend you check it out.

How Many More Megapixels Do You Need?

4 megapixel = 8x10"

5 megapixel = 11x14"

6 megapixel = 13x19"

8 megapixel = 16x20"

10–12 megapixel = 24x36"

36 megapixel = 30x40" and up

There's a ton of confusion (also known as marketing hype) around megapixels, and many people believe that megapixels have to do with image quality—the higher the number of megapixels, the better the quality, right? Unfortunately, that's not true. So, if you were using that as an excuse to buy a new camera, that's not going to float with me (although your spouse may buy that line). Here's what megapixels really mean: how large can I print my final photograph? That's it. If you're not going to print anything larger than 8x10", then a 5-megapixel camera is absolutely all you need. In fact, it's really more than you need, but I don't think you can even find a DSLR that's only 5 megapixels anymore (heck, our smart phone cameras are more than 5 megapixels these days). Anyway, if you want to routinely print 13x19" color prints, then you only need a 6-megapixel camera, so if yours is more megapixels (and you know, and I know, it is), then you're already set (I know, this is hard to swallow after years of thinking you needed more megapixels). So, what are today's 36-megapixel and up cameras for? Suckers. (Okay, not really, but you knew I was going to say that.) Actually, those high-megapixel cameras are for pros who need to print giant-sized images (think 30x40" and larger). If that's not you, then a 6-megapixel camera is all most people will really ever need, so put away your checkbook. Hey, don't blame me. I'm trying to save you some money, so you can buy some decent lenses and a fancy tripod.

Getting Lab-Quality Prints

SCOTT KELBY AND CANON U.S.A., INC.

At some point, after putting all these techniques to use, you're going to want prints, and today many pro photographers create their own prints. These days I'm using Canon printers and I love 'em. They give me lab-quality prints right on my own desk (well, technically, I keep them on a different desk altogether, but you know what I mean). The output from these printers is just remarkable (the vibrancy, sharpness, and just overall quality is pretty amazing), and Canon not only sells the printer and ink, they also sell really nice papers that are a perfect match for the printer, so it's all pretty convenient. They make printers that will print everything from a 4x6" borderless color print up to big poster-sized prints (the one I use prints up to 44" wide and as long as you want, using a big roll of paper), so choose the size that suits you best (though, I will tell you, 13x19" prints are really popular with serious photographers). Believe it or not, you can get into one of these lab-quality desktop printers (like the one shown above, the Canon PIXMA MG5620 Wireless Inkjet Printer) for only around $90 (don't get too excited—you'll make up for it buying ink and photo-quality paper).

What Determines Which Paper You Use?

PREMIUM LUSTER VELVET FINE ART

So, how do you know which paper to use? Believe it or not, there's an easy way—the paper you choose to print on is determined by one thing: the subject matter of your photo.

For example, if you're printing things of a softer nature, like flowers, birds, landscapes, waterfalls, or any type of image where you want a softer feel, try a textured paper like Epson's Velvet Fine Art Paper (provided you are printing to an Epson printer), which works wonderfully well for these types of images. This is your choice any time you want that "artsy" feel to your photography, and it also works well when your photo isn't tack sharp. Try it for black-and-white photography, too (especially on Epson's R3000), when you want extra texture and depth.

For serious portrait work, architecture, city life, travel, and finely detailed landscape shots, try Epson's Ultra Premium Photo Paper Luster. Anything with lots of detail looks great on this paper, and it really makes your colors vivid. So, when the shot has lots of detail and sharpness, lots of color, and you need it to "pop," this is the ticket for sharp, crisp prints.

Epson's Exhibition Fiber Paper is a great choice for landscape or cityscape black-and-white photos on the R3000 or the 3880 (this paper was designed expressly for printers that use Epson's Ultrachrome K3 inks), and it's one of the few fiber papers that print both color and black-and-white prints equally, as well. When you see one of your landscape shots printed on this paper, you'll momentarily black out. I am not kidding.

Getting Your Monitor to Match Your Printer

Color management (the art of getting your color inkjet prints to match what you see on your monitor) has gotten dramatically easier in recent years, but the key to getting a color management system to work is getting your monitor color calibrated. A few years ago, this was a costly and time-consuming process usually only undertaken by paid consultants, but now anybody can do it because (1) it's very affordable now, and (2) it pretty much does all the calibrating work automatically while you just sit there and munch on a donut (you don't have to eat a donut, but it doesn't hurt). I use Datacolor's Spyder5ELITE hardware color calibrator, because it's absolutely simple to use, it's affordable, and a lot of the pros I know have moved over to it. It sells for around $279, and that's pretty much all that stands in the way of having your monitor match your prints. Well, that and downloading the free color profiles for the paper you're printing on (see tip below).

> ### 💡 DOWNLOAD THE COLOR PROFILES FOR YOUR PAPER
>
> If you buy any of the major name-brand professional inkjet papers, definitely go to your paper manufacturer's website, go to their downloads page for your particular inkjet printer, and download their free color profiles for the exact paper you'll be printing to. Once you install these, when you go to Photoshop (or Lightroom, or Elements) to print your photo, you can choose the exact printer and paper combination you'll be printing to. This gives you the best possible results (and color fidelity) for your particular paper and printer. The pros do this every time and it makes a huge difference in the quality of their prints.

Desaturated Bleach Bypass Look

This can be done in either Camera Raw (part of Photoshop and Photoshop Elements) or Lightroom's Develop module (it's the same sliders, in the same order, that do the exact same things). You only need to move three sliders to get this look: (1) We desaturate the entire image by dragging the Vibrance slider to the left. I don't have an amount I drag it to every time, it just depends on the image. So, just look at the screen while you drag and, when it looks good to you, stop dragging. (2) Increase the amount of Clarity. Technically, this adds midtone contrast, but what you'll see is that it brings out texture and detail and makes things shinier (like the highlights on her skin, here). You do have to be careful, though, about adding clarity to women's skin because it can make them look bruised and rough. If that happens, just use the Adjustment Brush instead: set all the other sliders to zero and raise the Clarity amount, then just paint over everything but her skin. Problem solved. (3) Drag the Contrast slider to the right to add more contrast and give it more of that bleach bypass look (it helps darken the sky up a little bit, too!). If you like using plugs-in (I sure do), then here are two that have excellent built-in, one-click, bleach bypass effects, and that work with Photoshop, Lightroom, or Elements: (1) Macphun's Tonality Pro (www.macphun.com) comes with a couple Bleach presets (Warm, Drama, and Cool) that work really nicely. (2) The Google Nik Collection's Color Efex Pro plug-in (www.google.com/nikcollection/) has a Bleach Bypass filter that also nails this look in just one click.

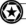
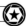

Grungy, Aged Look

©ISTOCK/DAVID M. SCHRADER

This can be done in either Photoshop or Photoshop Elements. You're going to combine two images into one: (1) To create this look, you'll need a paper texture. If you have some really old paper, you could scan it, but I just went to iStock.com, found this royalty-free image, and used it as my paper texture. (2) Now, in Photoshop (or Elements), use the Move tool (V) to drag-and-drop this old paper image on top of your main image, and then press Command-T (PC: Ctrl-T) to bring up Free Transform. Click-and-drag the corner points outward until your paper texture completely covers your image, then press Return (PC: Enter). (3) Press Command-U (PC: Ctrl-U) to bring up Hue/Saturation, and drag the Saturation slider to the left a bit to desaturate the paper image, so it's not quite as colorful and looks a bit washed out. Lastly, in the Layers panel, change the layer's blend mode from Normal to Multiply, and this blends the paper image in with your main image. Now, lower the Opacity of this layer to around 80%. Here are a couple ways you can change or vary the look: (1) Use a different paper texture. If you want a bunch of free paper textures—they are already out there—just do an Internet search for "paper textures," and you'll find links to hundreds of free, ready-to-go papers. A lot of them would work perfectly for this type of effect. Or, try this site, which offers 149 free paper textures: www.demilked.com/free-paper-textures-backgrounds/. (2) Try different blend modes. Although we used the Multiply blend mode to get this look, each blend mode gives a different look and, depending on the image, you might find a blend mode that works better for your image than Multiply. Here's a tip to quickly toggle through all the layer blend modes, so you can easily see each one (then you can just choose the one that looks best for your image): it's the keyboard shortcut of Shift-+ (plus sign). Once you've clicked on the pop-up menu, press it each time you want to toggle through a different blend mode.

Chapter Eleven

Pro Tips for Getting Better Photos

Tricks of the Trade for Making
All Your Shots Look Better

There are some tricks of the trade that just don't fit under any of the existing chapters, because they're not really just about getting better-looking portraits or more luscious-looking landscapes—they're about being a better photographer and getting better shots. And getting better shots is what it's all about, right? This is something we're all very passionate about, and if we get to the point where we're actually starting to sell our work (maybe as fine art prints, or through assignment work with a magazine), and are turning our passion into profits, then we're really living the dream— doing something we truly love for a living. Speaking of dreams, I haven't made a big deal about this on my daily blog (http://scottkelby.com) or in any of my live classes yet, because I don't want it to come off like bragging, but I recently signed a year-long contract with *National Geographic* that I'm pretty psyched about. In the terms of this agreement, I get 12 monthly issues for only $15, which is 74% off the newsstand price, so as you might imagine, I'm very excited. Anyway, in this chapter, we're going to focus on lots of those little tricks of the trade that you can apply to a wide range of photography to make everything you shoot look that much better. Now, one last thing: You might have heard I run with a dangerous crowd. We ain't too pretty, we ain't too proud. We might be laughing a bit too loud, but that never hurt no one. (I just wanted to see if you're still reading this after that whole *National Geographic* scam I pulled on you above. Come on, you have to admit, I had you going there for just a second or two, didn't I?)

Which Brand of Camera Should You Buy?

A lot of folks struggle with this one, especially when they're moving from a point-and-shoot camera to a DSLR. Which brand should you buy? Canon? Sony? Nikon? Pentax? Olympus? This choice is made tougher by the fact that they all make great DSLRs. All of them. However, I have two great ways to make sure you choose the right one (and although they may sound a bit silly, they work better for matching you to your camera than an online dating service does for finding your soul mate). Method #1: Choose the camera brand your photography buddy uses. That's right—if they use Canon gear, you should use Canon gear, too, because it will make your life infinitely easier, less stressful, and you'll learn your camera faster. Here's why: (a) now you have someone to call when you can't figure something out; (b) they can show you how to use your camera long after you've left the camera store and chances are they've already run into, and solved, all the roadblocks you're about to run into; and lastly, (c) you can swap (borrow) lenses, filters, flashes, batteries, the whole nine yards. When you're out on a shoot with friends, there's nothing worse than asking, "Anybody got a spare battery?" and everybody does, but not for your brand. Trust me, buy what your friends use. It just makes life easier. Method #2: Go to a real camera store and hold each of the brands you're considering in your hands. Fire a few shots on each, navigate through the menus, change the f-stop, change the shutter speed, and load a memory card. One of those is just going to feel "right" in your hands (just like each guitar has its own feel, or each golf club—one will just feel right). That's the one.

Keep from Accidentally Erasing Memory Cards

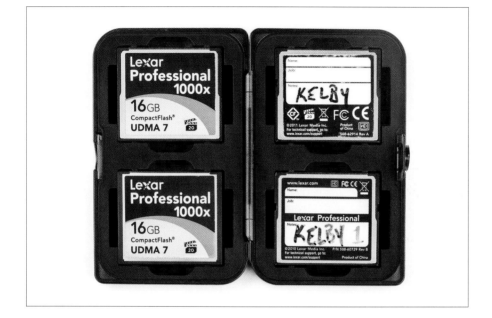

This is a small tip, but one that can save your hide when you're out shooting in the field. If you keep your spare memory cards in a card holder (and for the sake of your cards, I hope you do), there's a simple routine the pros use to keep track of which cards are full and which cards are empty and available for quick use. They turn the full cards backward in the case (with the labels facing inward), so they can instantly tell which cards are available for use (the ones with the labels visible) and which ones are full. The next time you're shooting in a fast-paced environment (like a wedding shoot or a sporting event), you'll be glad you adopted this system. Also, if your camera uses SD memory cards, there's a small switch on the cards themselves that keeps them from being erased, or reformatted, or...well...anything. So, if you know you've got a card of shots that you want to protect, just pop the card out, slide the switch to Lock, and you're set.

💡 HOW TO RESCUE A DAMAGED MEMORY CARD

Memory cards go bad. It happens. So, if the unthinkable happens (you put your memory card into your card reader, and it appears to be blank when you know it's not), there are downloadable software recovery programs (some free) that do a pretty amazing job, so all is usually not lost. However, if this happens, stop what you're doing, and start your recovery process immediately for the best chance of getting your images back (don't put the card back in the camera and keep shooting. Don't reformat the card. Don't do anything—just launch your recovery software right away). I've used SanDisk RescuePro software (there's a free demo), and it has worked well (even on non-SanDisk cards), but my favorite is Klix, and maybe only because it's rescued the images on every card that's ever died on me .

Pro Tips to Avoid White Balance Problems

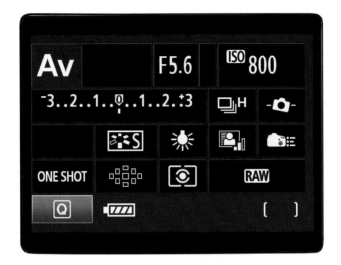

White balance problems often happen when you shoot indoors under fluorescent, incandescent, or just "them regular ol' light bulbs." Of course, you don't generally find out about them until you open the photos later on your computer and all the shots have either a yellowish, or greenish, or blueish color cast. By default, your camera is set to Auto White Balance, which works pretty well outdoors, but generally doesn't work worth a darn indoors. The pros use three methods to avoid white balance problems when they shoot: (1) They go into the camera and choose a preset white balance setting that matches the lighting they're shooting in (it's easier than you think—just go to your camera's white balance section, and choose either Incandescent [for regular indoor lighting] or Fluorescent [for typical office lighting]). You can choose preset white balance settings for outdoor shots as well, and you'll get more realistic colors there, too. (2) They create a custom white balance. Luckily, your camera will do most of the work for you if you just put a neutral gray card (you can find these at any camera store or B&H Photo) about 8 to 10 inches in front of your lens, and zoom in/out so the card fills your frame. Then, go to your camera's custom white balance menu and set it up to measure what it sees to create a custom white balance (it's easier than it sounds—just take a peek in your camera's manual). And, (3) they shoot in RAW format, so they don't worry about white balance, because they can choose the white balance after the fact, either in Adobe Photoshop's Camera Raw or in their RAW processing software (if they don't use Photoshop's RAW processor). This is just one advantage of shooting in RAW.

Which Format to Shoot In (RAW, JPEG, or TIFF)

Most digital cameras these days (and all DSLRs) offer at least these three main file formats: RAW, JPEG, and TIFF. Here's when to use each: **JPEG:** Shoot in JPEG if you're really good at nailing your exposure every time. If you're dead on (or really close) on your exposure and white balance, and don't think you'll need to tweak it much later (or at all) in Photoshop, then JPEG is for you. The file sizes are dramatically smaller, so you'll fit more on your memory card, and they'll take up less space on your computer. **RAW:** Shoot in RAW mode if you don't nail the exposure and white balance most of the time, and think you might need to tweak your images later in Photoshop or Photoshop Lightroom. In RAW mode, you can control every aspect of the processing of your images, so if the image is underexposed, overexposed, or has a color problem—you can fix it easily. RAW offers the highest-quality original image, too, and offers maximum flexibility. **TIFF:** Shoot in TIFF if you're loose with money. This is a great format for people who have money to burn, people who shoot to huge 128-GB memory cards and have plenty of 'em handy. TIFFs are also perfect for anyone who has lots of spare hard drive space and lots of spare time, because TIFF files are huge to deal with. Outside of that, I can't think of any really compelling (or remotely reasonable) reason to shoot in TIFF format.

WHICH JPEG SIZE TO SHOOT IN

I recommend shooting at the largest size and highest quality setting that your camera will allow, so if you're shooting in JPEG format, make sure you choose JPEG Fine and a size of Large, so you get the best quality JPEG image possible. If you choose a lower size, or JPEG Norm (normal), you're literally throwing away quality. The only trade-off is that JPEG Fine photos are just a little larger in file size.

Why JPEGs Look Better Than RAW Images

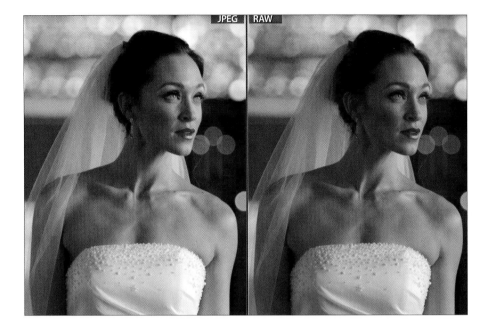

I know what you're thinking, "I've always heard it's better to shoot in RAW!" It may be, but I thought you should know why, right out of the camera, JPEG images look better than RAW images. It's because when you shoot in JPEG mode, your camera applies sharpening, contrast, color saturation, and all sorts of little tweaks to create a fully processed, good-looking final image. However, when you switch your camera to shoot in RAW mode, you're telling the camera, "Turn off the sharpening, turn off the contrast, turn off the color saturation, and turn off all those tweaks you do to make the image look really good, and instead just give me the raw, untouched photo and I'll add all those things myself in Photoshop or Lightroom (or whatever software you choose)." So, while RAW files have more data, which is better, the look of the RAW file is not better (it's not as sharp, or vibrant, or contrasty), so it's up to *you* to add all those things in post-processing. Now, if you're pretty good in Photoshop, Lightroom, etc., the good news is you can probably do a better job tweaking your photo than your camera does when it creates a JPEG, so the final result is photos processed just the way you like them (with the amount of sharpening you want added, the amount of color vibrance you want, etc.). If you just read this and thought, "Man, I don't even use Photoshop…" or "I don't really understand Photoshop," then you'll probably get better-looking images by shooting in JPEG and letting the camera do the work. I know this goes against everything you've read in online forums full of strangers who sound very convincing, but I'll also bet nobody told you that shooting in RAW strips away all the sharpening, vibrance, and contrast either. Hey, at least now ya know.

WHIMS Will Keep You Out of Trouble

Let's say you're going out shooting landscapes one morning. Do you know what your camera's settings are? They're whatever they were the last time you went shooting. So, if your last shoot was at night, chances are your ISO is set very high, and your white balance is set to whatever you used last. I've gotten burned by this so many times that I had to come up with an acronym to help me remember to check the critical settings on my camera, so I don't mess up an entire shoot (I spent a whole morning in Monument Valley, Utah, shooting at 1600 ISO because I had been shooting a local band the night before). The acronym is WHIMS, which stands for:

W: White balance check

H: Highlight warning turned on

I: ISO check (make sure you're using the right ISO for your surroundings)

M: Mode check (make sure you're in aperture priority, program, or manual mode)

S: Size (check to make sure your image size and quality are set correctly)

Before you take your first shot that day, take 30 seconds and check your WHIMS, and you won't wind up shooting important shots with your camera set to JPEG small (like I did when shooting one day in Taos, New Mexico).

How to Lock Focus

This is another one of those things that has snuck by a lot of people, and that is how to lock your focus. For example, let's say you're lying down, shooting a landscape through some tall grass, and you want the blades of grass in front of you to remain in focus, but when you lift the camera up to get the rest of the scene, the camera refocuses on the background. You can force the camera to keep its focus locked onto those blades of grass by simply holding the shutter button down halfway. While that shutter button is held down, your focus is locked, so now you can recompose the image without your camera trying to refocus on something else. I use this a lot on photos of people who may not be in the center of the frame (it keeps me from having to move the autofocus dot—I just point at the person, hold the shutter button halfway down to lock the focus, then recompose the shot the way I want it. When it looks good, I just press the shutter button down the rest of the way to take the shot).

> 💡 **SECURE YOUR LENS HOOD**
>
> Lens hoods come with most quality lenses and are designed to reduce or eliminate lens flare when shooting outdoors in daylight. But, the pros keep theirs on even indoors (basically, all the time) to protect the lens. It can save your lens if you drop it or knock it into someone or something. Now, the lens hood is also known to fall off your camera, but to avoid this, just buy a cheap roll of gaffer's tape, tear off a few small strips, and apply them directly to the hood itself. When you're out shooting, tear off two pieces and use them to secure your lens hood to the lens. Since I've been doing this, it hasn't fallen off once.

Moving Your Point of Focus

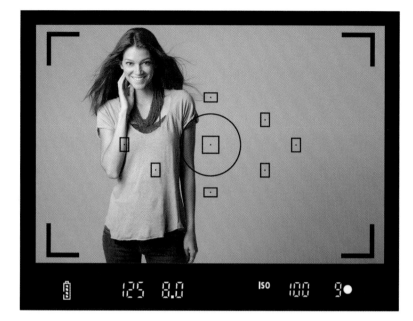

You know how you look through your viewfinder and, in the center of your viewfinder, there's a red circle or a red rectangle? That's your camera's autofocus (AF) point, and what that point hits winds up being what's in focus. Well, something a lot of people don't realize is that most cameras let you move that focus point up or down, left or right. That way, if you've composed a shot where your subject is standing over to the left side of your frame, you can move the AF point over, right on them, so they wind up being perfectly in focus. On Canon cameras, you move your AF point by using the tiny multi-controller joystick on the dial on the back of the camera. On Nikon cameras, you move the AF point by using the multi-selector on the back of the camera.

💡 WHEN IT'S OKAY TO ERASE YOUR MEMORY CARD

There's a rule a lot of photographers (well, paranoid photographers anyway, like me) follow, and that is: we don't erase our memory cards until we absolutely know that we have two copies of our photos elsewhere. For example, when you download your photos to your computer, that's only one copy, and you shouldn't format your memory card with just this one copy (because when your hard drive crashes one day [notice that I said "when"] all those photos are gone forever). Now, once you back up those photos from your computer to a second drive (a backup hard drive), then you'll have two copies—one set on your computer and one set on your backup drive—and then it's safe to format (erase) your memory card and keep shooting with that card.

Using the LCD on Your Camera

There's a cool feature in some DSLRs that lets you use the LCD monitor on the back of the camera as a viewfinder, so you can compose and shoot your image using just it (just like a point-and-shoot). Now, it may not sound that appealing, but check this out: on some cameras, when you're viewing the scene on your LCD, you can actually toggle through the different white balance settings and see right then and there how each white balance setting is going to look for that particular scene. This makes dialing in a great looking white balance absolutely simple—just scroll through the list, and when you see one that looks good, stop. Try it once, and you'll use it again and again (especially easy when you're on a tripod). Another reason to use the LCD monitor on the back of your camera, is to see if you "got the shot." And by "got the shot," I mean you can tell if your subject blinked when the photo was taken, if your flash actually fired, that sort of thing, but there's a big potential "gotcha" that gets a lot of photographers. It happens because the LCD monitor is so small, it can also fool you. Everything looks in focus on a tiny 3" monitor (think of it this way: even the screen on your cell phone is bigger than this!). When you open that photo later on your computer, you might find out that the key shot from your shoot is out of focus (or your camera focused on the wrong object, so the background is in sharp focus, but your subject is blurry). This actually happens quite often because (all together now) everything looks in focus on an LCD monitor. So, you absolutely must zoom in and check your focus regularly during your shoot. If not, you're setting yourself up for a nasty surprise when you download the photos later. Another way the LCD monitor will make you a better photographer is through instant creative feedback. If you take your shot, look at the LCD, and what you see disappoints you, then it challenges you to come up with something better. It makes you work the shot, try new angles, get more creative, and experiment until you finally see on the monitor what you set out to capture in the first place.

Removing Spots and Specks After the Fact

If you have a dust spot, smudge, or speck on either your lens or your camera's sensor, you're going to see that spot (or smudge or speck) again and again once you open your photos in Photoshop (or Lightroom, or Elements, etc.). If you want a quick way to get rid of that junk, try Photoshop's (or Elements') Spot Healing Brush tool. All you do is choose it from the Toolbox, then click it once over any spot or speck, and it's gone. That's all there is to it. Now, if you have Photoshop, you can fix a bunch of spots all at once (because, after all, if you have a spot on your lens, every shot from your shoot will have that same spot in that exact same location, right?). So, here's what you do: STEP ONE: Select all the photos that are in the same orientation (for example, select all your horizontal shots) and open them in Adobe Camera Raw. STEP TWO: Get Camera Raw's Spot Removal tool (from the toolbar up top) and click it once right over the spot. This removes that spot from your current photo. STEP THREE: Press the Select All button (on the top left) to select all your other photos, then click the Synchronize button. STEP FOUR: When the dialog appears, from the Synchronize pop-up menu up top, choose Spot Removal, and then click OK. This removes that spot from all your other selected photos automatically. Click Done to save your retouch. STEP FIVE: Open all the photos you took with a tall orientation and do the same thing. Now, all your spots are gone from all your photos in less than two minutes. If you shot 300 or 400 photos—that's sayin' something!

Want to Be Taken Seriously? Start Editing

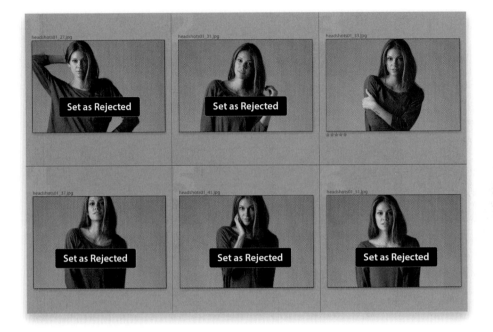

If you want to be taken seriously as a photographer and you want people to start to view you as a pro-quality photographer, then take a tip from the working pros, which is: only show your very best work. Period. One thing that makes a pro a pro is they're really good photo editors—they're really good at picking, and only showing, their very best stuff. You don't see their so-so shots or the shots that would have been great, if only.... You also don't see them showing seven or eight similar shots of the same subject. Only show your best of the best. That means if you went on a trip and you took 970 shots, you don't come home and show a slide show of 226 images. If you want people to think you're good, show your best 30. If you want people to think you're great, show just your best 10. Think about it: If you took 970 shots, maybe 400 are decent. Out of those decent shots, maybe 80 are pretty good. Out of those 80, maybe 30 are really good. Out of those 30, maybe 10 are outstanding. Now, just show those 10—and blow people away. (Just ask yourself what you would rather see—80 pretty good shots, or 10 outstanding shots.)

💡 **HOW TO BE A GREAT PHOTO EDITOR OF YOUR OWN WORK**

Your shots have to stand on their own, without you telling a story about why you like the shot. If you have to explain to someone why you chose it or why you think it's special, it doesn't belong in your portfolio.

Spot Metering

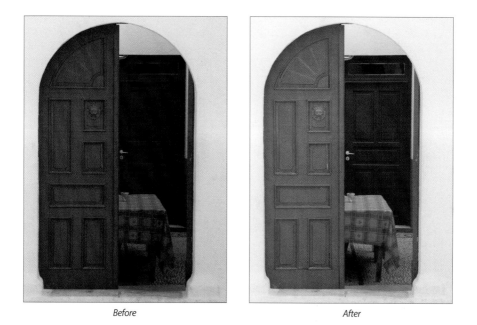

Before After

Most folks keep their camera's metering set at the default, which is evaluative metering (on Canons) or matrix metering (on Nikons) and that just means it kind of looks at the entire frame and it tries to create an exposure that works for the entire image. These modes, on today's cameras, do a pretty amazing job most of the time. However, there's another type of metering—spot metering—you'll want to know about for those sticky exposures, like in the image above left, where I'm trying to capture both the light inside the little entryway and outside the building at the same time. In the default evaluative (or matrix) metering mode, it's going to make that entryway very dark. So, just switch to spot metering mode. This essentially tells the camera, "the part of the photo I want to look good is just this little tiny area right in the center of the frame." Then, you aim the center of the frame directly at that area, hold the shutter button down halfway to lock in that exposure reading, then reframe your photo to look how you want it (without releasing that shutter button), and take the photo. In the example above right, I just switched from matrix metering to spot, then aimed at the table inside that doorway. That's all it took (just remember to switch back to matrix, or evaluative, metering when you're done, because you generally only want to use spot metering in tricky exposure situations).

> 💡 **APPLY FOR PERMITS TO SHOOT WITH YOUR TRIPOD**
>
> Many indoor locations (like museums, public buildings, etc.) don't allow shooting on tripods. But, sometimes, you can apply for a free permit to shoot on one. Just ask in advance.

You Need to Copyright Your Photos

With so many of us posting our images on the web, you've got to protect yourself (and your images) by legally copyrighting your work. Luckily, the process (at least in the U.S.) is all now web-based, so it's never been faster, easier, or more affordable than it is today. What copyrighting does is to legally define who owns the photo, and even though, technically, there is some very limited amount of protection afforded simply by the fact that you took the shot, if someone takes your photo off the web and uses it in their brochure, or website, or print ad, etc., without actually having registered your work as copyrighted with the U.S. Copyright office, your chances of winning a judgment in court against the "photo thief" are virtually nil. Because this process has become so quick, easy, and inexpensive, there's no reason not to add this process as part of your photo workflow. To register your work online in the U.S., start by going to www.copyright.gov/eco/index.html (it only costs $35, and you can register literally thousands of photos at a time for that same fee).

💡 DON'T GET BURNED BY SHOOTING WITHOUT A MEMORY CARD

Manufacturers set cameras up so you can take shots without actually having a memory card in the camera. You see a picture appear on the LCD on the back of the camera, just like always, except those photos vanish into thin air after, because they're not saved to a memory card. So the first thing I do with any new camera is turn the memory card lock on, so it won't even take a shot without a memory card in the camera.

Shoot Multiple Shots in Low-Light Situations

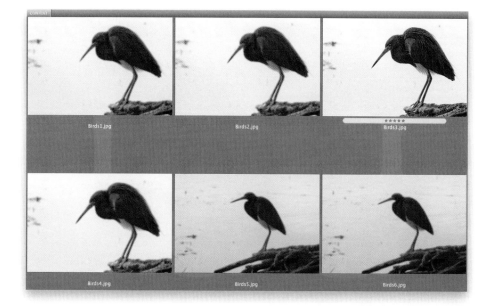

If you're in a situation where you're having to shoot in low light without a tripod (if your shutter speed gets under 1/60 of second, there's a pretty good chance your photo will be somewhat blurry if you're handholding), and you don't want to raise your ISO because your photo will get too noisy, here's a trick you can try that will usually get a sharp photo: shoot multiple shots in Burst or High-Speed Continuous mode. Chances are, if you take three or four shots in a quick burst, at least one of those shots will be in focus. I've done this numerous times and I'm always amazed at the results. You'll see a blurry one, blurry one, then all of a sudden there's a nice crisp shot (as shown here with the five-star image labeled yellow), and then right back to blurry. So, next time you're in one of those situations, crank off a few right in a row, and keep your fingers crossed that at least one of those will be in focus (hey, it's better than the alternative).

💡 WHAT LOOKS GOOD IN BLACK & WHITE

Some subjects just look great when you convert them from color to black and white, so when you're out shooting, keep an eye out for anything with lots of texture, like peeling paint on the side of an old building, rusty old machinery, anything with an interesting shape or lots of contrast, objects with a lot of metal, old barns, old cars, old abandoned factories, and also consider cloudy days with dark menacing skies a perfect subject for black and white.

The "Gotcha" of Using Picture Styles

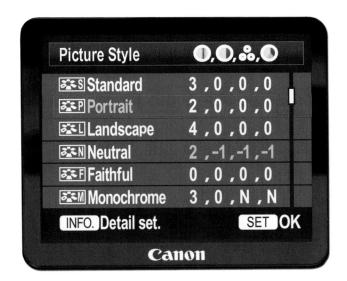

Picture styles, those in-camera color and contrast effects that let you, for example, have more vivid colors for landscapes, or a more neutral look for portraits, or a really vivid look for shooting in cities, etc., have a hidden "gotcha"—they don't get applied to your image if you shoot in RAW format. They only actually affect the image at all if you shoot in JPEG mode. What stinks about this is that, when you're shooting RAW, the preview you see on the LCD on the back of your camera is actually a JPEG preview, so you see the picture style being applied, even though when you open your RAW image in Photoshop or Lightroom, that picture style is long gone. Of course, if you have Photoshop, Photoshop Elements, or Lightroom, you can use the camera profiles in Camera Raw's or Lightroom's Camera Calibration panel to apply these same picture styles to your RAW file.

IS IT BETTER TO UNDEREXPOSE OR OVEREXPOSE?

First off, let me say this: your goal (my goal, our common goal) is to get the proper exposure. That's our goal. Always. But if that's not possible, if given a choice between overexposing (a photo that's a bit too light) and underexposing (a photo that's a bit too dark), go with overexposing—you'll have less noise. That's because noise is most prevalent in the shadows, and if you have to lighten an underexposed photo, you're lightening (increasing) the noise in the photo. That's why it's better to shoot lighter (overexposed), because darkening a photo doesn't increase noise the way lightening it does.

Rotate Tall or Rotate Image or Both?

When it comes to rotate settings in your camera, there are actually two different ones that do two entirely different things, and knowing which is which can save you a lot of frustration. Rotate Tall (on Nikons, under the Playback menu) means that when you shoot vertical (tall), the camera will rotate the image on the LCD on the back of your camera (that way, you don't have to turn your camera sideways to see tall images). The other rotate setting is called Rotate Image (under the Setup menu), which means it embeds the orientation of the image right into the file, so when you open the image in Lightroom, or Bridge, or Photo Mechanic, etc., it automatically rotates the thumbnails of tall images so they don't come in sideways and have to all be manually rotated by you. On Canon cameras, go under the Set-up 1 tab, and choose Auto Rotate. If you choose On with an icon of a camera and computer monitor beside it, it rotates the photo both on the LCD on the back of your camera and your thumbnails when you import the photos onto your computer. If, instead, you choose On with just the computer monitor beside it, then it only rotates the image on your computer (your camera will still show it on its side). If you choose Off, it means there's no rotation at all—everything stays on its side, on your LCD and on your computer.

💡 ZOOMING IN CLOSE? FAST SHUTTER SPEED HELPS

Using a long zoom lens, like a 200mm lens? To help get sharp photos, know that the closer you zoom in, the more any lens movement is exaggerated. Sunny day? Your fast shutter speed will neutralize the movement. But, in the shade, you'll fall below 1/250 of a second, so you'll need to be on a tripod or raise your ISO to raise your shutter speed to at least 1/250.

Reducing Noise in Low-Light Shots

If you shoot in low-light situations or at night, it's almost a lock that you're going to have some noise in your image (little red, green, and blue dots—kinda like film grain, but not nearly as endearing). Anyway, we used to have to buy plug-ins to get rid of noise, but in Photoshop's Camera Raw or Lightroom, the noise reduction built right in is so good, we can pretty much skip using noise reduction plug-ins altogether. If you shoot in RAW, it works really brilliantly, because unlike most plug-ins, it removes the noise while the image is still a 16-bit RAW image. If you shot in JPEG mode (so it's already 8-bit), you can open that JPEG in Camera Raw or Lightroom and still use its Noise Reduction, but it's not quite as robust (because now you're kind of using it as a plug-in). To find this noise reduction, open your image in Camera Raw, then click on the Detail icon. In Lightroom, go to the Detail panel in the Develop module. There are five sliders in this section, but we're only going to focus on the two most important ones: Luminance and Color (you can leave the others set at their defaults). The Luminance slider is kind of the overall noise reduction amount slider—the more noise you see, the farther you'll need to drag it to the right, but be careful, if you drag it too far, your image will start to look soft and lose contrast. Without going into too much detail (this isn't a Photoshop book, after all), if you increase either the Luminance or the Color sliders and things start to look too soft, or you lose detail, or the colors look desaturated, that's what the other three sliders are for—to help bring some of those back (the names of those sliders help you figure out which one is which).

What People Looking at Your Photos See First

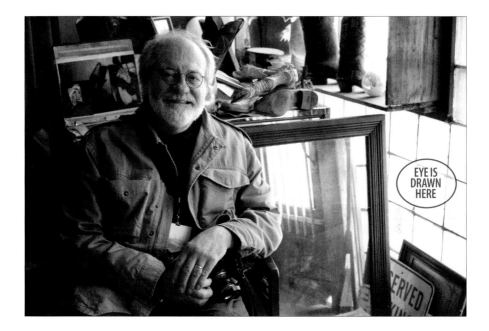

Knowing what your viewer's eye is going to see first in your photo can really help a lot in planning it out. Basically, the human eye is drawn to the brightest thing in the image, so if your subject is in the foreground, but behind him is a window with bright sunlight, their eye is going to go there first (not generally what you want). So, knowing that, you can recompose or relight the photo to make sure the brightest thing in the photo is precisely where you want your viewers to look. After the brightest thing, next they look for the sharpest, most in-focus thing, so if there's a very shallow depth of field, they lock right onto whatever's in focus (hopefully, your subject). Knowing these two things (where people looking at your photos are going to look first, and then where they'll look next) can really help you in creating photos where your viewer's eye goes right where you want it, by making sure that brighter and sharper areas don't appear somewhere else in your photos.

💡 AVOID SIGNS BECAUSE THEY DRAW YOUR EYE

If you're like me, and you're worried about things distracting your viewer from the story or subject you want them to see in your photo, keep a sharp eye out for any printed signs or text that might appear in your photos. We're all mentally programmed to read signs, and unless the sign is the subject of your image, your viewers will automatically start reading the sign, instead of looking at your subject. I learned this tip a few years ago from Jay Maisel, and I've seen it play out time and time again, whenever I showed an image with a sign somewhere in it. So, in short, try to compose your shots so signs or text don't appear in them unless you want them to be the first thing your viewer sees (and reads!).

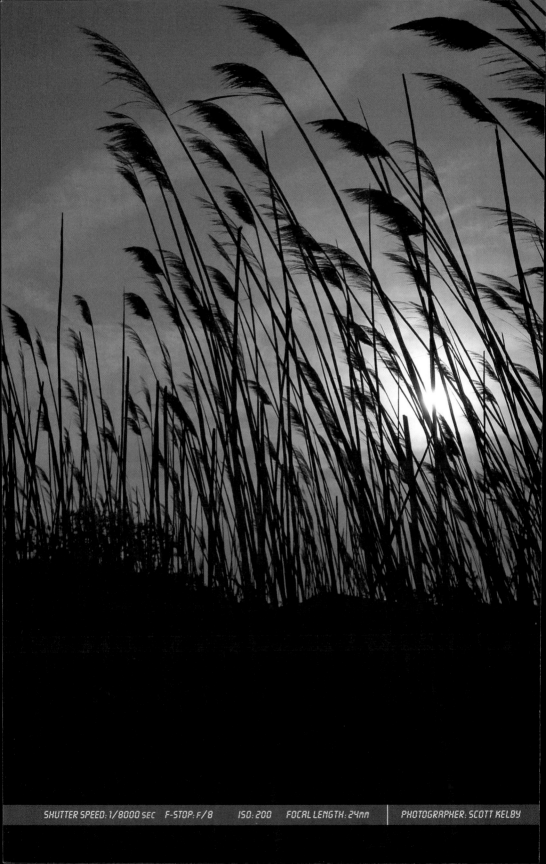

SHUTTER SPEED: 1/8000 SEC F-STOP: F/8 ISO: 200 FOCAL LENGTH: 24mm | PHOTOGRAPHER: SCOTT KELBY

Chapter Twelve

From Camera Phone to DSLR

*Tips to Get the Pro-Quality Images
You Bought a DSLR For*

Each of the other chapters in this book teaches you techniques that are pretty specific to a particular type of photography (like portraits, or shooting in the studio, etc.), but I also wanted to include some tips to help you get better shots if you're just coming from taking photos with your camera phone to now shooting with your first DSLR. At the end of the day, that's all we really want, right? We just want to take better photos. It's why we all work so hard to learn how to use our cameras—not so we can play around in the menus all day, it's because we know that once we really know the camera inside and out, then we can focus on getting the shots (and not the technology behind it all). Now, I know what you're probably thinking, "Scott, this all makes perfect sense, except for one thing: I'm reading this in one of the chapter introductions, and traditionally this is a part of the book that's not widely known for contributing to the chapter that lies ahead. What gives?" Well, here's the thing: my statement above would all make perfect sense if the chapter that follows was actually about making your photos look better, but sadly, it's not. What follows is actually a 22-page excerpt from my doctoral dissertation on neo-classical psychology patterns, which includes a non-apologetic look at man's inability to reconcile events from his pre-post-natal experiences and how those events have affected his non-verbal communication skills in the post-modern workplace. The reason I'm sharing this excerpt with you here is because I feel it deserves a wider audience than just my professor, who incidentally did not agree with several of the conclusions put forth in my well-documented, thoroughly researched, and flawlessly executed paper, which is why he will be referred to throughout the upcoming chapter as simply "Professor Big Poopie Head." Now, if you're thinking, "Dr. Kelby, I didn't know you had earned a doctorate," just remember this one underlying rule: I'm lying.

The Right Way to Hold a DSLR

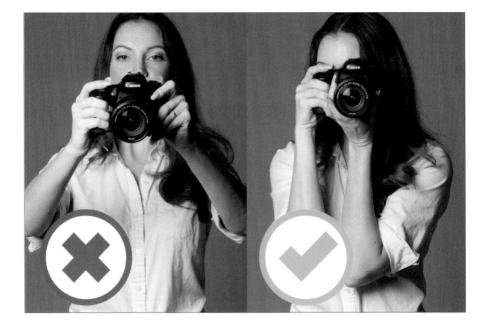

This is more important than it sounds, because it's something you didn't have to worry that much about with your camera phone. Holding it super steady as you shoot is critical with a DSLR for you to get sharp photos (more on why later in this chapter, but for now we've got to learn how to hold it so it stays really steady). Your right hand holds the right side of the camera (which puts your hand in perfect position to press the shutter button), and your left hand goes under the lens, cradling it in your hand, like you see in the photo above on the right. Okay, there's one more part: Take another look at the photo on the right above. See how she's holding her elbows straight down and they're tucked into her body? That's to help (you guessed it) keep the camera steady. Start shooting like this from the very beginning, and it will become second nature fast. You'll never have to even think about it again (and your shots will be sharper for it, especially in low-light situations like indoors or at night).

How to Focus

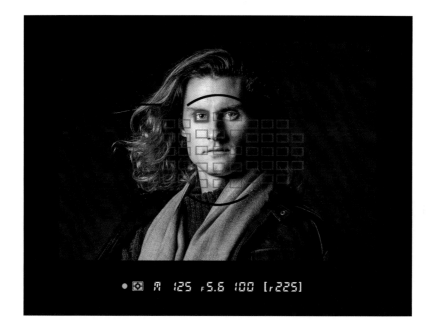

To set your focus on your camera phone, you'd just tap the screen over the person or object you wanted in focus, right? Well, it's kinda the same on your DSLR, but we're not "tapping the screen," we're moving a focus point over the person/object you want in focus (and if you're taking a shot of a person, we want that focus point to be on their eye closest to the camera, if possible). You see this focus point when you look through your viewfinder—it's usually a red dot, or a red rectangle, or a black rectangle (it just depends on which brand of DSLR you have) in the center of the viewfinder. You can either: (1) position your camera, so the focus point in the center is over the object you want in focus, or (2) use a little round (or plus-shaped) toggle/dial on the back of your camera to move that focus point right over what you want in focus (in case what you want in focus isn't in the center of your image). Once you get it over what you want in focus, hold the shutter button halfway down to lock the focus on your subject (when you do that, you'll often hear a beep, depending on your brand of camera, and whether you have this feature turned on to let you know you're in focus). You'll also generally see a solid "dot" appear in your viewfinder as a visual way to know your shot is in focus (in case you have the beep turned off, like when you're shooting at a wedding). Now that your focus is locked on, with the shutter button still halfway down, you can move the camera to recompose the shot the way you'd like it, and when you're ready to take the shot, press the shutter button down all the way. This may sound complicated, but it's really easy. It's just: (1) put the focus dot on the subject you want in focus, (2) hold the shutter button down halfway to lock focus, and (3) compose the shot the way you want it and take the shot.

Start with This Shooting Mode (It Feels Familiar)

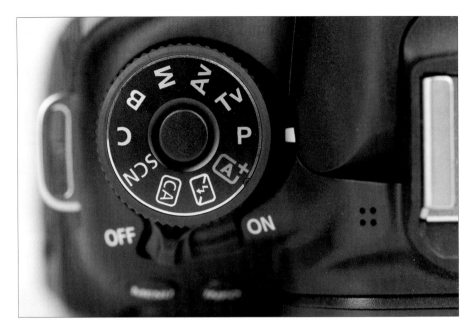

With your camera phone, you don't think about shooting modes, you just launch the Camera app and start shooting. With DSLRs, you have a number of different shooting modes that all do different things for different types of situations. So, which should you start with? I recommend starting with program mode (if your DSLR has a mode knob on the top, you'd turn that knob to the letter "P." If you set your mode through a menu on the camera [again, it all depends on the make and model of DSLR you use), choose Program). What does this mode do? It kind of mimics what your camera phone does—you can just turn it on, start shooting, and the camera will do all the math for you to create a proper exposure, and it's usually pretty good at it (kinda like your phone is, though the DSLR will usually get you better results in the same situations). What I don't recommend is auto mode, which sounds like it does the same thing as program mode, except for it has one huge drawback: it keeps popping up your DSLR's pop-up flash (providing, of course, your DSLR has one—the higher-end pro cameras don't usually have one). Why is this a bad thing? It's because your pop-up flash is awful. Terrible. It's what you use to "get even" with people who have "done you wrong," so we try to avoid using it if at all possible (it's definitely a tool of last resort), and in auto mode it keeps popping up and turning on all the time. Heck, if you're out shooting under the blazing sun in the desert, it'll pop-up. So, program mode has all the good stuff of auto mode (it makes all the exposure decisions for you), without the bad stuff (the flash doesn't pop up at all unless you push the little button to pop it up, but don't do that because your shot will look awful around 96% percent of the time). So, in short, I recommend starting with program mode. You can branch out to other stuff later (and you will want to), but it's a good safe starting place.

How to See Your Pictures

Like your camera phone, right after you take a picture, that picture appears onscreen for a few seconds, then it goes away. You get to choose how long it stays onscreen in the preferences for your camera, but of course, just like your phone, the longer it stays onscreen, the more battery power it uses. Just so ya know. Anyway, to see the images you've taken after that brief display period goes away, just press the Play button on the back of your camera and the last shot you took appears (again, for a few seconds, but as long as you're doing something with the photos—scrolling through them, zooming in/out, etc.—it will stay "on"). To scroll through them, it's of course different on every camera (ugh), but generally there's a dial or a wheel on the back of your camera that you use to move forward and back through your images. To zoom in on an image (ideal for checking to see if the image you just took is sharp), look on the back of your camera for a button that has a little magnifying glass icon on it with a plus sign (circled here above). Press that to zoom in. Press it again to zoom in tighter. Then, press the button with the magnifying glass with a minus sign icon to zoom back out. To delete an image, click the Trash icon button.

Changing Lenses (and Other Lens Stuff)

One of the biggest advantages of DSLRs (and I'm pretty sure you know this, and it's probably one of the main reasons you bought a DSLR in the first place) is that you can change lenses, swapping in/out for long zoom lenses or super-wide-angle lenses or a macro (close-up) lens, and so on. Changing lenses is easy: you just press the button beside the lens on the front of the camera and twist the lens until it releases (which way to twist depends on the brand of DSLR you purchased—Canons and Sonys twist to the right and Nikons twist to the left. If you're not sure, check your camera's manual). When you're changing lenses, you want to be very careful to not let junk get into your camera body, so try to avoid changing lenses in dusty, dirty, or windy situations. If junk gets on your camera's sensor, junk gets on every picture (ack!). To minimize the chance of something getting into your camera body, and onto your sensor, try to change lenses quickly. You don't have to race through it, but don't dilly-dally either (I've been dying to use that phrase). One more thing: you also want to be very careful not to scratch the glass at the end of your lens because that scratch will appear on all your photos. So, before you toss that lens into your backpack or purse (like you used to toss your phone), make sure you put the lens cap back on the lens and make sure it's secure.

How Big a Memory Card Do You Need?

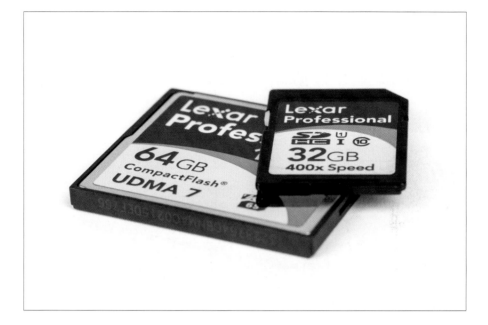

This is easy. How often do you want to change memory cards? If you don't mind changing often, get some 8-GB cards. If you don't like messing with memory cards (you never had to mess with them on your phone, right?), then get a larger card and you'll have to change them much less often. My recommendation? Get at least a 32-GB card. Now, if you're thinking that sounds expensive, they're actually really affordable these days. For example, I use Lexar memory cards and at B&H Photo, you can get a Lexar 32-GB SD memory card for around $16. If you want a really fancy super-fast high-end pro-quality card (handy if you plan on shooting sports), you can spend around $32. Heck, you can get a Lexar Platinum II 300x (speed) 64-GB card for around $26, and one of their "fancy dancy" ones for $4 more. Heck, at that price, I should probably recommend the 64-GB. Yeah, let's go with this: spring for the 64 GB and just keep on shootin'! If you need a backup card (in case you fill that 64-GB bad boy), maybe pick up a 32-GB then. That's nearly 100-GB of storage. Not too shabby!

Getting Sharp Pictures Using Auto ISO

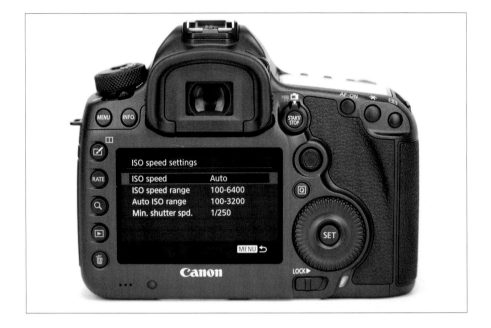

One thing you never had to worry about with your camera phone was shooting in low light, like indoors, or outside downtown, or in a restaurant. That's because your camera phone uses something behind-the-scenes called Auto ISO. This means it automatically increases the light sensitivity of your sensor when you get in low-light situations, so your shutter speed is fast enough that you don't get blurry photos in low-light situations, even if you're not holding the camera incredibly still. Instead, you get really, super noisy, grainy photos, but at least they're in focus. With your DSLR, we generally have to keep an eye on the shutter speed ourselves, making sure our shutter speed doesn't fall below 1/125 of a second (most folks can hold their camera pretty steady at 1/125, and some to 1/60 no problem, but let's use 1/125 of a second as our baseline "low as we want to go" number, just for safety's sake). If this all sounds like a pain in the "b-double-oh, tee, y," then turn on Auto ISO, and your camera will take care of watching your shutter speed, just like your camera phone did. You turn this on in your camera's menus (of course, once again, which menu this is found under depends on your camera's make and model), usually under ISO Sensitivity (or somewhere near it). When you turn on Auto ISO it lets you choose a "minimum shutter speed" it will never let your camera fall below, so as long as you hold your camera reasonably still, your low-light shots will be in focus. Set that minimum shutter speed to 1/125 of a second, shoot in program mode, and you're off and running in low light, with less noise than your camera phone.

How to Take a Selfie

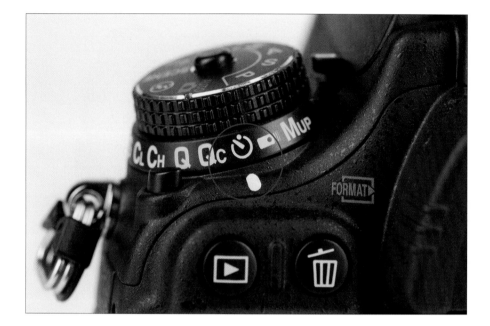

Before the camera phone was born, the term "selfie" didn't exist with a DSLR, and when you hold one in your hand, you'll see why—there is no flipping to the rear camera to do a selfie. So, the way we do selfies with a DSLR is to go all "old school" on it. That means, putting your DSLR on something stable (a table, a low wall, or ideally, a tripod), and then turning on the camera's Self Timer mode, which by default gives you 10 seconds to run around to the front of the camera and get in the frame. Usually, a little red or white light will start to blink slowly as soon as you press the shutter button (letting you know it is counting down), and then a second or two before it fires, it starts blinking really fast (that's your cue to smile), and then it takes the shot. Now you can see why we didn't take a whole lotta selfies before camera phones came out. This Self Timer mode is found in different places, depending on your camera's make and model. Some have it on a dial, some a push button, some in the menus— you'll just have to take a look in your camera's manual to find where the function is on your particular model. Now, all that being said, it is possible to take a selfie with your DSLR by holding it as far as you can from your body, twisting your wrist so the camera is facing you, and firing. But, you're kinda doing it blind as far as composition goes, so you might get half your head, or just part of your ear, but with practice you can get your full ear (sorry, I couldn't help myself).

Where to Store Your DSLR

Your cell phone is rugged. Amazingly so. Think about how many times you've dropped your phone, and you just pick it up and keep going about your day. Your DSLR isn't like that. Well, if you bought a high-end pro model, they are pretty sturdy, but for the most part, they require a bit more care, especially when it comes to your lenses, which is why you're going to need some sort of camera bag to store your body and lenses. There are hundreds of different bags to choose from, and I'd start with a small, simple inexpensive bag. As your lens collection grows, and you get a little farther in your journey, you'll know what you'll need when you go to buy a really nice bag.

Which Apps to Use to Edit Your Images

You're probably used to editing your camera phone photos on your phone, but now you're going to be mostly editing on your computer (although, you'll still be able to edit on your phone if you like, but you'll have to get your image over to the phone first, and quite honestly, for most situations, emailing yourself the image is probably easiest. There may be better ways, but for something that's quick, familiar, and works, emailing's probably best). But this isn't about apps on your phone, it's about the application on your computer for editing photos, and I highly recommend Adobe Lightroom. I don't recommend starting with Photoshop—it's fairly complicated (that's being kind), with a fairly steep learning curve, whereas Lightroom was made from the ground up for photographers, and it's much easier to learn. It's reasonably priced at $149, if you want to buy the application, or you can subscribe to Adobe's Creative Cloud Photography plan, which includes the latest versions of both Lightroom and the full version of Photoshop (but still, start with Lightroom first, learn it, then learning Photoshop will be much easier because they share some common things). Anyway, Lightroom pretty much rules the photography industry today, and everybody from beginners to pros are using it. So, if I were to tell a friend what to get as far as a computer photo editing application, I would absolutely tell them "Get Lightroom—you'll love it!" (Full disclosure: I have written books on Lightroom, I've got online classes, I've written countless articles, I publish *Lightroom* magazine, and on and on, but even if I didn't, my advice would still be the same: get Lightroom, you'll love it.)

How to Make Panoramas (Panos)

A lot of camera phones (like the iPhone for example) have a pano feature built in, and they work brilliantly. You can shoot panos with your DSLR, too, and create really high-resolution panos that even print beautifully. You just gotta work a bit for it. And, have Lightroom. Or Photoshop (but Lightroom's pano feature is faster and easier). The first difference is that you don't take one continuous photo like you do with your camera phone. You take a series of photos, one after another, with a little overlap between them. So, you might have four or five shots, or maybe even 10 or 12 in a row across a very wide scene. That's the first part—shoot the frames. Take the shots, one after another, and try to overlap each one by a bit, so what you see on the far right of your first photo, appears on the far left of your second photo. The second part is to take those into Lightroom. Once you're in Lightroom, select all the images in that pano, then go up under the Photo menu, under Photo Merge, and choose Panorama. The next thing you'll see is a preview dialog with your stitched panorama, and it does a really brilliant job (make sure you turn on the Auto Crop checkbox if it's not already turned on)!

How to Shoot HDR Images

There are some phones now (like the iPhone, for example) that have a built-in HDR feature for capturing scenes where there's a huge range of difference between the bright and dark areas of an image, like when you're shooting a shot indoors and need to see out the window, as well (HDR stands for "High Dynamic Range," by the way). Anyway, you can create awesome HDRs, you just have to work a bit harder in your camera, and then in Lightroom, but the results are worth it. You start by turning on Exposure Bracketing in your camera. This tells your camera to take multiple shots when you press the shutter button just once, but these other shots will be darker and lighter than the normal exposure. How much darker or lighter? You choose that in your camera and, as luck would have it, every camera make and model is different (even from the same manufacturer), so as much as I hate to say it, you have to find out how to turn on Exposure Bracketing (say it with me…) in your manual. You will only need two shots to make an HDR image in Lightroom (that's not a typo—just two shots): one that is two stops darker than normal; one that is two stops brighter. Your camera may let you do "two-stop bracketing," in which case your camera will take three shots total (but, you only need the darkest one and the brightest one). Your camera may only let you do "one-stop bracketing," in which case you'll have to shoot five shots and use just the darkest one and brightest one. Import those into Lightroom, select just those two images, then go under the Photo menu, under Photo Merge, and choose HDR. In a few seconds the HDR preview dialog will appear, showing you your two images merged into one, but the real fun begins when you click Merge and it opens in regular ol' Lightroom. Go to the Develop module, drag the Clarity slider to the right a bit, along with Shadows and Contrast, and you'll be super-digging it!

Getting a Soft, Blurry Background

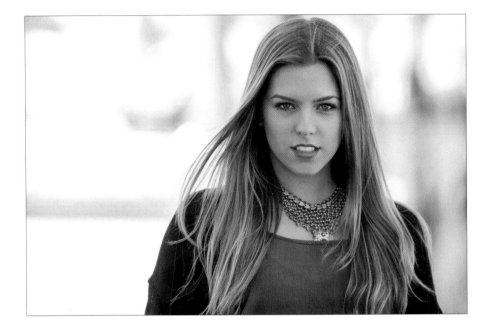

To get that soft, blurry, out-of-focus background behind your subject, you do two things: (1) Use the lowest f-stop your lens will allow, so something like f/5.6 or f/4, or if you're lucky (and wealthy), f/2.8 or lower. Then, (2) zoom in tight on your subject. Press the shutter button. Done. That's it. Those two things together will do the trick. Now, if you're asking, "How do I change my f-stop?" Try this: switch your camera to aperture priority mode (it's the letter "A" on your mode dial on the top of your camera, providing of course, you have a mode dial, but you probably do). Then, move the dial on your camera that changes the f-stop until you see f/2.8 in your viewfinder. That'll do the trick.

Working With Your Pop-Up Flash

First, just know up front that taking a portrait of someone with your pop-up flash is cruel. It's the most unflattering thing you can do to them, and it doesn't make you look good either. It's a harsh, nasty, angry light quality, and I would avoid using it at all costs. However, if you have no choice, I would recommend using something, anything, to soften it, or at the very least, most DSLRs have a control that lets you turn down the power of the pop-up flash, so it doesn't look like a lighting grenade just went off in front of your subject. So, where is this magic button? Well, as luck would have it, once again, it's in a different place on every make and model of camera, so it's back to the stinkin' camera manual to find out, but at least you know it can be done. Now, if you're really interested in flash, you can jump over to the Hot Shoe Flash chapter here in the book and it has all the stuff you need, including accessories, to get you awesome looking flash results. (Spoiler: I try to talk you out of using your pop-up flash there, too!)

Using the Viewfinder (Don't Point & Shoot)

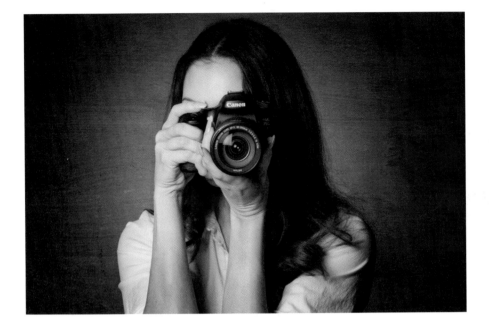

One thing you don't want to do, after you've invested all this time and money on buying and learning a DSLR, is use it like it's a camera phone by holding it out in front of you, shooting in Live View mode (like you do with your camera phone). You're going to get a *lot* of blurry shots, and it will wind up keeping you from getting the kind of pro-quality shots you bought a DSLR for in the first place. You've really got to use the camera's viewfinder (yes, you have to look through that little hole at the top of your camera). First off, there's a lot of important information that appears within the viewfinder, and even if you don't know what any of it means right now, you will shortly. Secondly, it's very hard to keep a heavy camera still when held out in front of you like that. You need it resting against your forehead to help with steadiness while you shoot (see page 210 for more on how to hold it). Yes, it makes that big a difference. Not to mention the visibility problems when it's bright outside, or that the auto focus is pretty slow in Live View mode, or that it eats up way more battery life, or that the camera was designed to put all the functions where they're easy to access while you're shooting with it up to your eye. I could go on, and there are instances when you will want to shoot with Live View, but when you're just making the jump to DSLR (like we're talking about here), I would highly recommend that you start by getting used to the viewfinder. I promise you'll be glad you did.

Take Advantage of Scene Modes

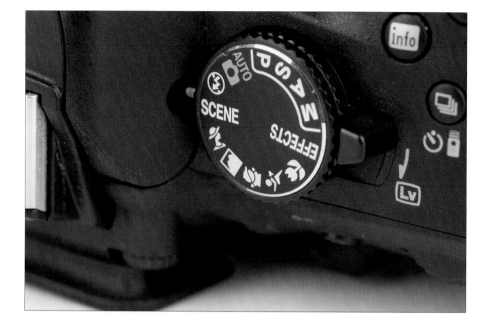

If you're humming along shooting in program mode and life is good, but then you come to a particular situation where you think, "Can't this camera do a bit better?" then it's time to branch out a bit to scene modes. When you choose one of these (usually from the mode dial at the top of your camera), it puts in place all the settings that would make it ideal to shoot what you're about to shoot. For example, if you're shooting sports, and you switch to the sports scene mode (the icon is usually of a man running), your camera puts in settings for you that would work well for shooting sports. Shooting flowers? Turn your mode to the icon that looks like a flower, and you'll get better results. Same with portraits. Same with landscapes. You're one click away from having your DSLR put better settings in place for you, so make sure you at least give it a try.

How to Shoot Video

Does your DSLR shoot video? You bet. In fact, it would be hard to find one that doesn't. It's easy to start recording: Just turn the switch on the back of your camera (or up on your mode dial) and your monitor switches to Live View mode, so you can see what you're filming. Press the record button and it starts. Press it again to stop. Now, that sounds pretty simple, so is it as easy as shooting video on your camera phone? Oh, h@#l, no! It's kind of a pain in the butt because most DSLRs' video features don't have auto focus. What?! I know. I thought the same thing when I first heard that years ago, and in all these years, still very few DSLRs have built-in auto focus that's anything like what we're used to on our camera phones or camcorders. So, who is this DSLR video for? Filmmakers. I'm not joking. The quality of the video, if you have the right lenses, and the right video camera techniques, is absolutely insane. But, it's still not something that folks who are used to camcorder video or camera phone video are using a whole lot, and when they do, they just shoot a clip here and a clip there. So, what do I recommend? Honestly, keep shooting your video on your camera phone or camcorder—they do all the stuff you want them to do without all the hassles of DSLR video and video editing. I know this isn't what you were hoping to hear, but my job is to tell you the same thing I would tell a friend if they asked, and frankly there's no way I would tell a friend (who is not already seriously into video) to mess with DSLR video, unless (and this is a big unless) the particular model they bought has a built-in auto-focus when shooting video. Don't shoot the messenger.

How to Set Your Exposure

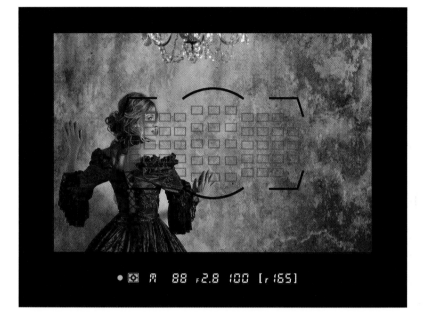

Remember earlier, how I told you how to set your focus, by moving the red dot or rectangle (focus point) over the part of the image you want the camera to focus on? Do the same thing for exposure. Whatever that dot is over, that's what the camera thinks is the most important part of the image, so it exposes to make that part look great. If it's wrong, you can always move that spot over something else in the image and try again. Is there more to exposure than this? Yup. But, this is a good start.

RAW or JPEG?

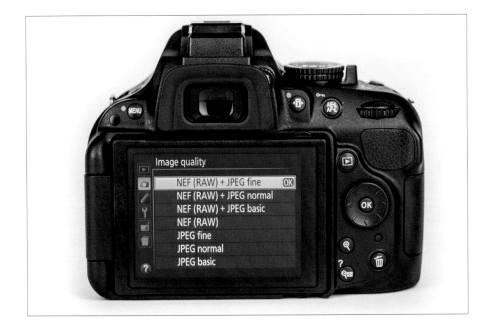

That's easy. JPEG! (Unless you're already pretty decent at post-processing your images in something like Lightroom, Photoshop, or another desktop application that edits RAW photos.) Look, you're going to read all over the web that shooting in RAW captures a wider dynamic range, and it's more forgiving if you're way off on white balance or your exposure. What you don't normally read on the web is that JPEG images look much better than RAW images straight out of the camera. That's because JPEG images have sharpening added, contrast added, noise reduction added, and a whole bunch of other stuff applied to the photo in the camera itself. It basically tries to create a finished image. When you switch your camera to shoot in RAW mode, you're telling it to turn off the sharpening, turn off the contrast, turn off all that stuff, and just give me the raw, flat, untouched photo, and I'll add all that stuff in my post-processing. That's why: (1) RAW photos look so flat and not as contrasty, colorful, or sharp as what you saw on the LCD on the back of your camera (even when you shoot in RAW, it still displays the JPEG image), and (2) it's why the #1 most-asked question I get is, "How do I make my RAW images look more like the JPEG?" This is why I recommend, for starters, you shoot in JPEG. Now, there will probably come a day when you'll want to switch to RAW, and that's okay, but you'll know when you're ready, because you'll have gotten pretty good at editing your JPEG images. Then, it's time to switch and you won't look back. But, for now, let's keep it in JPEG, so you can post your images online without a whole bunch of fussing in post production.

Start Outside

Want to get really comfortable learning the ins and outs of your camera, and getting familiar with all the dials and controls and stuff without getting frustrated? Then, for the first couple of weeks, just shoot outside on nice sunny days (or at least on days where there's a lot of light outside, because even very cloudy days can be pretty bright when it comes to cameras). Why outside? Because you'll be thrilled with the results. Shooting outdoors is a breeze, and you'll get good quality photos all day long. Step indoors, or in low light, or in a cathedral, or a gymnasium, before you know what you're doing, and you'll get very frustrated with your camera, and the results. Start outside for the first few weeks, and you'll love that DSLR like a puppy, and it will work really well all day, every day. Once you've got the hang of it, and where all the key buttons and dials are and what they do, then you can move indoors and start worrying about things like ISO and shutter speed, and holding your camera steadier than the Rock of Gibraltar. I know what you're thinking, "But my camera phone worked fine indoors. It was grainy. It was noisy, but it worked." This is different. Start outside. You'll thank me one day (unless that day it's raining).

Chapter Thirteen

Ten Things I Wish Someone Had Told Me

When I First Started Out in Photography

So, why don't pro photographers tell you about these things when you're "on the way up?" It's actually very simple, but you need to know the back story to understand how, historically, this has all worked. For as long as I can remember, there has been a "Secret Society of Photographers Who Have Taken a Blood Oath to Never Share Their Hard-Earned Secrets with Outsiders" (known as the SSOPWHTABOTNSTH-ESWO, for short), and this cartel of working pros (supposedly funded by an "unofficial" government agency, or Pentax) controls the flow of information, much like the ICANN controls the distribution of top-level web domains. Anyway, the sacred brothers (as they're called) of the SSOPWHTABOTNSTH-ESWO controlled the flow of photographic techniques for many years by only sharing them with other sacred brothers during a ritualistic "sharing of the mastery" ceremony held once a year in a hidden cave (which some claim is in Dunwoody, Georgia, just outside Atlanta). Anyway, what finally broke this chain of religious-like secrecy was actually a clerical error—a typo, if you will. When they were updating their official letterhead and business cards back in 2006, an intern working on the design apparently typed in their name as "SSOPWHTABOTTH-ESWO," accidentally leaving off two critical letters, "NS," which was the "Never Share" part of their name. As things tend to go in secret societies like this, the members felt this was actually an edict from the governing body (the Parliamentary Order of Professionals, a group which regular members are forbidden to ever refer to by their acronym), and so members began to share these once secret techniques openly and freely, and that's how we got to where we are today. Or, it could be that those pros are just afraid that if other people learn this stuff they'll wind up losing wedding jobs to them. It's hard to say.

#1: Buying a More Expensive Camera Doesn't Necessarily Mean Better Photos

If you bought a new DSLR camera in the past year or two, even an entry-level model, it already takes better quality photos right out of the box than the high-end pro models did just a few years ago. The quality of the sensors in today's entry-level digital cameras is truly amazing and, whether it's a Nikon, Canon, Sony, Pentax, etc., they all make great quality photos. For example, if you went out at dawn to a beautiful landscape location, set up a tripod, and took 10 shots with an entry-level camera, like the Canon Rebel SL1 (I found a body online for $549), then took the same shots, in the same location, with the high-end Canon 5DS (around $3,900), printed all 20 images, and mixed them up, you wouldn't be able to tell which camera took which images. They'd be that close in quality. So, if they both take such great shots, why would anyone ever need a high-end pro camera? Well, it's *not* because they take better photos; it's because they have more features. It's kinda like buying a car. You can buy a Toyota Camry from around $23,000 up to around $33,000. They're all Camrys (great cars), but you buy the $33K model because it has more features—heated seats, a back-up camera, a bigger engine, a security system, more speakers, and so on. But, when you're on the highway going 60 mph, the results are the same. So, how can you get better photos out of the camera you already have? Learn your camera inside and out—all the features, all the menus, and what all the buttons do. That way, using your camera becomes automatic and you can stop worrying about all the buttons and dials and start focusing on making great pictures, which is really about two things: what you aim your camera at and how you aim it.

#2: You Need to Sharpen After the Fact

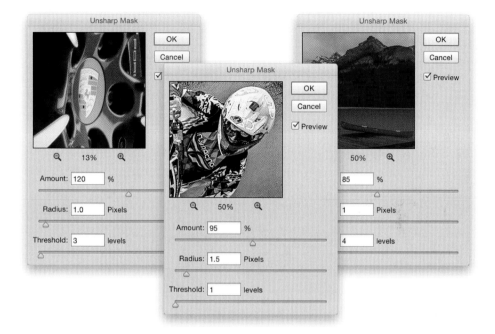

There are lots of things you can do to help really sharpen photos, and obviously I thought it was so important that I included a whole chapter just about sharpness in this book. But, if there is one single trick that really takes a sharp shot to one that's tack sharp, it's sharpening after the fact on your computer. It doesn't matter whether you use Photoshop, Photoshop Elements (the "light" version of Photoshop that really isn't very light), or Adobe's Lightroom, you need to sharpen every single photo to get the look the pros have. Think about this: with all the money we spend on tripods, and cable releases, and really sharp lenses, the reality is that as long as the shot is pretty sharp coming out of the camera, the money you spend on a program like Photoshop Elements will have the most impact on you getting a truly sharp photo (heck, I just did a quick Google search and found Elements for $80—that's a small price to pay to have all your photos from here on out jump to the next level of sharpness). By the way, whether you buy Photoshop Elements for $80 or subscribe to the full version of Photoshop for $9.99 a month, the sharpen filter we use, called the Unsharp Mask filter, works exactly the same in both. To use it, go under the Filter menu, under Sharpen, and choose Unsharp Mask. Back on page 50, in Chapter 3, I gave you the settings I use day-in, day-out for people, cityscapes, urban photography, or travel, general everyday use, super-sharpening (for sports photos, landscapes, stuff with lots of details), and for images I've already made smaller and lower resolution, so I can post them on the web. Try them out and see if this sharpening doesn't make as big of a, or bigger, difference than all the rest.

#3: The Pros Take Lots of Bad Photos

You just don't see them, because one of the traits of a real pro is that they only show their very best work. I know a lot of folks think that these pros walk up to a scene, take one amazing shot, and then walk away and do it again someplace else—every time they press the shutter button, they create yet another amazing shot. I can tell you, for certain, that's just not how it works (if it was that way, the photographer's workday would be all of five minutes long, right?). I've worked and taught alongside some of the most famous photographers in the world today and they'd be the first ones to tell you that it often takes hundreds of shots of the same subject to come away with that one amazing shot (the only one that anyone will see). But, when we shoot, we see *all* our shots (the good ones and bad ones), so we start to compare *all* our shots to the pros' highlight reels, and it bums us out. Remember: we're not judged as photographers by the bad shots we take; we're judged by the ones we share. Take a cue from the pros—only share your best shots and just know that pros simply don't nail every shot. So, don't compare all your shots to the pros' cream of the crop. By the way, if I shoot 200 or 300 shots and I come away with five or six really good ones in there, I'm thrilled. Sometimes I get a few more than that; sometimes I literally walk away with none, which is disappointing, but it happens. If that happens to you, don't let it get you down—chances are that at the next shoot you'll make up for it. One more thing: every once in a while something amazing happens right in front of us and we raise our camera, shoot, and capture something magical. It happens to both amateurs and pros and it's called "getting lucky." Thankfully, it happens more often than you'd think.

#4: Learn Exposure Compensation

If you take a shot and you look at it on the back of your camera and it just looks awful (it's way too dark, way too bright, your subject is in shadows, etc.), do you know exactly which controls on your camera will fix it? If not, the next most important thing for you to learn is exposure compensation. I talk about it back on page 135, but a lot of people will skip over that page because the phrase "exposure compensation" doesn't mean anything to them at that point. I wish it had a better name, because I think it's probably one of the most important camera techniques to learn when you're starting out. It helps you overcome two big problems: (1) your camera's built-in light meter is really good, but sometimes it's wrong and you know it's wrong, but you're not sure how to fix it; and (2) it helps you retain the detail in your photos, primarily in the brightest parts of your image. If you and I were out shooting and you asked me what one thing you needed to understand about your camera itself to really take better shots, learning exposure compensation would be it. Learning this is what will turn more of your messed up shots into prints you'll want to hang on your wall. Turn to page 135 right now and learn when to use it. You can always come back to this chapter later (yes, it's that important).

#5: Don't Worry About Manual Mode

Good news: you can be a great photographer, and make amazing images, and live a long, happy life all without ever having to learn to shoot in manual mode. I know a lot of new photographers worry that the reason their photos don't look like they want them to is because they're not shooting in manual mode. But, trust me, manual mode isn't some magical mode that transforms everyday photos into gallery pieces—it's just another shooting mode on your camera like the rest. And, ultimately, what makes magical photos is, say it with me, "what you aim your camera at and how you aim it." It's not which mode you shoot in. I think the reason some of us get sucked into thinking it's the magical unicorn of modes is that you'll sometimes read in an online forum some photographer bragging that he "only shoots in manual mode" (like he's earned some special honor). But, again, trust me, it's just another exposure mode on your camera, so you can scratch that one off your worry list. Now, I don't want you to think that I'm saying you shouldn't learn manual mode, or that manual mode is bad (I actually recommend it for shooting in a photo studio with strobes), but I don't want you to think it's this big hill that one day you're going to have to climb to get to photography nirvana. In the list of things we have to worry about in our quest to become better photographers, you can move this one way, way down your list.

#6: Today You Should Probably Shoot Wide

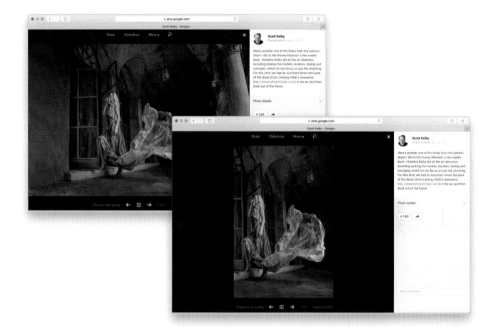

Where do most of our images wind up being seen today? On the web, right? I mean, we still make some prints from time to time (you do make prints, right?), but really, in today's world, you'd have to admit that for most of us, the web is where most folks will see our images. If that's the case for you, then I hope you take this advice I got a few years ago: shoot wide. By wide I mean shoot horizontal (landscape) shots rather than tall, vertical shots. Here are two reasons why: (1) The bigger your images appear, the more impact they have, right? Right! So, when you shoot tall shots and put them on the web, they usually wind up looking like small thumbnails because that's the way most websites, portfolio sites, and social media sites are designed. Your image will have a lot of empty space on either side of it, and in the middle, there's your little picture. However, if you shoot wide, you'll be able to make your images much larger on the web and they'll have that much more impact. (2) It's usually much easier to crop a wide image so it looks like a tall image, than it is to try to crop a tall image so it looks like a wide image (give it a try and you'll instantly see what I mean). So, I know there's an old saying that goes, "When do you shoot a tall image? Right after you've shot a wide version of it," but there's a reason that's an "old" saying. It used to apply because all our images used to be prints, and they all had the same impact because you could just rotate the print. Today, things have changed and we need to change our thinking (and our shooting strategy), too!

#7: Nothing Has Impact Like a Print

If you want to really make an impression on people, make a print. I know it sounds simple, but a printed piece, especially today, is one of the most powerful, impactful things you can do for your photography, and the bigger the print, the more powerful the impact (I personally think the impact size starts at 13x19", but if you can go bigger, like 17x22", it really adds impact. This is a case where bigger is better). So, why do prints have such an impact these days? (1) Prints are real. The rest of the time we're looking at images inside a glass screen on a computer. We can't hold them. We can't touch them. They're "inside" a box of some sort. When you make a print, your image is no longer a bunch of 1s and 0s and a bunch of digital code. It's real. (2) When you make a print, watch the person's hands right after you hand them the print. They start feeling the paper. Touch is one of our five senses, and when you add touch to your visual sense, your image connects with the viewer on a different level. (3) There is a certain legitimacy to having prints of your work. It says something about you, about how serious you take your work, and it's an investment in your photographic journey. (4) Prints open doors. If you want to shoot in a particular location (let's say it's a restaurant interior), and you take a large print in to show the restaurant owner the type of work you do, my guess is they'll welcome you to shoot in their restaurant. It tacitly says, "I'm legit—it's okay to let me do this." Believe me, it works wonders. Lastly, (5) prints make an amazing gift. Think of it this way: How much impact does it have when you email an image to a friend? Now, make a nice print, sign it, roll it in a tube, and mail it to them the old fashioned way. You'll be amazed at the reaction you get. There's power in the print. Try it once, and you'll see.

#8: Ignore Your Histogram

I know that headline above just made someone's head explode, but remember, these are things I'd tell a personal friend (and things I wish somebody had told me), and one of those things would be to ignore the histogram on the back of your camera. I know that people desperately want a tangible, technical measure of the age-old question, "Is this a good photo?" But, I can promise you the answer isn't found there. I remember being one of the guest speakers at a photography workshop and, during my presentation, the subject of histograms came up. Standing in the back of the room were some of the other instructors (literally, some of the best in the business—Joe McNally, Vincent Versace, Laurie Excel, and Moose Peterson). I mentioned I didn't use histograms, and then I asked those famous photography instructors if they ever used the histogram on the back of their camera. They yelled back: "Nope," "Never," "Not me," and "Not a chance!" What is it that these pros know that so many people arguing endlessly on the web don't know? They know that great photos don't come from looking at a graph. They know that great photos aren't about the technical stuff (even though so many photographers desperately wish that it was, because people can learn technical stuff—it's much harder to develop an "eye" and a heart for photography). Getting a good exposure with today's digital cameras just isn't that hard. In fact, it's simple, because today's cameras are so advanced that you almost have to work hard to get a bad exposure. So, stop worrying about the graph and start worrying about what you aim your camera at, and how you aim it. That's where great photos come from.

#9: Figure Out What Type of Photographer You Are

You should try shooting all sorts of stuff—from food to landscapes, from portraits to sports, from products to travel, and everything in between. When you're just starting out, shoot everything! And once you've done that, sit down and figure out what kind of photographer you really want to be and work on that. The first step is to take a good look at the stuff you've been shooting and ask yourself, "Which one of these do I seem to have a knack for?" Or, "Which shots have people told me I have a knack for?" Chances are there is something you shot that you particularly felt you had a knack for—you just kind of knew what to do. Okay, that's step one (and it might be more than one thing—you might feel like you have a knack for travel, sports, and natural light portraits, and that's okay). The next step is to ask yourself, "Which one of these do I really enjoy shooting?" This is really important, because this is what you should be focusing on. There's no sense in getting really good at product photography when what you really want to be is a natural light portrait photographer. But, few photographers, even more experienced ones, really sit down and think this through—they just shoot what comes their way. And, while they may wind up being competent at shooting a lot of different things, I'm guessing being *competent* isn't your goal (it's like getting a C+ in class). Finding out who you are as a photographer allows you to focus your learning, your energy, and your time in the right direction. When you start to get good at what you really enjoy, this is when the magic happens.

#10: Do What It Takes to Get the Photos You Want

Look, somebody has to tell you this (I wish it wasn't me, but since we're here together, here goes): great photos aren't around your house. One day, they might be, but chances are, you're going to have to venture out, perhaps quite far, to make the type of photos you want to make. For example, if you decide you want to take great landscape photos, chances are (unless you live in Page, Arizona, or Moab, Utah), you're not going to be able to make great landscape photos in the city where you live. You're going to have to go someplace where great landscape photos are made. I know that takes time and it costs money, but if you want amazing landscape photos, you'd better start by standing in front of an amazing landscape, preferably at dawn. That's the other part. If you do spend the money and make the trip, don't sleep in and shoot at 9:00 a.m. You need to be in place, ready to shoot, at least 30 minutes before sunrise—more like 4:45 a.m. This is what I mean when I say, "Do what it takes to get the photos you want."When you see amazing landscape photos, someone did just that. They paid for the trip. They learned the settings. They bought (borrowed, or rented) the right equipment. They got up at dawn (maybe two mornings in a row at the same location. Maybe more). They did what it took to get the type of shot they wanted. But shouldn't you practice a lot before you make that trip? That trip is the practice (and this won't be your only practice trip). If you want to shoot people, find interesting looking or extremely photogenic people, and then either learn to light them or find amazing light. If great photos were easy, everybody would have them. Making great photos takes more than a great camera. Do whatever it takes to make the shot or you'll wind up with a lifetime of shots you're disappointed with.

#11: You Need a Portfolio

You're probably thinking, "Wait, this is #11. I thought you said there would be just 10 things?" I know, but 11 things just sounds kind of weenie, so consider this one a bonus thing. Okay, back to the portfolio. It doesn't matter if you have an online one or a printed portfolio. The most important part at this point is that you have one. Why is this so important? It's because you probably have literally thousands of photos on your computer, so what you really have is a big pile of photos that doesn't really tell you much, besides that you've taken a bunch of photos. The reason you need a portfolio of your best work is so you know where you are, right now, as a photographer. When you compile your best photos, you'll get a real sense for where you are on your journey and only then can you decide what you need to learn or do next. Okay, so how many photos should be in your portfolio? Start with just 24 of your best photos and compile them into a portfolio. I don't mean put them in folder on your computer—you need to post them somewhere online (yes, you have to post them). You don't have to pay a bunch, as there are lots of places to get an online portfolio for free or next to nothing (try 500px.com or www.squarespace.com, which are both very cool and affordable). If you don't think you can narrow things down to just 24 images, ask another photographer who you feel can give you an unbiased opinion to help. If you're serious about growing as a photographer, this is an important step (a bigger one than it sounds).

#12: Stop Reading Books About Photography

Now you're thinking, "Really? There's a number 12?" Well, this was going to be a blank page, because of the way books are printed, so I thought I'd toss in another bonus one, and although the headline sounds kind of negative (well, certainly from my book publisher's point of view), it actually isn't. But, let's switch gears for a moment. Have you ever read *Golf Digest* magazine? Terrific magazine, full of great articles on everything from how to improve your swing to "bunker shots made simple." I always learn a thing or two reading *Golf Digest*, which is great because I love golf. I'm just not very good at it. When I play a round with my brother Jeff, I don't score very well. I do hit a few nice drives, sink a nice putt or two, and every once in a while I even make a simple bunker shot. I've taken golf lessons, I have a pretty decent set of clubs, and thanks to *Golf Digest*, I pretty much know what to do, which is why it's so frustrating that when I play a round, I don't do nearly as well as I should. But, at least I know why. I don't practice. Taking lessons, reading *Golf Digest*, and watching the Golf Channel teach me about golf, but it's not practice. I need to take what I've read, watched, and been taught, and actually go practice those techniques. I need to hit the driving range regularly. I need to practice my short game. And, I need to practice actually getting out of bunkers (and not just reading about how to do it). Photography is the same way. If you want to get better, reading will pretty much show you what to do, but that's not doing it. That's reading about it. You need to practice. You need to shoot regularly with the single intent of practicing the things you've read about. I really do appreciate that you bought this book, and I hope it gives you some great ideas about what to work on, but now put down the book. It's practice time.

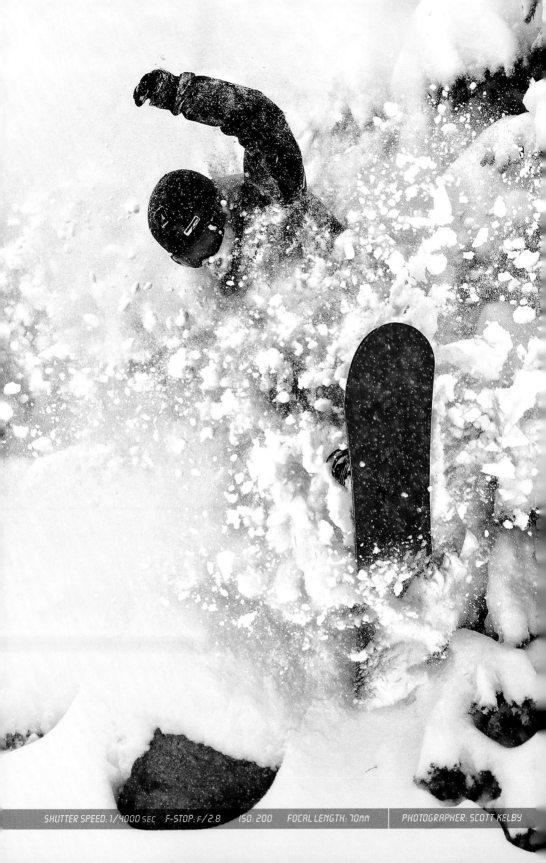

SHUTTER SPEED: 1/4000 SEC F-STOP: F/2.8 ISO: 200 FOCAL LENGTH: 70mm | PHOTOGRAPHER: SCOTT KELBY

Chapter Fourteen

Photo Recipes to Help You "Get the Shot"

The Simple Ingredients That Make It All Come Together

Hey, it's the end of the book, and now is as good a time as any to let you in on a secret. There's really no way in hell we're going to get those really magical shots (like you see in magazines such as *Outdoor Photographer* or *Shutterbug*). That's because when we get out to that prime shooting location at the crack of dawn to hopefully capture one of these once-in-a-lifetime shots, carrying so much gear that our chiropractors are on speed dial, we'll soon find that it's too late—there are already a dozen or so photographers set up there waiting for that magical light, too. Since they were there first, the only spot left on that tiny plateau is behind them, and every shot you take is going to have some, if not all, of their camera gear fully in your frame, ruining any possible chance of you getting "the shot." But this chapter is all about recipes for getting the shot, and I've got a special recipe for this very situation. Just as the golden light appears over the horizon, you quietly slide your foot inside one of their tripod legs, then quickly pull your foot back, toppling over their entire rig, and as their thousands of dollars of gear begins to crash violently to the ground, you deftly press the cable release on your camera and capture that amazing vista as the sound of broken glass echoes off the canyon walls. Ahh, that, my friends, is the magical sound of you getting "the shot." If you hear the faint sound of sobbing in the distance, it all becomes that much sweeter. Enjoy.

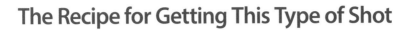
The Recipe for Getting This Type of Shot

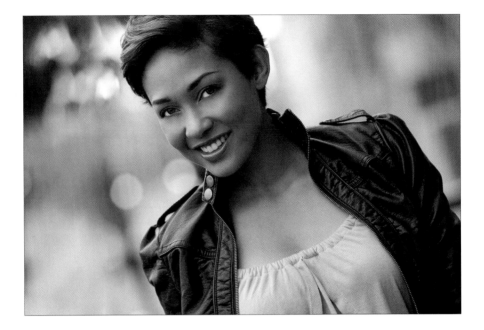

Characteristics of this type of shot: A soft, glamorous look, with the background way out of focus, and a soft-creamy look to the entire image.

(1) For this look, you're going to need a telephoto lens (this was shot with a 70–200mm lens out at around 200mm). By zooming in tight like this, it helps to put the background out of focus, but that alone isn't enough to make the background this out of focus. The other thing you need to do is shoot in aperture priority mode and use the smallest number f-stop you can, like f/2.8 or f/4 (if your lens will let you go that low).

(2) This is actually a natural-light shot, but the reason the light is so beautiful is because it's taken outdoors very late in the afternoon, maybe an hour and a half before sunset. To give the shot a bit more energy, tilt the camera at a 45° angle when you take the shot.

(3) To make the light even softer, have a friend hold up a 1-stop diffuser between your subject and the sun (it's large, round, and basically looks like a reflector, but instead of being silver or gold and reflecting light, it's white and translucent, so it allows some of the sunlight to come through, but spreads and softens it quite a bit). Have them hold the diffuser as close to your subject's head as they can get without it actually being in your frame, and it creates the beautiful, soft, diffused light you see here (the diffuser is above the left side of her head at a 45° angle). These diffusers are collapsible just like a reflector, and they're fairly inexpensive, too.

The Recipe for Getting This Type of Shot

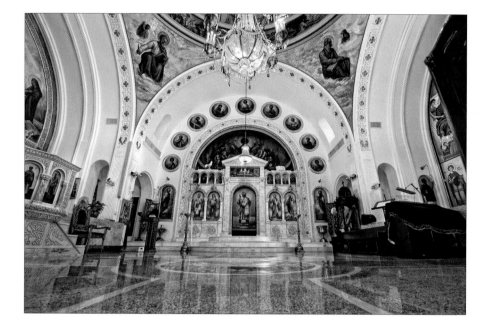

Characteristics of this type of shot: A large, wide, sweeping shot of a cathedral with lots of detail in all the ornate objects in the scene.

(1) In many ways, this shot was taken like it was a landscape shot—it was designed from the outset to have that big, sweeping look. Shoot a church like this with a wide-angle lens (this was shot with a full-frame camera, which means it was extra-wide compared to a cropped sensor camera, and it was shot with a 14mm lens).

(2) Churches generally have low light, and even though the ceiling of this church was white and there was natural light coming in through the windows, it was still dark enough that, at f/4, my camera needed to keep the shutter open 1/13 of a second, which is way too slow to handhold. So, you'll absolutely have to be on a tripod.

(3) This is the beautiful St. Nicholas Greek Orthodox Cathedral in Tarpon Springs, Florida. I'm positioned in the center aisle between the pews, right at the first pew, so there are no obstructions (pews) between the camera and altar.

(4) Compositionally, I used a trick that helps make it look like a big, sweeping shot: I collapsed the tripod legs, so the tripod was only about 18" tall (if that). That way, you see a lot of the marble floor leading up to the altar, which creates its "bigness."

(5) To bring out the detail, you finish it off in Photoshop (or Elements or Lightroom) using a plug-in filter that creates a tonal contrast effect, like the Google Nik Collection's Color Efex Pro or Topaz Labs' Topaz Adjust—all offer one-click presets for that effect (you can download fully-functional, free trial versions of both from their websites).

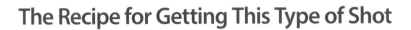
The Recipe for Getting This Type of Shot

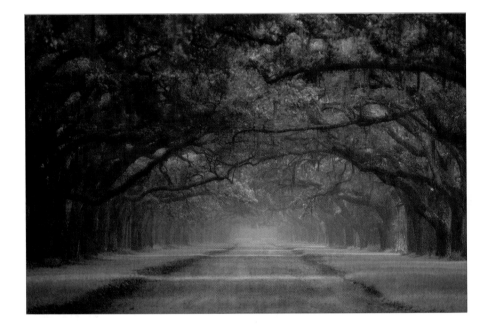

Characteristics of this type of shot: A soft, misty landscape with lots of depth and dimension.

(1) To get a shot like this, you have to either get up early and be in position before dawn (that's when this shot was taken) or shoot it late in the day, right around sunset. The foggy mist you see is a big part of landscape photography—it's called luck. You can increase your luck by visiting the same location more than once. This was taken the second day of shooting in the exact same location—the previous day had no mist whatsoever.

(2) This is shot in fairly low light (maybe 30 minutes after sunrise), so you'll need to be on a tripod to keep your camera still enough for a really sharp shot. You'll also need to use a remote shutter release, so you don't introduce even a tiny bit of vibration by touching the camera to press the shutter button. Also, shooting from a low perspective gives the shot its "bigness," so put your tripod down so low you have to shoot on your knees.

(3) To have detail throughout the image, I recommend shooting at f/22, an ideal f-stop for telling a big, sweeping story. Also, to add visual interest, don't put the road in the dead center of the photo (because that's dead boring—notice how it's cheated over to the left a bit?) and don't put your horizon line in the middle of the photo, because that's what your average person would do, and you don't want your images to look average.

The Recipe for Getting This Type of Shot

Characteristics of this type of shot: A bright, sunny shot with the sun clearly visible, but your subject isn't lost in the shadows.

(1) This is a very easy shot to pull off—you just need a simple pop-up reflector. Position your subject so the sun is behind them or to the side (in this case, it's beside her, but when she faces the camera, she's fully in shadows. That's what the reflector panel is for—to bounce some of that sunlight back into your subject's face). The reflector should be to the left of you, held up high over the head of a friend or assistant and angled toward your subject.

(2) This was taken on a beach, but the beach wasn't very pretty at all, with lots of vegetation right at the shoreline. So, the trick is to get down low, very low—lying down, in fact—and shoot upward at your subject with a wide-angle lens. Make sure you put your subject to one side or the other—don't center her.

(3) This is going to sound silly, but if you're shooting outdoors, buy a long veil. You'll thank me, because if any tiny bit of wind comes along, it does beautiful things all by itself. If there is no wind, create your own using a second reflector panel—literally have a second friend (or assistant, or passerby) fan your subject with that large reflector. It doesn't take much to make that veil take flight, and it creates a beautiful look.

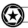

The Recipe for Getting This Type of Shot

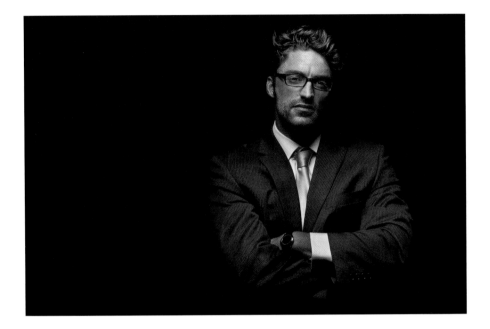

Characteristics of this type of shot: A dramatic corporate portrait with an editorial cover-shot look to it, with a fast falloff of light, where the subject's face is lit, but then it falls off to dark very quickly.

(1) This is an amazingly simple, one-light shoot. The light is a studio strobe with a beauty dish that's about 1 foot directly in front of the subject, but up about 2 feet above his head, aiming back at him at a 45° angle. That's it.

(2) Because this is supposed to be a dramatic portrait, you don't want to kill him with light, so keep the power of your strobe just about all the way down (if you're using a hot shoe flash instead, switch the flash to Manual mode and use 1/4-power, and then see if it needs to be a tad brighter or if that's okay).

(3) Your subject isn't moving, and you're using flash, so you don't have to shoot this on a tripod. I would recommend shooting in manual mode. For your starting place settings, try f/11, so everything is perfectly in focus, and set your shutter speed to 1/125 of a second (that way, you don't have any sync speed issues). Lastly, move your camera's focus point directly onto his eye (the one closest to the camera), press-and-hold your shutter button halfway down to lock the focus, and keep it held down. Now, compose the shot the way you want (here, I put him way over to the right) and take the shot.

The Recipe for Getting This Type of Shot

Characteristics of this type of shot: A bright, backlit, blown-out look with visible motion to give the sense of speed.

(1) In sports photography, you normally try to freeze the action, which means getting a shutter speed of 1/1000 of a second or faster. However, there are times (and certain sports, like cycling and motorsports) where you want to create a sense of motion and speed, so the athletes (cars) appear to be moving (and not parked in position, ready for the race to start). To do this, shoot at a slow shutter speed and pan with your subject (in this case, the cyclist), which keeps most of the bike in focus, but makes the wheels and background show motion.

(2) To do this, shoot in shutter priority mode (S) and set your shutter speed to 1/60 of a second (far below the 1/1000 you'd use to freeze motion), and then turn on Continuous Shooting (on a Canon or Sony) or Continuous High-Speed mode (on a Nikon), so it takes multiple photos when you press-and-hold the shutter button.

(3) When the athlete is nearly to you, lock your focus on them (I usually aim my center focus point at their helmet), and then track along with them, firing in continuous mode, taking a series of photos as they go by. Hold that shutter button down until they are well past you.

(4) Many of the shots will be terribly out of focus and that's normal, but in that burst of shots, you'll usually find one that looks just right (and that's the only one you need).

(5) Lastly, to get the popular blown-out look, take your lens hood off your camera, position the athlete between you and the sun, and fire away. Lens flare will come.

The Recipe for Getting This Type of Shot

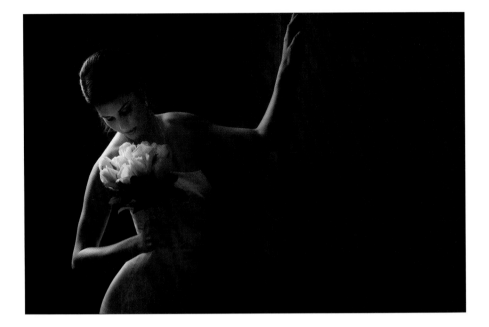

Characteristics of this type of shot: A soft, dramatic, backlit silhouette of a bride taken with just one small light.

(1) This was shot using only one light with a small (24x24" square) softbox attached. Start by making the room she's standing in so dark that the only thing lighting her is the light from the softbox. Set your camera to manual mode, so you can control the shutter speed and aperture separately. Set your shutter speed to the highest number that will still sync your camera/flash (for most studio strobes, that's 1/200 of a second. For most hot shoe flashes, it's 1/250 of a second). By using a high shutter speed number like this, it lets in less existing room light.

(2) Keep your flash turned off, set your f-stop to f/8, take a test shot, and then look at the image on the back of your camera. If you can clearly see the bride, raise the f-stop to f/11, and take another shot. Keep doing this until you're pretty much getting a solid black image (no bride, no detail, no nuthin'). Now, turn on your flash.

(3) You're going to position the flash with the small softbox behind her, but not directly behind her. You want to position it off to one side behind her, so it is coming from behind but aiming back at her at an angle. Next, position her so her head is turned a little toward that light, so some of that angled back light reflects back onto her face (here, you can see some of the light reflecting off the flowers back into her face). Now, your job is to keep the power of the flash low (like 1/4 power or less) to keep it looking dramatic.

(4) When you're done, convert the photo to black and white and add a brown tint in Photoshop or Elements (use a Photo Filter adjustment layer), or Lightroom (use a Develop preset).

The Recipe for Getting This Type of Shot

Characteristics of this type of shot: A "beauty style" shot with soft, punchy light that eliminates most shadows on the face.

(1) This is a two-light shoot: The main light is a studio strobe (flash) with a 17" beauty dish attachment that's directly in front of the subject (to soften the punchy light from a beauty dish, put a diffusion sock over it), up about 2 feet above her face, aiming down at her at a 45° angle. (*Note:* If you don't have a beauty dish, you can use a small softbox instead.) The other light is a small 24" square softbox down at her waist level, aiming up at her at a 45° angle.

(2) Position the camera height right at eye level and, to keep everything in focus from front to back, you'll need to use an f-stop that holds details (like f/11) and a long enough lens (like a 200mm) to give nice perspective. You're in the studio, so use the lowest native ISO you can (100 or 200 ISO max).

(3) Position your subject about 8 to 10 feet in front of a white seamless paper background. Don't put any light on the background, and your white seamless paper will be light gray, like you see here.

(4) If you only have one strobe, use that as the main light up top, then have your subject hold a reflector flat at their chest level, as high as possible without being seen in the frame, to reflect the light from the top strobe back up onto their face to reduce any shadows.

The Recipe for Getting This Type of Shot

Characteristics of this type of shot: A nighttime shot of a building lit with neon lights (this is Flo's V8 Cafe in Cars Land at Disney California Adventure Park).

(1) There are just three things you need to make a shot like this: The first is patience. I had to wait quite a while until there was a 5-second break between streaming crowds of tourists walking right in front of the cafe. This also took a lot of patience for my wife and kids (luckily, there was a gift shop nearby).

(2) The second thing you need is a tripod to steady your camera in low light. Unfortunately, I didn't have a tripod with me, so I had to find something to steady my camera because the shutter was going to be open for a couple of seconds (if I handheld that, it would be out of focus for certain). I tried leaning my camera on a garbage can right across the way from Flo's. I also tried setting it on the ground and using a self-timer. I tried setting it on a railing and a few other different locations, but to get the perspective you see here, I actually wound up setting it on the seat of a park bench.

(3) The third thing is to shoot in manual mode. If you shoot in aperture priority mode, it's probably going to overexpose the shot (not always, mind you, but enough times to where when I shoot nighttime shots, I switch to manual mode). Start by taking one shot in program mode, then note the settings it used. Now switch to manual mode, enter those settings as your starting place, and then if the shot looks too bright, raise your f-stop by one stop (like from f/5.6 to f/8) or higher until the sky gets nice and black.

The Recipe for Getting This Type of Shot

Characteristics of this type of shot: A tight-in shot, giving you an up-close view you don't usually see, and the shot has a lot of energy and vivid color.

(1) The key to this shot is using a very long lens (in this case, a 400mm lens) to get you really in tight to the action.

(2) Because you're shooting in direct sunlight during the middle of the day, getting a shutter speed greater than 1/1000 of a second won't be a problem at all (in fact, this was shot at 1/4000 of a second, which freezes everything).

(3) Because the car is coming almost straight at your shooting position, you hardly see the wheels like you do with a side or three-quarter view of the car, so you don't have to be as concerned about using a slow shutter speed to have the wheels blurred to show motion. Because of that, you can shoot with a much higher shutter speed and create a really crisp image.

(4) One thing that greatly adds to the energy of the shot is tilting the camera 45° to one side—a very popular angle for motorsports shots.

(5) You'll want to use a monopod to steady a lens 300mm or longer.

The Recipe for Getting This Type of Shot

Characteristics of this type of shot: Soft daylight-looking light, with large, tall highlights in the bottles and glasses, and a very shallow depth of field.

(1) These shots are a mixture of natural light and continuous daylight fluorescent studio lighting. The natural daylight was coming from a window behind and to the left (from our view) of the wine bottles.

(2) The main light (lighting the front of the wine bottles) is a Westcott Spiderlite (not a strobe, but a continuous light) using daylight fluorescent bulbs with a 24x36" softbox attached to soften the light. The light is just off to the left of the wine bottle, and in really close (just outside the left side of the camera frame). To get that nice tall reflection, just rotate the softbox so it's tall (rather than wide).

(3) Both lights (the natural window light and the Spiderlite continuous light) are on the left side of the frame, so to bounce some light back into the dark area on the right side of the bottles is a white foam core reflector (you can buy these at your local office supply store), and it's standing straight up, to the right of the wine bottles, just outside the frame.

(4) This is a product shot, so shoot it on a tripod (especially in lower light like this).

The Recipe for Getting This Type of Shot

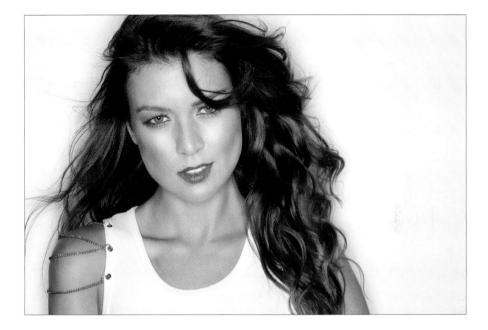

Characteristics of this type of shot: This is the bright, flat, shadowless look that's very popular right now in flash photography. However, with ring flash, you'll actually see a shadow halo outlining your subject, which is part of "the look."

(1) There's only one light—an AlienBees Ring Flash, which is a circle of very small flashes, and your lens goes through the middle of this circle of flashes, so it's mounted right to the camera. You shoot from directly in front of your subject.

(2) Normally, you'd keep your subject about 10 feet away from the white seamless paper background, but to get that halo shadow behind her, you can reposition your subject so she's only around a foot or two from the background. That way, you can see the shadows created by the ring flash, but they're not too large.

(3) Since you're this close to the background, you don't need to light the background with a separate flash—the light from the ring flash is enough to light the background at the same time.

(4) A ring flash produces a harder light source than a strobe with a softbox, so to keep the shadows that outline your subject soft, make sure you shoot in close to your subject (this increases the relative size of your light source, which makes the light softer).

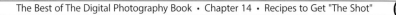
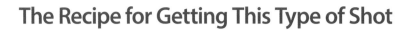
The Recipe for Getting This Type of Shot

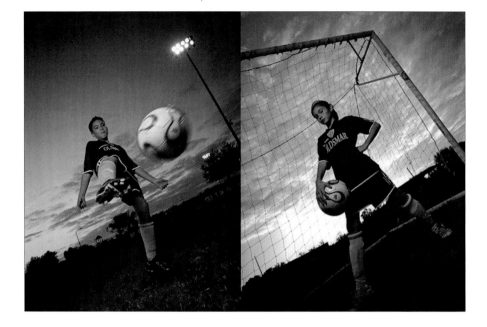

Characteristics of this type of shot: A great mix of sunset color and on-location flash, coupled with a shooting angle that makes these young kids look larger than life.

(1) There are two keys to the shot: The first being composition. To make the kids look big, you have to get down really low and shoot upward with a wide-angle lens (I used a 14–24mm ultra-wide-angle zoom on a full-frame camera). When I say to shoot really low, you actually need to be lying on the ground shooting upward to get this perspective. The other key to this shot is waiting until right around sunset to take it.

(2) The kids are lit using an off-camera flash (in this case, a Nikon SB-900 flash) mounted on a lightweight, portable light stand, with a small Ezybox softbox in front of it to soften and control the spill of the light. For both shots, the flash on the stand was on their right (from our view), just outside the frame.

(3) The key here is to switch to program mode, turn off the flash, aim at your subject, hold the shutter button halfway down, and then look to see the shutter speed and f-stop chosen by your camera. Then switch to manual mode, put in that f-stop and shutter speed, turn the flash on, and put the power really low—just enough to light your subject. Also, put an orange gel over the flash head, so the light from your flash doesn't look so white and artificial.

The Recipe for Getting This Type of Shot

Characteristics of this type of shot: A sweeping landscape with beautiful overall light and some areas lit brighter than others.

(1) This type of beautiful light doesn't happen at 2:00 p.m. You have to get up early and be in place, ready to shoot, 30 minutes before the sun comes up.

(2) To get a big, sweeping feel to your image, you'll want to use a "big, sweeping feel" type of f-stop, something like f/22, which is perfect for landscape shots like this.

(3) Right around sunrise, the light is very low and since you're shooting at a slow f-stop, like f/22, you'll need to be on a tripod, and you'll need a cable release (or wireless shutter release) to reduce the chance of any movement of your camera.

(4) Since you'll be on a tripod, you can shoot at the lowest native ISO for your camera (usually 100 for Canon and Sony cameras, and 200 for most Nikons, although some of the newer ones are 100 ISO, as well. Check the manual for your camera).

(5) For landscape shots like this, use the widest wide-angle lens you have. If you're using a full-frame camera, something like a 14mm or 16mm would be ideal. If you're shooting a cropped-sensor camera, something like a 12mm would be ideal.

(6) For a warmer look overall, set your white balance to Cloudy.

(7) This particular shot was taken right at sunrise, which is why some of the mountains are still in the shade and some have some light peeking through. The red glow on the arch (that's Mesa Arch in Moab, Utah) appears right before and during sunrise.

The Recipe for Getting This Type of Shot

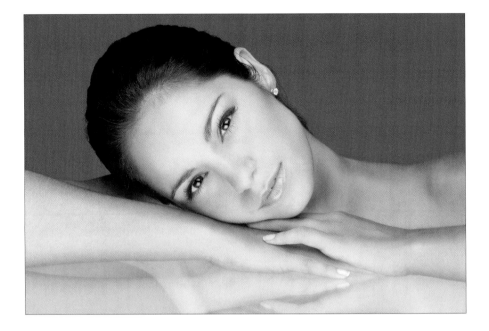

Characteristics of this type of shot: A "beauty-style" shot with soft, full lighting that wraps around your subject and gives you bright, flat, almost shadowless light.

(1) There are two keys to a beauty-style shot like this: The first is to have the subject put her hair back into a ponytail and hide as much of that behind her head as possible, leaving the face open and clean. The second is the lighting, which bathes the subject in light and gives the image the clean beauty look.

(2) There are just two lights used for this look: the main light is a beauty dish that's directly in front of the subject, but up about two feet above her face, aiming down at her at a 45° angle. The other light is under the plexiglass, aiming up at her at a 45° angle (this is some-times called "clamshell" lighting, because it looks like you're shooting in between an open clamshell). Position the camera height right at her eye level.

(3) To keep everything in focus, from front to back, you'll need to use an f-stop that holds details, like f/11, and a long enough lens (like a 200mm) to give a nice perspective.

(4) She's leaning on a clear piece of plexiglass that I also use for product photography, which is held up by two people assisting in the studio. The background is a gray seamless paper background.

The Recipe for Getting This Type of Shot

Characteristics of this type of shot: Sports photo, freezing the action and keeping the athlete in focus while the background is soft and out of focus.

(1) To get a tight-in shot like this, you'll need a very long lens, ideally a 400mm f/2.8 lens or a 300mm lens with a 1.4x teleconverter to get you in closer. If this seems like a crazy-expensive proposition, turn back to the sports chapter for a refresher.

(2) To get the out-of-focus background (which you want, as it creates separation of the player from the background), you need to shoot at the widest possible aperture your lens will allow (meaning, shoot at the lowest number your lens will go. Ideally f/2.8, but if your lens won't go that low, then f/4. If your lens will only go down to f/5.6, you're not going to get the type of out-of-focus background and separation you see here, which is why these fast lenses—ones that shoot at f/2.8 or f/4—are ideal for sports). During a game, I shoot in aperture priority mode and I won't change the f-stop even once—it will always be f/2.8 (and the camera will pick the shutter speed for me).

(3) Your shutter speed needs to be at least 1/1000 of a second or faster to freeze action in sports. During a daylight game like this, with you shooting at f/2.8, it will not be a problem (you'll probably see shutter speeds more like 1/4000 or higher). However, if part of the field winds up in shadow later in the day, you might have to raise your ISO to get your shutter speed back up to 1/1000 of a second.

(4) Lastly, to shoot a moving athlete like this and not lose the focus, switch your camera to AI Servo Mode (Canon) or Continuous Focus mode (Nikon and Sony). That way, the focus tracks and moves with your athlete as he/she moves during the action.

The Recipe for Getting This Type of Shot

Characteristics of this type of shot: A food shot, cropping in tight with lots of detail, while the background falls off to being out-of-focus very quickly.

(1) The first step to a shot like this happens before you're seated at your table. Ask to either be seated outside (if possible) or near the window. The reason is the challenge of shooting food—you need light. Nice, natural light looks wonderful for food shots, so if you can sit near a window, or outside, you're halfway there. However, to keep the plates looking white (instead of tinted blue), make sure you change your camera's white balance to Cloudy or Shade (try both and see which one looks better).

(2) The other key to great-looking food shots is to zoom in really tight on the food. For example, if you have an 18–200mm lens, zoom all the way in to 200mm. Don't try to show the whole plate, just show part of it. To do this, you'll probably have to stand up behind your chair for a moment, then shoot from a little lower angle (don't stand up straight and shoot down on your food—crouch down to lower your angle).

(3) To get the soft, out-of-focus background, shoot in aperture priority mode at the lowest number f-stop your lens will allow (in this case, it was only f/5.6, but because I was zoomed in so tight, it still creates that out-of-focus background). If my lens would have gone to f/4 or f/2.8, I could have made it even more shallow and out-of-focus.

(4) To create some energy in food shots like this, I normally tilt the camera to the right or to the left (as seen here).

The Recipe for Getting This Type of Shot

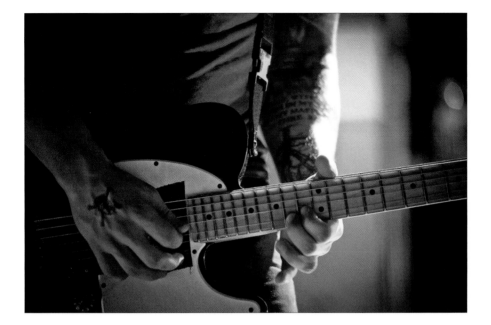

Characteristics of this type of shot: A concert shot with multi-colored lighting.

(1) You can't (and shouldn't) use a flash for concert or event photography, so you don't have to worry about that. One key to a shot like this is to use the lowest possible f-stop your lens will allow (ideally, f/2.8 or f/4) to help separate the musician from the background by making the background go out of focus. In fact, the depth of field here is so shallow that the arm on the left is in focus and the arm on the right is out of focus.

(2) For a close-up shot like this, you'll need a zoom lens to zoom in tight (this was taken with a 70–200mm lens at 200mm).

(3) The real challenge in getting a shot like this is freezing the motion of the musicians on stage, so the shot is in focus. That means keeping an eye on your shutter speed. If it falls below 1/60 of a second, your shot will definitely be out of focus. If you're shooting a big major touring act, most times light will not be a problem, because there will be a ton of it. However, in some cases (like with the shot above), the light is low. Here, there were only four lights total for the whole night, so I had to shoot at (wait for it…wait for it…) 8,000 ISO to get to a shutter speed of just 1/100 of a second. If this happens to you, you'll need to use the noise reduction software in Camera Raw (in Photoshop or Elements, or the Develop module in Lightroom) to reduce the amount of visible noise that you see when shooting at that high an ISO. Go to the Detail tab (panel) and drag the Luminance slider to the right until the noise starts to disappear (stop as soon as it's gone, or your image will get blurry).

Index

ADD MORE TO ALL THE MEMORIES.

You eat, sleep and breathe creativity. You don't take life for granted. You take it for more than that. With the photos on the fly and the designs that you draw. These are the bottles that you always leave open by your side, ready and waiting to catch lightning whenever it should choose to strike. Fuel your creativity.

Personalized Support
for the Imaging Professional.

Canon Professional Services (CPS) provides exceptional support for full-time imaging professionals. CPS members receive exclusive 24/7 phone and email support, expedited and discounted equipment maintenance and repairs, Equipment Evaluation Loans, on-site support at select events and shows, discounts on select Canon Live Learning seminars and workshops, and more.

Learn more about CPS and our Enterprise CPS Program at:
cps.usa.canon.com

FAST REPAIR TURNAROUND **DEDICATED PRO TECH SUPPORT** **PRO EDUCATION & TRAINING**

- Discounted repair service
- Expedited Repair Turnaround
- Equipment Evaluation Loans
- 24/7 U.S.-based domestic & international hotline
- On-site support at major events and shows
- Product Maintenance

OUR FOCUS IS YOU

Take your best shot and make it even better with the Adobe Creative Cloud Photography plan.

Get all the essential tools, including Adobe Photoshop Lightroom CC and Adobe Photoshop CC, to craft incredible images every day, everywhere — whether you're a beginning or a pro. It's all your photography. All in one place.

Learn more at
http://www.adobe.com/creativecloud/photography.html

BandH.com

Ⓐ Apple 21.5" iMac All-in-One Desktop Computer
Ⓑ Apple Mac Pro Desktop Computer (Six-Core)
Ⓒ Adobe Photoshop Lightroom 6 Software for Mac and Windows
Ⓓ Canon EOS 5D Mark III DSLR Camera with 24-105mm Lens
Ⓔ Rode VideoMic Pro Compact Shotgun Mic
Ⓕ Generic DSLR Rig
Ⓖ Sekonic Litemaster Pro L-478DR Light Meter
Ⓗ Nikon SB-910 AF Speedlight i-TTL Shoe Mount Flash
Ⓘ Nikon D750 DSLR Camera with 24-120mm Lens
Ⓙ Fujifilm X-T1 Mirrorless Digital Camera
Ⓚ Sigma 105mm f/2.8 EX DG OS Macro Lens for Nikon AF
Ⓛ Oben CT-3561 Carbon Fiber Tripod

B&H Delivers in Every Way
FREE Expedited Shipping on orders over $49*

B&H is the world's leading Photography equipment retailer
• The largest inventory • Top industry experts on staff
• The most helpful customer service anywhere
Visit BandH.com the ultimate resource for all your Photography needs
Be informed with B&H.com/Explora's huge collection of Photo educational content:
• Articles • Tutorials • Trends • Reviews • Tips • Interviews
• Newly-Release Gear Profiles • Recorded Live Events • Streaming Videos

420 Ninth Ave, NYC
Visit Our SuperStore

800-686-0955
Speak to a Sales Associate
or consult with Live Chat online

www.BandH.com
Shop conveniently online